DANGEROUS TO SHOW

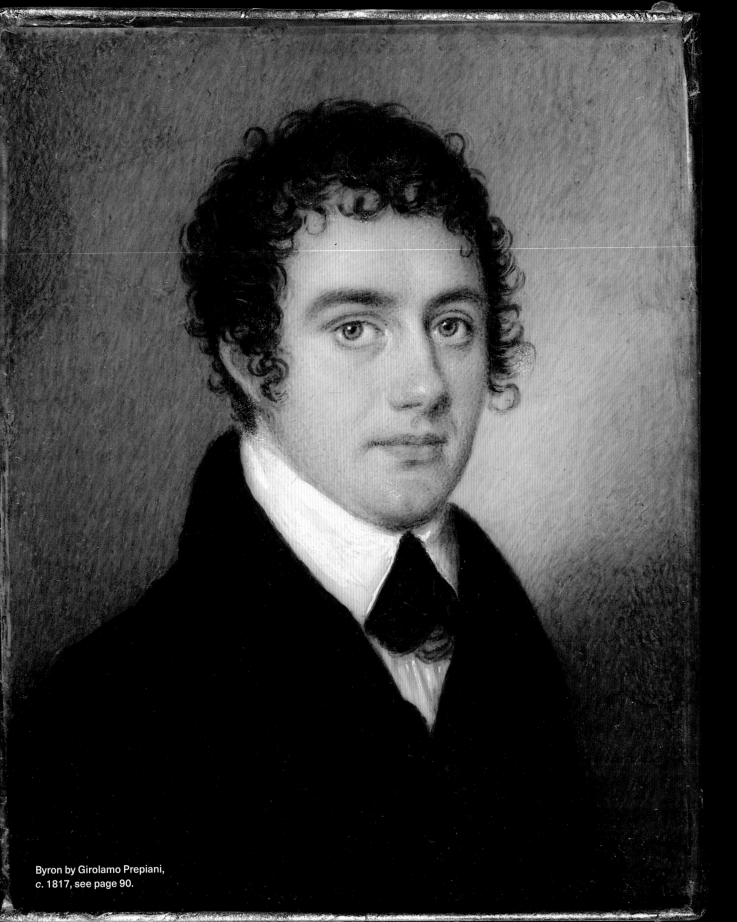

Byron by Girolamo Prepiani,
c. 1817, see page 90.

DANGEROUS TO SHOW

Byron and His Portraits

Geoffrey Bond &
Christine Kenyon Jones

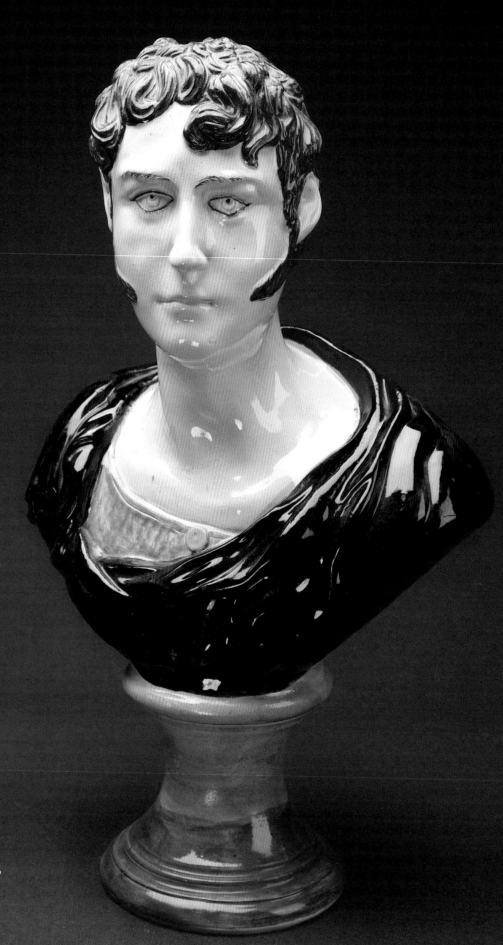

Ceramic bust of Byron,
c. 1820, see page 121.

Contents

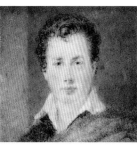

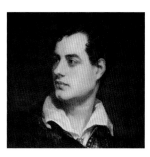

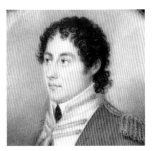

Foreword

NO OTHER ENGLISH POET – with the possible exception of
Shakespeare – has a name which so readily converts to an adjective.
True, the term 'Byronic' encompasses more than the merely visual;
yet the expression immediately conjures up a certain image – a pale
face, often in half profile, with dark curly hair receding at the temples
and a distant gaze – a portrayal instantly recognisable thanks to the
ubiquity of its reproduction. But when we hear mention of the poet's
name, is it the 'real' Byron who comes to mind or merely an artist's
imagination of the Byronic Hero?

My own childhood impression of Byron came from a copy of a
George Sanders portrait we had at home – a youthful image with
full face and a central forehead curl (fig. 26). This was superseded
when my father inherited the much more familiar 'cloak' portrait by
Thomas Phillips (fig. 41), perhaps the most widely reproduced of all
Byron portraits. Other images have gazed down at me from time to
time: the magnificent Bertel Thorvaldsen statue in the Wren Library
at Trinity College, Cambridge and, in the College's Great Hall, a
portrait described as Byron (fig. L, page 13) though – as the authors
explain – the identification is probably erroneous. The well-known
portrait by Richard Westall (fig. 31) used to hang in the Peers' dining
room in the House of Lords – though it is now back in the National
Portrait Gallery.

We are greatly indebted to Geoffrey Bond and Christine Kenyon
Jones for their detailed exploration of the portraiture of Byron to
discover what the 'real' Byron may have looked like. In so doing they
have provided us for the first time with not only a comprehensive and
fully illustrated survey of the full range of Byron portraits but also

the inside story of how they came into being and what Byron and his contemporaries thought of his different representations.

Many readers will have their own mental picture of Byron which they can compare to the paintings, sculptures and prints shown in this fascinating volume. Those coming to Byron for the first time will be intrigued to see the variety of different images and to discover how Byron and those around him struggled to control and manipulate the Byronic look.

Robin Byron

Robin Byron, 13th Lord Byron

Byron family tree

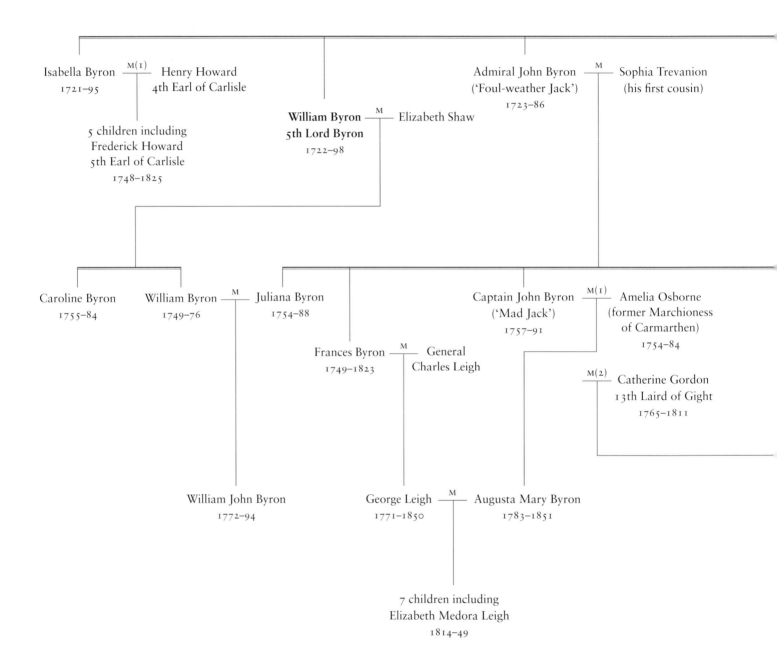

Isabella Byron
1721–95
—— M(1) ——
Henry Howard
4th Earl of Carlisle

5 children including
Frederick Howard
5th Earl of Carlisle
1748–1825

William Byron
5th Lord Byron
1722–98
—— M ——
Elizabeth Shaw

Admiral John Byron
('Foul-weather Jack')
1723–86
—— M ——
Sophia Trevanion
(his first cousin)

Caroline Byron
1755–84

William Byron
1749–76
—— M ——
Juliana Byron
1754–88

Frances Byron
1749–1823
—— M ——
General
Charles Leigh

Captain John Byron
('Mad Jack')
1757–91
—— M(1) ——
Amelia Osborne
(former Marchioness
of Carmarthen)
1754–84

—— M(2) ——
Catherine Gordon
13th Laird of Gight
1765–1811

William John Byron
1772–94

George Leigh
1771–1850
—— M ——
Augusta Mary Byron
1783–1851

7 children including
Elizabeth Medora Leigh
1814–49

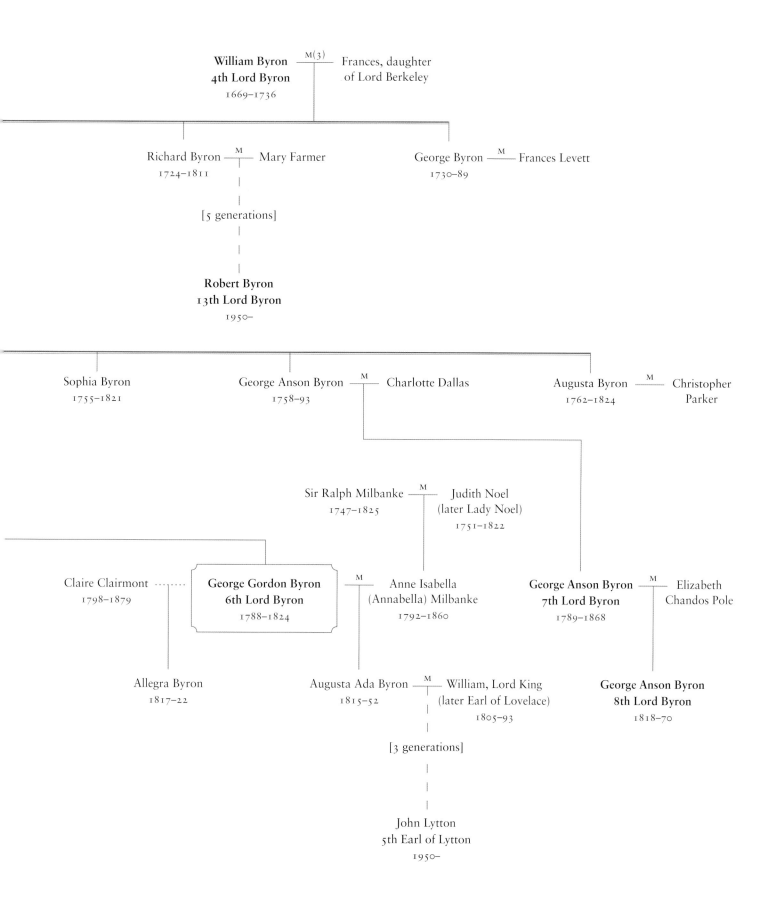

William Byron
4th Lord Byron
1669–1736

M(3)

Frances, daughter
of Lord Berkeley

Richard Byron
1724–1811

M

Mary Farmer

George Byron
1730–89

M

Frances Levett

[5 generations]

Robert Byron
13th Lord Byron
1950–

Sophia Byron
1755–1821

George Anson Byron
1758–93

M

Charlotte Dallas

Augusta Byron
1762–1824

M

Christopher
Parker

Sir Ralph Milbanke
1747–1825

M

Judith Noel
(later Lady Noel)
1751–1822

Claire Clairmont
1798–1879

George Gordon Byron
6th Lord Byron
1788–1824

M

Anne Isabella
(Annabella) Milbanke
1792–1860

George Anson Byron
7th Lord Byron
1789–1868

M

Elizabeth
Chandos Pole

Allegra Byron
1817–22

Augusta Ada Byron
1815–52

M

William, Lord King
(later Earl of Lovelace)
1805–93

George Anson Byron
8th Lord Byron
1818–70

[3 generations]

John Lytton
5th Earl of Lytton
1950–

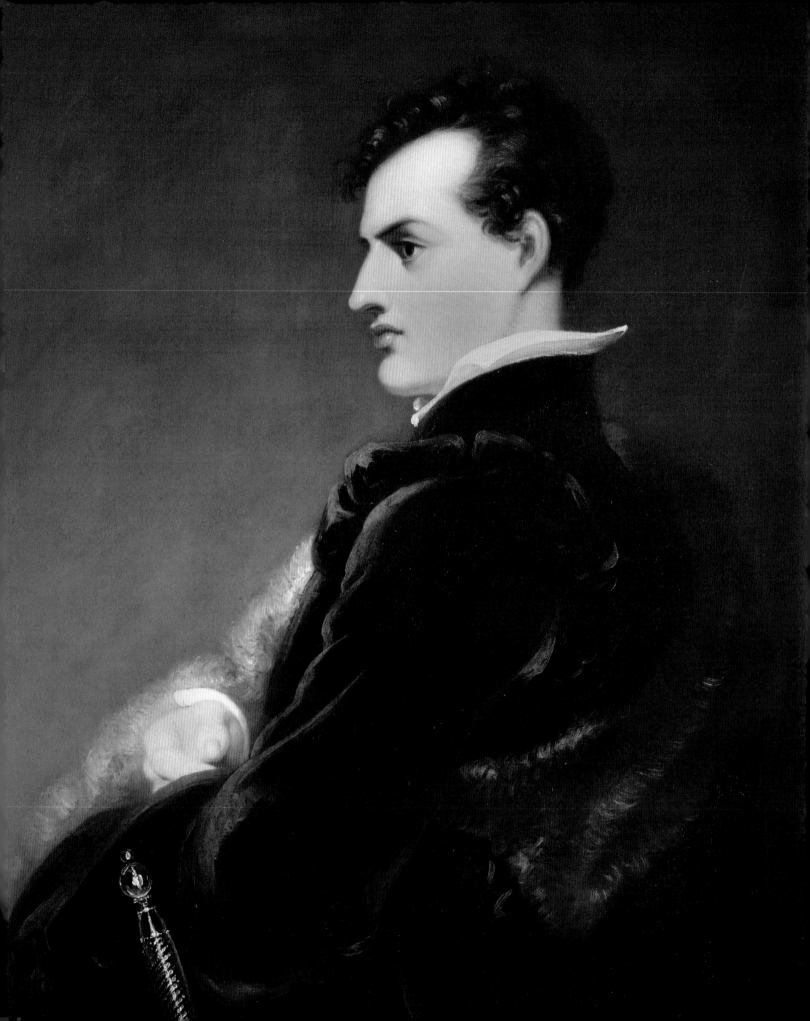

Introduction

'Mad – bad – and dangerous to know.'
Lady Caroline Lamb of Byron, 1812.[1]

'Don't look at him. He is dangerous to look at.'
Lady Liddell to her daughter, on seeing Byron in St Peter's, Rome, 1817.[2]

'I have a print of you to which I talk every day, and I make your answers, and I should like you to fancy me a friend.'
Isabella Harvey, aged 'nearly eighteen', writing to Byron in Genoa, 1823.[3]

LORD BYRON ONCE DESCRIBED himself as 'The grand Napoleon of the realms of rhyme' and, although he meant the comparison as an ironic comment on his and the Emperor's parallel falls from grace in 1815–16, he was, like Napoleon, one of the most famous men of his age: the Romantic poet and satirist whose poetry, personality and death in Greece captured imaginations worldwide.[4]

Handsome, aristocratic and mysteriously seductive, Byron was what we would now call a celebrity, whose face, figure and lifestyle added greatly to his fame and the appeal and challenge of his poetry. Being 'dangerous' was part of Byron's public character from early on in his life, because his poetry raised strong emotions, invited people to identify the poet himself with his wild and glamorous protagonists, opened up contentious areas of moral, political and religious debate, and laughed at many serious matters. Personally, too, his reputation as a seductive libertine made him supposedly fatally attractive to both women and men.

All this encouraged a wide range of artists to create portraits of Byron during his lifetime and to memorialise him after he died in

Byron by Richard Westall, 1813, see page 52.

Greece. Both in the originals and in print, these images were, and still are, a major part of his allure, drawing viewers into a relationship with him and making him instantly recognisable even to those who have never read his compelling work, his vivid correspondence or his arresting life story.

But while Byron's 'dangerous' writing and personal life can be regarded as his own choice, the question of how far he was responsible for the powerful visual effect of his portraiture and what can be called his iconography is more complex. Any portrait includes the contribution of the artist as well as the sitter and, as Byron soon discovered, he was by no means fully in control of the way he was represented by artists, even if he had chosen and commissioned them himself and sat face-to-face with them to produce an *ad vivum* or 'from life' portrait. In terms of his personal style and the way he looked, he certainly made strenuous efforts to control the presentation of his own face and figure, using rigorous dieting and exercise, and the careful disguise of the deformed foot and calf which embarrassed him and darkened his life. The way he dressed was important, too: he employed fashion of the scrupulous, Beau Brummell, type (acknowledging a 'tinge of Dandyism' in his youth), chose to wear sailors' and 'Albanian' dress for his portraits, and commissioned elaborate Homeric helmets for his final voyage to Greece.[5] He also instructed artists *not* to portray him with the pens or books that belonged to a poet, preferring to be presented as a nobleman and man of action rather than a sedentary writer. But even in face-to-face portrayals he could not exert total control over the artists – and in portraits which were not from life, such as the thousands that circulated during his lifetime through copies, prints and imagined representations, he as the subject had no control at all.

Commissioning, sitting for, checking, responding and reacting to portraits of himself was a significant part of Byron's life, as this book shows, and many of his relationships, both personal and with his public, were conducted through this process and through his portraits. There were social customs concerned with the exchange of miniatures and private portraits which Byron endorsed enthusiastically, although he often expressed doubts about the value of public portraits ('vanities'), frontispieces of the author's face ('a paltry exhibition') and particularly busts ('pretensions to permanency').[6] Ironically, some of Byron's favourite portraits of himself are no longer extant for us to see in the original. Both the 1812 miniature by George Sanders, which was once purloined by Lady Caroline Lamb, and the 1816 miniature by James

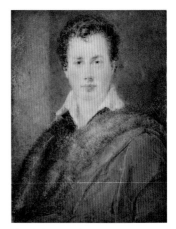

Fig. A **George Sanders,** artist's copy, 1812, page 32.

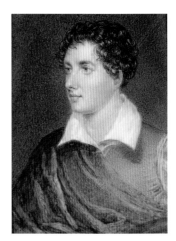

Fig. B **James Holmes, artist's** copy, 1824, page 45.

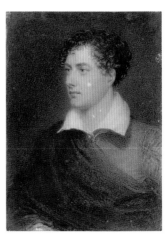

Fig. C **Emery Walker, photograph** after Holmes, *c.* 1898, page 44.

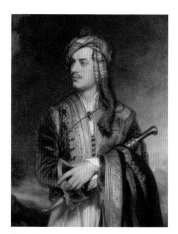
Fig. D **Thomas Phillips, 1814,** page 62.

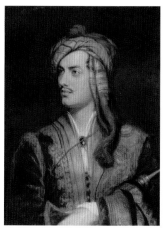
Fig. E **Thomas Phillips, 1835,** page 67.

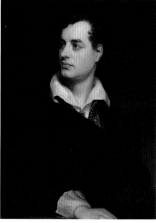
Fig. F **Thomas Phillips, 1818,** page 58.

Holmes, which Byron called *'the very best … one of me'*, are now only available in copies (figs A and B), photographs (fig. C), or engravings.[7]

On the other hand, many of the famous portraits of Byron with which we are now familiar were not actually available to the public during Byron's lifetime, and in that respect (as in many others) we now know more about Byron than his contemporaries did. Notable examples include the famous Thomas Phillips 'Albanian' portrait (fig. D) which was shown at the Royal Academy Exhibition in 1814 but then shut up by Byron's hostile mother-in-law and not known, even through engraving, until nearly twenty years after Byron's death. The version of the 'Albanian' portrait which is most familiar today (fig. E) – because it hangs in the National Portrait Gallery in London – was actually not painted from life but is an artist's copy, created by Phillips in 1835, eleven years after Byron's death. Even the best-known version of the equally famous Phillips 'cloak' portrait (fig. F), at Newstead Abbey (Byron's ancestral home in Nottinghamshire), is not the original, but again an artist's copy. What does appear to be the prime, face-to-face version of this 'cloak' portrait is published here in colour for the first time, on the cover of this book (and fig. 41).

The George Sanders 1807–9 portrait of Byron and Robert Rushton (fig. G), too, was in private hands during the poet's lifetime, and was only made available, through engravings, in 1830, six years after his death. The beautiful 1815 drawing of Byron's profile by George Harlow (fig. H) was never exhibited before the twentieth century, but was engraved in 1815 and 1816 with an alteration which gave the prints (fig. I) a very different expression from the portrait itself, which remained unidentified until the 1960s. The fine original clay model of the bust by Lorenzo Bartolini, created during numerous sittings with the poet in 1822 (fig. J), was unknown to the public until it came up for auction in 2019. Just how much an engraving or a copy can differ from the original artwork can be seen from the engraving of this bust made by Raphael Morghen (fig. K), which gave rise to Byron's mournful opinion that it 'exactly resembles a superannuated Jesuit'.[8]

Many Byronists still dream of the possibility that there is, hidden in some bank vault perhaps, a copy of Byron's personal memoirs, whose burning in 1824 was authorised (by people who had not read them) because of their supposed scandalous content. The very recent emergence of the Bartolini bust, in excellent condition despite its extremely fragile material ('terracruda' or unfired clay), opens up hopes of the discovery in an attic or museum storeroom of an unknown portrait of Byron – although the original of Byron's favourite miniature

of himself that did re-emerge in 2007 turned out to have been badly disfigured because of amateur overpainting by his great-granddaughter, Lady Wentworth.[9]

And there is still the tantalising challenge of the extant portraits that *might* be of Byron, and could be originals taken at face-to-face sittings, rather than copies, or portrayals of other people looking 'Byronic'. Byron inspired a generation of young men who wanted to look like him, including Benjamin Disraeli, the future Prime Minister, and many early-nineteenth century portraits exist of youths who look Byronic enough to mislead the experts. Even Rowland Prothero, editor of the 1898–1904 edition of Byron's letters and journals, was led into believing that figure L was a portrait of Byron as a young man, after being introduced to it by the author and academic A.C. Benson. Prothero used it as the frontispiece to the opening volume of his Byron edition, and Benson presented the portrait to Trinity College, Cambridge, where it continues to be displayed as a genuine likeness of Byron.[10] But, meanwhile, there is the real possibility that well-executed portraits such as figure M, which belongs to the Byron family, may be of Byron, and taken from life.

Byron's claim that he 'awoke one morning and found [him]self famous' on 10 March 1812, on the publication of the first two cantos of *Childe Harold's Pilgrimage*, implies that he saw himself as the passive recipient of this fame.[11] The reality, however, was that his publisher, John Murray, was a master of publicity and had worked very hard in the months prior to the publication of the poem to ensure that the reading public was aware of its impending appearance. He not only spent some thousands of pounds (in today's values) on advertising, but also assiduously spread the news by word of mouth among booksellers and the literary reviews, and exploited Byron's status as a peer by carefully timing the publication just after Byron had delivered his maiden speech in the House of Lords on 27 February.[12] Byron was aware of Murray's marketing strategy, as is evident from a comment to his friend Francis Hodgson about the proposed luxury, quarto-sized volume, that it was a 'cursed unsaleable size'.[13] And when Murray proposed showing the manuscript of *Childe Harold* to William Gifford, editor of the powerful *Quarterly Review*, Byron was distinctly alarmed. 'Though not very patient of Censure,' he told Murray, 'I would fain obtain fairly any little praise my rhymes might deserve, at all events not by extortion & the humble solicitations of a bandied about manuscript.'[14]

Byron's reference to his intolerance of censure was to his scathing 1809 satire, *English Bards and Scotch Reviewers*, which responded to the criticism of his early verses by the *Edinburgh Review* in particular.

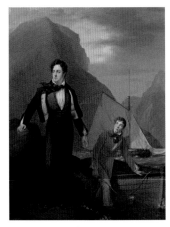

Fig. G **George Sanders**, 1807–9, page 27.

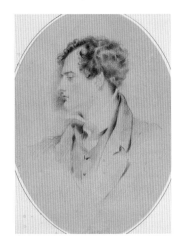

Fig. H **George Harlow**, 1815, page 70.

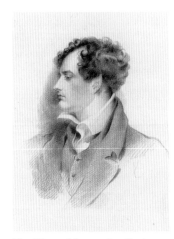

Fig. I **Henry Meyer after Harlow**, 1816, page 72.

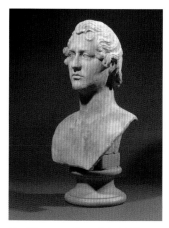

Fig. J **Lorenzo Bartolini, 1822, page 94.**

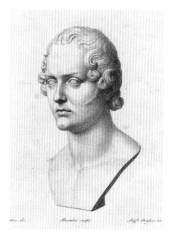

Fig. K **Raphael Morghen after Bartolini, 1822, page 98.**

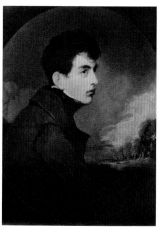

Fig. L **Frontispiece to the 1898 edition of Byron's works.**

But his edgy reputation as the author of *English Bards* also played into the reception of *Childe Harold*, enabling Murray's influence in the book trade to combine with the notoriety of his author to ensure record sales. The first 500 copies of *Childe Harold*, priced at the exorbitant price of 30 shillings each, sold in three days, prompting the Duchess of Devonshire to declare that it was 'on every table' (meaning on the tables of those who could afford to pay about one-third of a gentleman's weekly income to purchase it).[15] This grand quarto edition was followed a few days later by an edition of 3,000 copies in the smaller, less expensive, octavo size, priced at 12 shillings, and within six months 4,500 copies of the poem had been sold. Later, *The Corsair* sold 10,000 copies on the first day of publication. Byron as a nobleman declined to receive any financial profit from his writings at this stage, but in the following few years those who made a fortune from Byron and his work included not only John Murray but also the printer Thomas Davison of Whitefriars, who printed all Byron's publications for Murray and some two-thirds of Murray's publications in general, and rose from humble beginnings to become a wealthy man.[16] Other significant economic beneficiaries were the many artists and highly-paid engravers who catered during Byron's lifetime and after for the extraordinary desire of the public to see his portraits.

After the first flush of sales of *Childe Harold* in early 1812, Murray's next intention was to promote it by visual means; his Lordship's handsome face could, Murray thought, be deployed to sell thousands more copies of the work with a portrait as a frontispiece. The popular success of Cantos 1 and 2 of *Harold* was based not only on the poetry but also on the extensive notes, printed as a commentary on the verse, which conveyed the author's personality in some ways even more intensely than the strong and varying emotions of the verse, giving readers the feeling that they were in something like a personal conversation with Byron. But although Byron cultivated this strongly personality-based style of writing, he was, at this stage, wary of visual self-exposure. In particular he wanted to control the quality of any public prints and how they represented him, hence his '*very strong objection* to the engraving' of the Sanders 1812 miniature made by Henry Hoppner Meyer (fig. N) for the fifth edition of *Childe Harold*, which therefore appeared without the frontispiece that Murray had planned.[17] Byron was still trying to stay in control when Murray proposed the engraving by John Samuel Agar of the Phillips 'cloak' portrait for an edition of his works in 1814 (fig. O). But on this occasion Murray appears to have got what he wanted, and this engraving, and its many copies and versions, went on to provide an important basis for the way the public saw Byron.[18]

Eventually Byron seems to have accepted this aspect of his reputation, understanding the obsession of his time with likenesses of people, and even participating like a modern celebrity in the circulation of prints of his portraits to fans (fig. P). In what was perhaps an attempt to emulate the reputation of his notorious Byron family forebears whose scandalous exploits included murder, elopement, incest and adultery, his behaviour in London society over the next few years also helped to increase his notoriety as well as his fame.[19] His affairs with aristocratic women, his oppositional politics, his attendance at prize fights, his heavy drinking in gentlemen's clubs, his involvement with the Theatre Royal, Drury Lane, and above all, the very public breakdown of his marriage, offered excellent possibilities for gossip and the satirical print-makers (figs Q and R). Perhaps a similar motivation lay behind Byron's forthright accounts of his libertine life in Venice, detailing sexual encounters with 'more women than I can count or recount' between 1817 and 1819.[20] Sent to John Murray in London, they soon (as Byron must have known) became public through being shared by the publisher with his friends, acquaintances and business partners.

Later, however, when his popularity as a poet began to wane, Byron began to resent what he now saw as the appropriation and unauthorised imaginative 'creation' of his image by the public. Using intensely visual metaphors to describe this process, he characterised women in particular as powerful artists who could make independent visual artefacts out of his face and body, himself and his works. Byron's epic poem *Don Juan* gives an ironically passive role to the legendary great seducer, and at the end of the poem he describes Juan's treatment by women in the same way that he saw himself, as the passive object of female fantasies:

> with women he was what
> They pleased to make or take him for; and their
> Imagination's quite enough for that;
> So that the outline's tolerably fair,
> They fill the canvass up – and 'verbum sat.'
> If once their phantasies be brought to bear
> Upon an object, whether sad or playful,
> They can transfigure brighter than a Raphael.
> *(Don Juan*, Canto 15, lines 122–8).[21]

Byron's stance reverses the common twentieth-century view, particularly in cinema, of the male as an active gazer and the female as the passive object of that gaze.[22] Thus his alter ego in Lady Caroline Lamb's novel

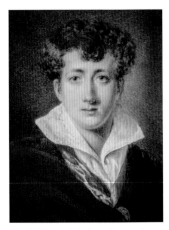

Fig. M **Portrait belonging to the Byron family.**

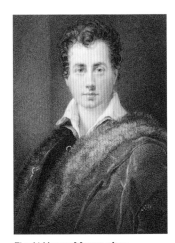

Fig. N **Henry Meyer after Sanders, 1812, page 37.**

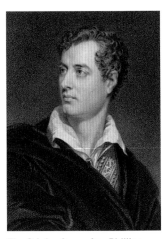

Fig. O **John Agar after Phillips, 1814, page 59.**

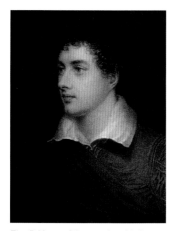

Fig. P **Henry Meyer after Holmes, 1817, page 45.**

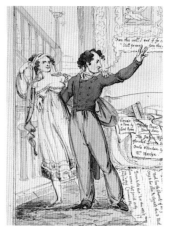

Fig. Q **Isaac Robert Cruikshank, 1816, page 132.**

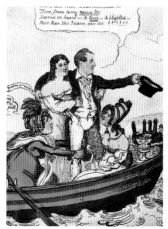

Fig. R **George Cruikshank, 1816, page 133.**

Glenarvon became for him a surreptitiously taken 'picture', which 'can't be good – I did not sit long enough', while in an angry letter about *Don Juan*'s unpopularity he characterised his women readers as sculptors, who 'made me without my search a species of popular Idol – they – without reason or judgement beyond the caprice of their Good pleasure – threw down the Image from it's [sic] pedestal – it was not broken with the fall – and they would it seems again replace it – but they shall not'.[23]

The term 'Byromania' was invented by Annabella Milbanke (later Lady Byron and herself an unwilling Byromaniac) to describe what we would call the celebrity cult around her future husband.[24] This social and literary phenomenon has been the subject of several studies, and in particular the visual aspect of Byronism – a complex social construction, built up by many hands over more than two centuries – was highlighted in an exhibition and conference at the National Portrait Gallery in London in 2002–3.[25] In the twenty-first century, visual Byronism and fandom is flourishing, especially on screen, online and on social media, where images based on face-to-face sittings and those created from the artists' fantasy or imagination circulate side-by-side as equally authentic 'portraits of Byron'. One of the purposes of this book is to try to illustrate the historical basis for these portraits as well as to show how, from early on in Byron's lifetime, they have developed into a rich imaginative Byronic culture of many kinds – although to follow this process fully over more than two centuries would require far more space than we have here.

Byron was the first contributor to the creation of his own legend and, despite his wish to be seen as a passive rather than an active participant, he became an important part of this game. In the same way that his poetry provided the 'word' for his readers, the visual images he sat for in turn created the 'outline' upon which his public – both female and male Byromaniacs – have fantasised Byron, building visions which have transfigured him and effectively rendered him immortal.

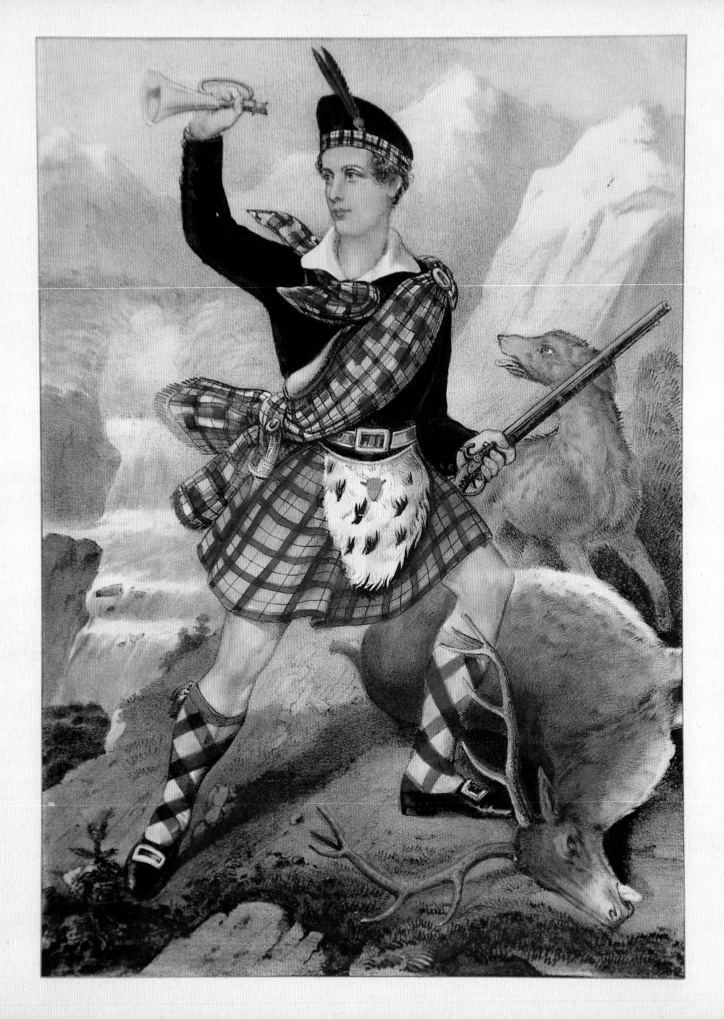

Childhood and youth

1795–1809

And who is he? The blue-eyed northern child.
The Island, Canto 2, line 163.[26]

THE SMALL WATERCOLOUR on the next page, of Byron at the age of six or seven by the little-known Edinburgh artist William Kay (fig. 2), marks a change of almost fairy-tale proportions in the life and expectations of its young subject. It records the moment when George Gordon Byron, the little lame boy living with his widowed mother in modest lodgings in Aberdeen, became the heir presumptive to the barony of Byron, destined to be a peer of the realm and proprietor of a large ancestral estate.

Dated 1795, this naïve but charming painting seems to be the first ever portrait of Byron, the beginning of a long line of representations of him of all types and in all media. These were produced on an industrial scale to meet the wishes of hundreds of thousands of people, all over the world, who wanted to see the face of the poet whose verse had drawn them into a relationship with him that seemed to them almost personal.

The whereabouts of this fragile object are now unknown, but photographs show that it was signed by William Kay, son of the caricaturist and engraver John Kay (1742–1826).[27] It seems to have been commissioned after the news came through to Aberdeen that Lieutenant William John Byron, grandson of the fifth Lord Byron and heir to the barony, had been killed at the battle of Calvi, Corsica, on 31 July 1794 while serving in the war against France. The fifth Lord Byron was still living, but Lieutenant Byron's unexpected death made the elderly Lord's great-nephew, young George Gordon Byron, his presumptive heir.

Fig. 1 'Byron in the Highlands' imagines young Byron's childhood in Scotland, up to the age of ten, showing him in the kilt and Scottish dress which had become highly fashionable by the time this print was made in 1865. Although in later life Byron did sport the Gordon tartan, he never wore the kilt and he later ridiculed those who enjoyed hunting.

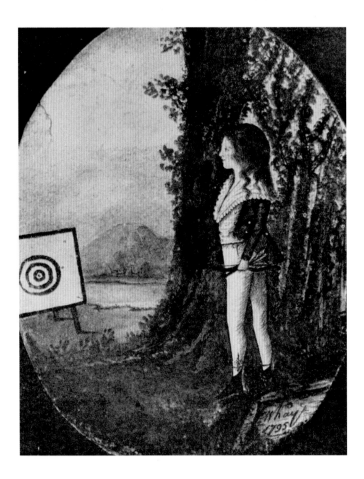

Fig. 2 **In 1794, six-year-old George Gordon Byron unexpectedly became heir presumptive to the barony of Byron (see Byron family tree, pages 6-7). William Kay's watercolour, painted in Aberdeen where the boy and his mother were living, conceals young George's lame right foot behind a plant.**

Kay shows George with long curly hair and smart clothes: a shirt with a wide frilled white collar, short jacket with large brass buttons, long tight trousers and ankle-length boots. Only one of the boots is fully visible because the other foot is hidden behind a plant, a hint which confirms that Byron's right foot, ankle and lower leg were deformed and twisted inwards from birth. The cause of the deformity has not been definitely established, but medical suggestions include a club foot, a dysplasia, or a hidden spinal cord weakness, such as *spina bifida occulta*. It was a disability that would sour his life and contribute in incalculable ways to forming his character, temperament and outlook.

In the background, the artist provides a glimpse of a low mountain and a large mansion or group of buildings: perhaps intended to represent the estate the boy was now expected to inherit. Kay poses his subject against a large tree trunk which completely dwarfs him, and he also provides him with a bow and arrows, carried in the left hand. This seems to have been a nod to the practice of dressing and portraying young boys (especially aristocrats) in the guise of Cupid, but in this case it looks as if someone – perhaps Byron himself – insisted on including a proper target to shoot at, prominently placed at the left of the picture.[28]

Four years later, when the fifth Lord died on 21 May 1798, the now ten-year-old Byron succeeded him as sixth Baron Byron of Rochdale,

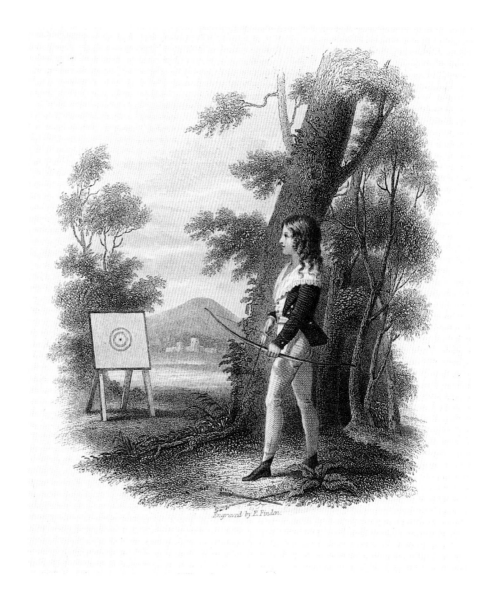

Engraved by E. Finden.

inheriting estates in Lancashire and Norfolk as well as the ancient,
former monastic, buildings and extensive estate of Newstead Abbey in
Nottinghamshire. As a peer he became part of a highly exclusive group
of some 300 men entitled to take part in the government of the country
as members of the House of Lords. This was a responsibility that he
seriously aspired to as a teenager and a young man, before becoming
disillusioned in his mid-twenties, deciding that he was 'not made for
what you call a politician'.[29] At this point he turned more decidedly to
the poetry which arguably gave him a more influential voice than any
political career is likely to have done.

The little portrait was given by Byron to his nurse Agnes Gray and
passed via Agnes's sister May Gray to a Dr Ewing of Aberdeen, who
in 1832 lent it to be engraved by Edward Finden (fig. 3) and published
by John Murray in connection with Thomas Moore's two-volume
biography, *Letters and Journals of Lord Byron with Notices of His Life*

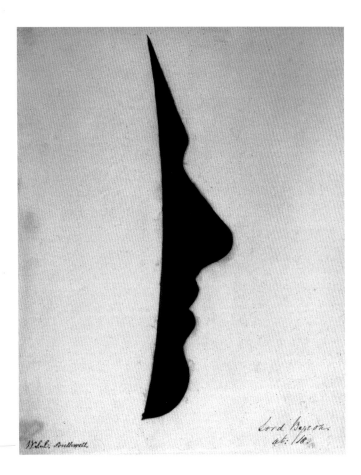

Fig. 4 A silhouette of Byron's face at the age of eighteen (1806) created by John or Robert Leacroft, his neighbours when he lived at Burgage Manor, Southwell, Nottinghamshire, not far from his ancestral home, Newstead Abbey. Byron's strong nose, rounded chin and very short upper lip are shown in this tracing of the shadow of his profile.

(1830).[30] Finden's engraving refines Kay's image by making the boy's figure older, slimmer and more active, and by idealising Byron's features according to the fashionable standards of the 1820s. This process was repeated time after time during Byron's life and after his death, subjecting his image to the nineteenth-century equivalent of airbrushing, photoshopping or computer graphics. Perhaps based on the Finden image, or more likely a fanciful representation of what Byron's Scottish childhood *ought* to have been like, is a coloured print of 1827 (fig. 1), 'Byron in the Highlands', showing young Byron in the kilt and full Scottish dress which had by then become fashionable. The gun and dead stag are particularly unlikely props, however, since Byron ridiculed those who liked hunting, shooting and fishing.[31]

But there are some early images, dating from the years before Byron became a celebrity, which do not attempt to give him a makeover to conform with fashion or fantasy, and show his features in a form not yet influenced by his later fame and poetic image. They reflect Samuel Johnson's view that the value of portraiture lay more simply 'in diffusing friendship, in reviving tenderness, in quickening the affections of the absent, and continuing the presence of the dead'.[32] Most closely related of all to the 'real' Byron of this period, perhaps, is the silhouette of his face at the age of eighteen (fig. 4) and on the cover of this book, created

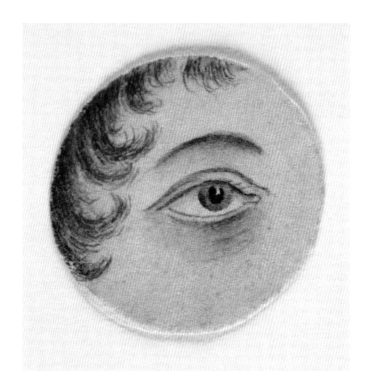

Fig. 5 This small watercolour of Byron's right eye, dated 26 April 1807, is only 2 cm in diameter. It was painted by Elizabeth Pigot, Byron's neighbour in Southwell, and also shows his curly, dark auburn hair. Byron's eyes were presented by different artists as blue, grey, hazel and brown.

by Robert or John Leacroft. These brothers were Byron's neighbours and contemporaries in Southwell, Nottinghamshire, some twelve miles from Newstead Abbey, where his mother lived at Burgage Manor from 1803 to 1808. The silhouette was made by using a light to throw the shadow of Byron's profile onto a piece of paper placed on a wall, then tracing the outline of the shadow with a pencil, and finally filling in the image with black ink. Byron's characteristic strongly rounded chin, large nose, full lips and very short upper lip are clearly shown.

This particular copy of the silhouette was found inserted into the copy of Thomas Moore's biography of Byron that was presented by Moore in 1830 to another of Byron's Southwell neighbours and close friend, Elizabeth Pigot, who lived across Burgage Green from the Manor. She helped Moore with research for his biography by contributing many reminiscences and mementos about the teenage poet. Six years older than Byron, she stood in something of the role of an affectionate older sister to the adolescent Lord, and it was she who created the small circular painting of Byron's right eye, dated 26 April 1807 (fig. 5). Eye portraits of this nature were common in this period and were an intimate token of affection, often worn, as in this case, in a locket: on one side the eye portrait and on the other a lock of the subject's hair.

Elizabeth Pigot was unusual in choosing Byron's right eye to be portrayed, since nearly all subsequent representations focus on the left side of his face. This was because his right eye was noticeably smaller than his left, a feature which his half-sister Augusta linked to the

lameness of his right foot and the weakness of 'that side' of his body.[33]
As a pupil at Harrow School Byron was nicknamed 'Eighteen pence'
because the difference between his left and right eyes was said to be
as great as between a shilling (twelve pence) and a sixpence.[34] This
difference was recorded both verbally and visually by many observers
and can help to identify genuine portraits of Byron. Elizabeth Pigot's
sketch also appears to show accurately the blue/grey colour of Byron's
eyes, which were later recorded by different artists and observers as
blue, grey, hazel and even brown.

Miss Pigot's acute observation of Byron found its sharpest and most
detailed form in a small graphic story, with her affectionate verses
accompanying a series of drawings showing the young Lord on his
visits to Southwell, with his famous Newfoundland dog Boatswain
('Bos'en' as Pigot calls him). *The Wonderful History of Lord Byron &
His Dog* – a small manuscript booklet, dated 26 March 1807 – includes
ten drawings of Byron playing with Boatswain, writing at a table,
playing cricket, taking a slipper bath and riding in a carriage. They
present Byron as a dandified young aristocrat, intent on impressing his
mother and country neighbours, with his carriage and horses, dressed
in a ruffled shirt, high collar, cream trousers and small black shoes, and
sporting the fashionable haircut with curls falling over his forehead that
was to become characteristic of his later portraits.

Pigot celebrates Byron's great attachment to dogs (often his 'best
friends' as Geoffrey Bond points out) and many other pets.[35] She also
illustrates his lifelong recourse to dramatic slimming regimes to reduce
his naturally chubby figure. Two of her accompanying rhymes describe
how he 'went out to cricket to make himself thinner' (fig. 8); and then
'went to the Bath, to boil off his Fat' (fig. 9). This is confirmed by a note
from Byron's doctor dated 19 November 1806:

> Mr Hutchinson judges it to be essentially requisite that Lord Byron
> should rise every morning at 8 o'clock, and take a walk of three or four
> or *more* miles, and a repetition of Exercise in the Course of the Day
> ... Abstinence from Malt liquor of *every* Description should be most
> scrupulously attended to. Animal food ought to be taken only once in the
> Day and at Meals nothing but Imperial [cream of] Tarter or water should
> be drunk ... Two Glasses of Port may be drunk after Dinner, no white
> wine: nor any Supper should be taken except a biscuit and a glass of
> water or Imperial. The tepid Bath may be used three times a week at the
> Temperature of 90 or 100 degrees of Fahr[enheit]: the time of bathing
> being about noon. ... Exerxise [sic] is recommended after the immersion.

Figs 6 and 7 **Elizabeth Pigot also created** *The Wonderful History of Lord Byron & His Dog* (1807), a handmade book of rhymes and drawings about Byron and his favourite Newfoundland dog, Boatswain (Bos'en).

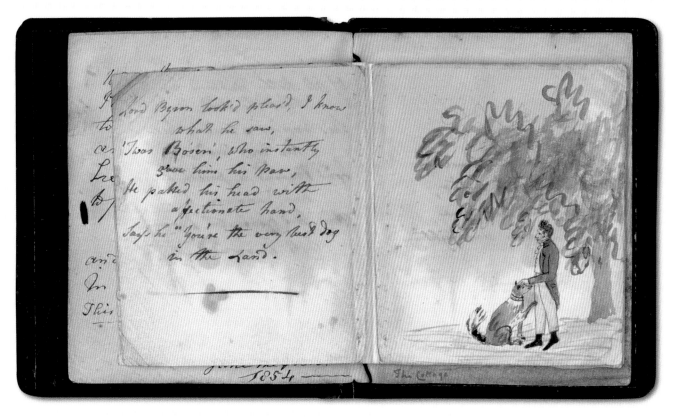

Fig. 6 *Lord Byron look's pleas'd, I know what he saw,*
'Twas Bo'sen, who instantly gave him his paw.

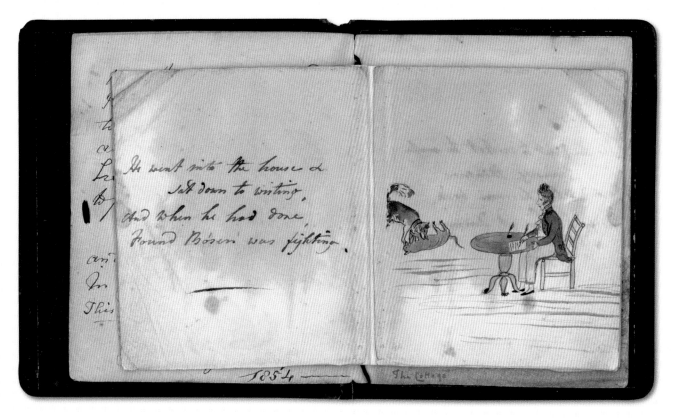

Fig. 7 *He went into the house & sat down to writing,*
And when he had done, Found Bo'sen was fighting.

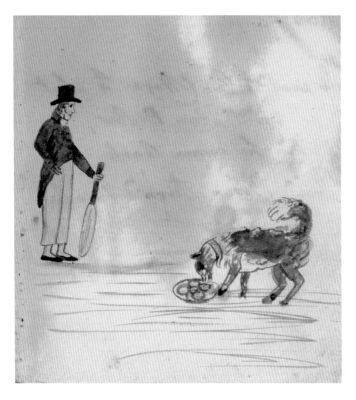

Fig. 8 *He went out to cricket to make himself thinner,*
And when he came back, he found him at Dinner.

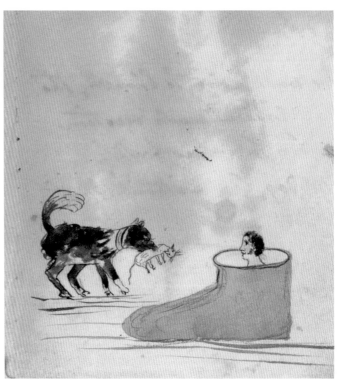

Fig. 9 *He went into the Bath, to boil off his Fat,*
And when he was there, Bo'sen worried a Cat.

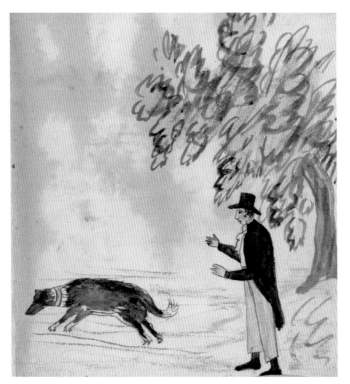

Fig. 10 *He went down to Church, tho' without much devotion,*
& when he came back, His dog lay without Motion.

Fig. 11 *He thought he was dead, & began for to weep,*
But in a short time, He awoke from his Sleep.

Fig. 12 *He went to the Club to eat oysters with Many,*
And on his return, Found him playing with Fanny.

Fig. 13 *So he call'd for his Carriage, drove off from the door,*
Bo'sen went along with him, I know nothing more.

Figs 8-13 **Pigot celebrates Byron's lifelong attachment to animals (especially dogs) and illustrates some of the dramatic slimming regimes he undertook to reduce his naturally chubby figure.**

One of the powders is to be taken twice or three times a day mixed in nearly half a pint of Water. These directions ought to be immediately attended to for the space of three months.[36]

By the beginning of April 1807 Byron had lost eighteen pounds by dieting, 'run[ning] and playing at cricket' and 'us[ing] the hot bath daily'.[37] His weight eventually fell from fourteen stone six pounds (202 pounds, 91.6 kg) to nine stone eleven and a half pounds (137.5 pounds, 62.4 kg), making his five foot eight-and-a-half inch frame look distinctly emaciated. He continued extreme diet regimes and strange forms of eating and drinking throughout his life, and several modern commentators who have studied this aspect of his personal development have suggested that he was anorexic.[38]

Between 1805 and 1808 Byron attended Trinity College Cambridge, and the last of the affectionate amateur records of his appearance by his friends, before he became famous, is an ink sketch (fig. 14) made by Scrope Berdmore Davies, dandy and Fellow of King's College, Cambridge, who was responsible for the story of having found Byron in bed with his hair 'en papillotte' (in curlers), although this seems unlikely, as Byron's hair was naturally very curly.[39] Davies' sketch was probably drawn in June 1809, when it was sent in a letter from him to

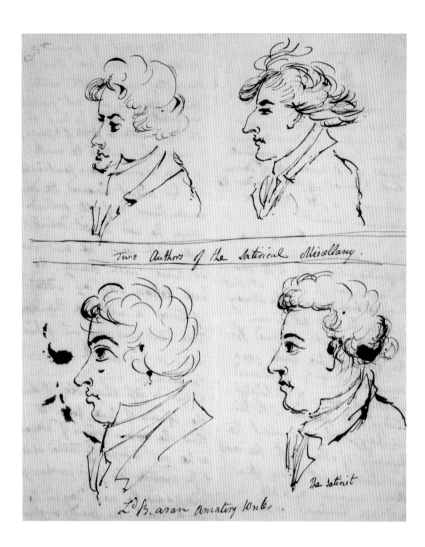

Two Authors of the Satirical Miscellany.

Ld. B. as an Amatory Writer.

The Satirist

Byron, and it shows Byron's profile alongside those of three friends, who are probably Davies himself ('The Satirist', bottom right) Charles Skinner Matthews (top left) and John Cam Hobhouse (top right). Matthews and Hobhouse are labelled as 'Two Authors of the Satirical Miscellany' (an ill-fated publication which Matthews later dubbed the 'Miss-sell-any'). Davies entitles Byron 'an Amatory Writer', apparently referring to his verse collection *Hours of Idleness*, published in 1807, although the grumpiness of his expression may be a reference to the collection's poor critical reception and to Byron's satirical 1809 riposte, *English Bards and Scotch Reviewers*. Davies remained a good friend to Byron, visiting him in Switzerland in 1816. Matthews was to die tragically young while swimming in the river Cam in 1811, in what may have been suicide, while Hobhouse (much later Lord Broughton de Gyfford, Whig politician and Privy Councillor) became Byron's travelling companion in Greece, Switzerland and Italy, his most faithful and perhaps closest lifelong friend, his best man and his executor.

The next portrait (fig. 15) marks a pronounced change in the character of Byron's portraits, and illustrates the transition from images

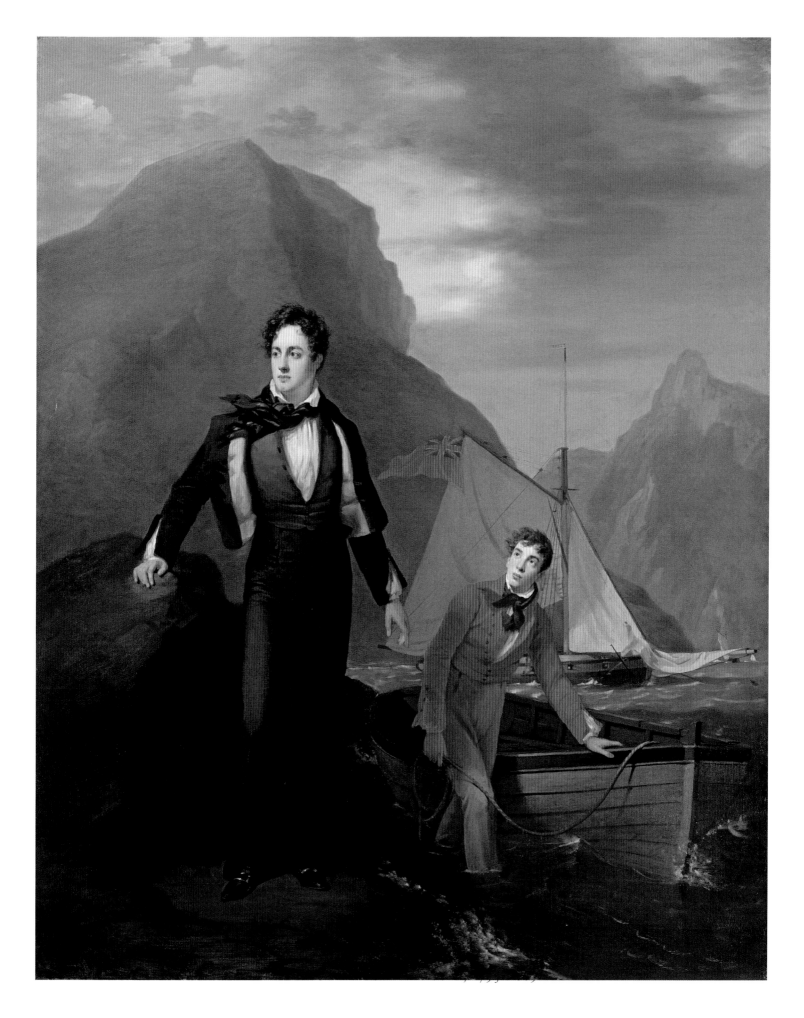

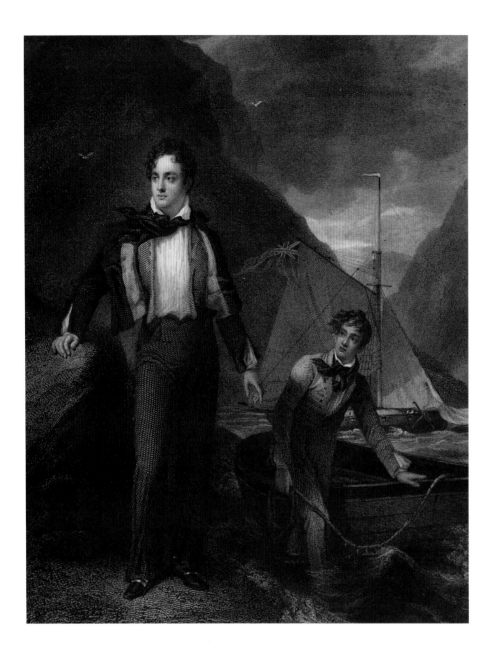

Fig. 16 **Sanders' painting first became public in 1830 as the engraved frontispiece to the second volume of Thomas Moore's biography of Byron. The engraver, William Finden, increased the darkness and storminess of the scene, but opened Byron's waistcoat to show more of the white shirt as a contrast, also adding white seabirds to the background.**

made by friendly amateur observers to one created by a professional artist: the Scottish painter George Sanders. Arriving in London around 1807, Sanders came with a reputation as the creator of a panorama of Edinburgh taken from a ship in the Forth, which was more a seascape than a landscape and included many ships. Naval officers were prominent among his clientele, and this may have influenced Byron in choosing him to paint this, the first and only full-length portrait of himself he ever commissioned, at a price of 250 guineas.[40] It was also unusual in Byron's portraiture in showing him with another person: the boy in the picture is almost certainly Byron's Nottinghamshire servant and favourite, Robert Rushton, who accompanied him to Portugal and Spain in 1809 and went abroad again with him in 1816. Described when it was first engraved some twenty years later as 'Lord Byron at the

age of 19', the painting seems to have been begun in 1807, although it was perhaps not finished until 1809, when Byron was twenty-one, and it was finally delivered to Byron's mother by the artist who, according to Mrs Byron, had kept it in his studio 'as an honor [sic] and credit to him'. She also commented that '[t]he countenance is angelic, and the finest I ever saw and it is very like'.[41] She was never to see her son again, since she died suddenly, while still in her forties, two years later on 1 August 1811, just as Byron had arrived back in London from Greece.

Although commissioned early in Byron's adult life, and hung at Byron's publishers, John Murray, in London's Albemarle Street between 1813 and 1816, Sanders' image did not become known to the general public until after Byron's death. The painting was then owned by Hobhouse, who reluctantly lent it to be engraved as the frontispiece of the second volume of Thomas Moore's biography of Byron, published in 1830 (fig. 16). In various different engraved forms it became very well known, and one of the defining images of Romanticism and of Byron as the poet of *Childe Harold's Pilgrimage*.

But although it looks archetypally Romantic to modern eyes, the original portrait does not seem to have been planned in any such spirit by either the sitter or the artist. The original conception, showing a yacht with the royal ensign of the British Navy and demonstrating Sanders' skill with marine subjects, seems to have reflected Byron's unfulfilled intention in October 1807 to take a voyage with a sea-faring cousin.[42] Designed to hang at Newstead Abbey, the painting also refers to Byron's role in the context of his ancestral home and his family: his connection with his seafaring grandfather Admiral 'Foul-weather Jack' Byron (famous for surviving shipwrecks), and his apparent wish to leave behind a painted substitute of himself for his mother and his household as he set out on his travels.[43] A visitor who saw the painting at Newstead in 1811 described it as 'a portrait of his lordship as a sailor boy with rocks and beach scenery' and the wind-blown, Romantic-looking effect in the painting actually arises from its strongly-stated nautical or marine features.[44]

The portrait was painted soon after the battle of Trafalgar (1805), when nautical styles had a strong appeal, and it certainly reflects Byron's own enduring love of the sea, as expressed in Canto 4 of *Childe Harold's Pilgrimage* (lines 1648–50):

> And I have loved thee, Ocean! and my joy
> Of youthful sports was on thy breast to be
> Borne, like thy bubbles, onward.[45]

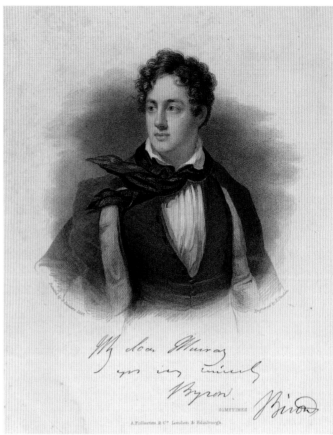

Sanders shows the young nobleman stepping ashore (or about to embark), the pose perhaps reflecting that of the Apollo Belvedere. The way Byron lays his hand proprietorially on a rock also usefully enables him to take the weight off his lame right foot while posing. His role as head of the Newstead household and estate is also emphasised by the inclusion of Rushton in a subordinate position, which also echoes the presence of a similar young page in a portrait of John, 1st Lord Byron, by William Dobson (c. 1644). When Hobhouse wrote about the picture to Byron in 1811 he referred to Walter Scott's poem *Marmion* which features a beautiful page boy, and insinuated that Rushton might have become Byron's lover, a hint that Byron repudiated while by no means denying young Rushton's attractiveness.[46]

The costumes of both the figures are fashionable and also decidedly nautical. Byron's navy-blue suit, consisting of a short jacket, waistcoat and wide trousers, is an imitation of the dress of ordinary sailors, and the half-open shirt collar and loose cravat, characteristic of mariners, are part of this image, although the fine material of the suit and the silk of the jacket lining and the neck scarf are far more refined and expensive than any real sailors' garb. When the portrait was made public in 1830, these nautical, windblown features happened to coincide with the open-necked Byronic images emerging from the poetic tradition of

Figs 17 and 18 **Engravings of the Sanders painting by William and Edward Finden (1833, left and 1834, right) show Byron in white trousers, without his companion. Sanders' portrait was much reproduced in engravings like these and became very well-known as one of the defining images of Romanticism.**

portraiture that were already established for Byron, and thus reinforced the Romantic presentation of him that was already current.

The first engraving (fig. 16) of this Sanders painting was made in 1830 by William Finden, brother of Edward Finden who engraved the childhood portrait of Byron. In Byron's lifetime and afterwards, before photographic reproduction of images became possible, engravers such as the Findens had a crucial role in reproducing paintings for those who were not able to see the original artwork. The brothers were important members of the coterie of craftsmen employed by John Murray to illustrate Byron's works. As can be seen by comparing the Sanders original with the Finden versions, these engravers in fact provided not so much a duplication or copy of an original as an interpretation and recreation of it, making changes that, although individually insignificant, had a sometimes major effect on the image and its character.

In William Finden's engraving of Sanders, for instance (see page 28), the figures have been slightly enlarged relative to the background, and Byron's waistcoat has been opened up to provide a brighter expanse of white shirt-front within the overall dark scheme. This serves to draw attention to his face, although the actual depiction of the facial features is considerably less refined than in the painting. Sanders' original subtle play of colour, with his touches of soft blue and bright red, is of course lost in the monochrome engraving, and in Finden's version the landscape appears darker and more craggy, while the sky has become distinctly cloudy and stormy, and the outlines of white seabirds have been introduced in places to break up large areas that would otherwise be monotonous.

There were many subsequent engraved versions of this highly influential image, such as figures 17 and 18, and in these Byron generally appeared alone, without his companion, full-length, and then half-length, and with the background disappearing further at each step. This gives us Byron as he was commonly known to the Victorians: softened and feminised to suit the new audience of young, female, middle-class readers who could now afford to buy such prints, and whose choice of Byron texts was often limited by the publishers' removal of controversial political or sexual topics from the verse and from the biographies. The original painting by Sanders was not in fact widely known until an RA exhibition in 1956; it was left by Hobhouse to his daughter Lady Dorchester, who bequeathed this and Hobhouse's Thorvaldsen bust of Byron to King George V in 1914, and it is now in Buckingham Palace as part of the Royal Collection.[47]

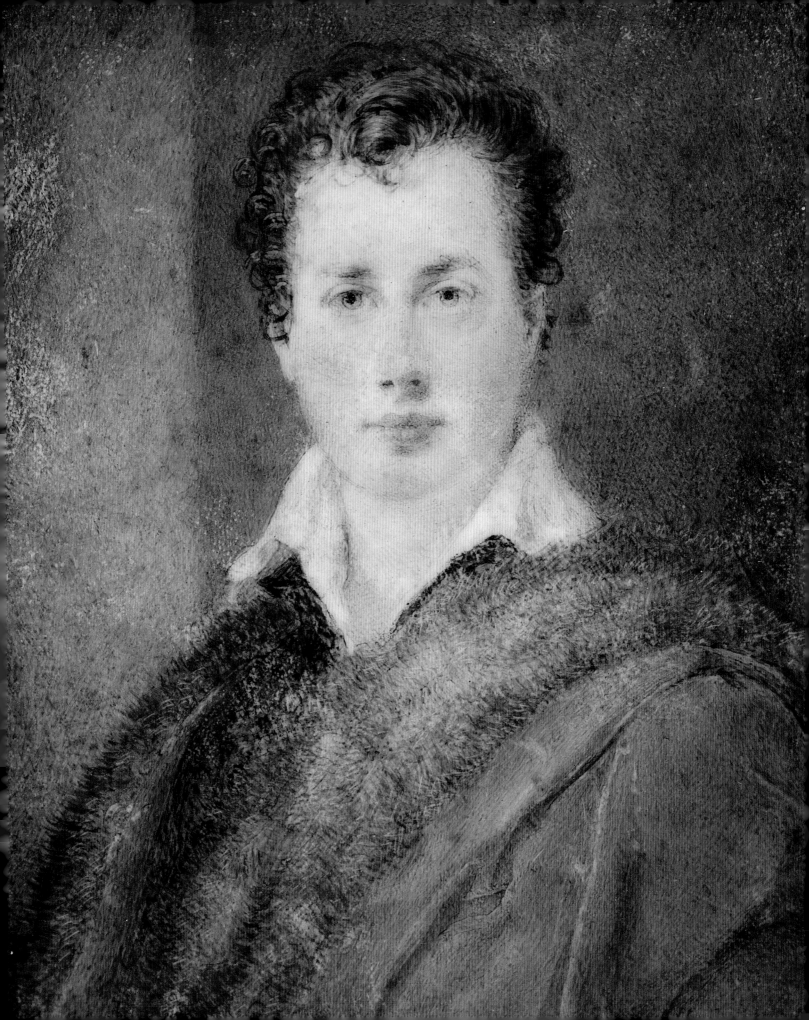

First years of fame

1812–13

For I was rather famous in my time,
Until I fairly knocked it up with rhyme.
Don Juan, Canto 14, lines 71–2.[48]

THE PAINTINGS IN THIS CHAPTER bring us to the early years
of Byron's fame: a time when his portraits – no less than his poetry –
became a valuable commodity for his publisher, and also objects of
desire and competition among his various lovers. Soon these qualities
would be extended further, reaching beyond those who actually knew
Byron to draw in the readers who had never met him.

The two miniatures by George Sanders (figs 19 and 20) show
Byron after and before his travels abroad between 1809 and 1811.[49]
The Napoleonic Wars had put out of bounds the usual young British
aristocrats' 'Grand Tour' route to Italy via France and Germany, and so
Byron and Hobhouse struck out for more distant destinations, travelling
via Portugal, Spain and Malta into the Ottoman territories of Greece,
Albania and Turkey. It was Byron's experience of these unfamiliar and
exotic locations that set the course for some of his best-known poetic
work in the next few years, providing materials to create Childe Harold
and his *Pilgrimage*, as well as the 'Oriental Tales' with their bandits
and robber-barons and their fierce, primitive loves and adventures: *The
Giaour* and *The Bride of Abydos* (published in 1813); *The Corsair* and
Lara (1814), and *The Siege of Corinth* (1816).

These materials were visual as well as verbal, and Byron contributed
decisively to the way in which his oriental Byronic heroes would be
envisaged when, probably in Ioannina, he bought the 'Albanian'
costume in which he was later portrayed by Thomas Phillips

Fig. 19 George Sanders' striking
1812 miniature may have
been commissioned to mark
the moment in March when
Byron 'awoke one morning and
found [him]self famous' on the
publication of the first two cantos
of *Childe Harold's Pilgrimage*.
This rather faded copy, probably
by Sanders, shows the ghost
of the original, which was
irreparably damaged by amateur
scraping and overpainting in the
twentieth century.

(see figure 47).[50] Moving northwards, he and Hobhouse reached the most exciting of their destinations in October 1809 when they arrived in Tepelena, and were presented at the court of the Ottoman Albanian ruler, former bandit and multiple-beheader, Ali Pasha. Ali (who seems to have been told that Byron was of royal blood) made his admiration for the young Lord's handsome looks very evident, inviting Byron to visit him at night and commenting that he was certain he was 'a man of birth because [he] had small ears, curling hair, & little white hands'.[51] Sanders was in fact the first portraitist to clearly show these unusual ears, with their very small lobes attached directly to the jaw: a feature commented on by Byron's lover Lady Caroline Lamb and several other contemporary observers, which still provides a useful way of identifying genuine portraits of Byron.[52]

Sanders' first miniature (fig. 20), shown here in an 1830 engraving, had the same head at the same angle as in his full-length painting of Byron of 1807–9 (see page 27) and was clearly directly associated with it. It was completed in 1809, just before Byron left England, and it seems to have been planned as part of a series of exchanges of keepsake miniatures with his close friends as he prepared for his travels, as Byron explained to one of his Harrow favourites, William Harness, in March 1809:

> I am collecting the pictures of my most intimate School fellows, I have already a few, and shall want yours or my cabinet will be incomplete. I have employed one of the first miniature painters of the day to take them, of course at my own expense as I never allow my acquaintance to incur the least expenditure to gratify a whim of mine. ... I shall see you in town and carry you to the Limner [painter], it will be a tax on your patience for a week, but pray excuse it, as it is possible the resemblance may be the sole trace I shall be able to preserve of our past friendship & present acquaintance.[53]

Perhaps also associated with this or a later process of exchange, and possibly a copy of the Sanders miniature, is figure 21, which is inscribed on the back (fig. 22) 'given by Ld. Byron to his friend Andrew Fitzgerald Reynolds, Melton Grange'. Reynolds (born in 1795) was not, however, Byron's contemporary at Harrow or Cambridge, and nor is he mentioned in his letters.[54] The original of the 1809 Sanders miniature, which has an elegant frame including a coronet, was probably intended for the Earl of Clare, with whom Byron had a particularly tender and sentimental relationship from his schooldays onwards. But, perhaps as

Fig. 20 Sanders had painted a previous miniature of Byron in 1809, shown here in an engraving of 1830. The original was completed just before Byron left England for two years of travel in Portugal, Spain, Greece and the Ottoman Empire. It seems to have been part of a series of exchanges of keepsake miniatures with his close friends on parting.

the result of a quarrel, the miniature in fact remained with Byron, who left it at Newstead when he went abroad. Sometime after his return in 1811 he took it back to London, and in 1812 it became caught up in amatory intrigues and games with his various lovers, before being given in 1813 to his half-sister Augusta Leigh, who by then had probably also become his lover. Eventually it reached the engravers (see above, figure 20), and thus – as with most of Byron's portraits – what had originally been a highly personal object became public property, to be shared with thousands of viewers.

Although this miniature shows Byron's head at the same angle as in Sanders' full-length painting, it makes alterations to suit the smaller, more personal mode. It takes the wind out of Byron's hair, restoring the carefully arranged curls over the forehead, replacing the sailor-style necktie with a neatly turned-down lace collar and draping a dark pelisse over his shoulder and chest. Originally worn by hussar cavalry soldiers, this type of short, fur-trimmed jacket was often thrown loosely over

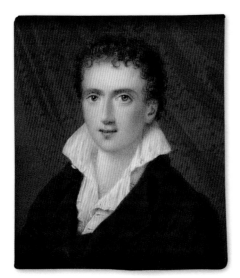

the left shoulder, ostensibly to prevent sword cuts, and became widely fashionable during the Napoleonic Wars.

Byron bought several of these garments, including in January 1812 an 'extra superfine' one described by the tailor as 'Corbo' (i.e. 'crow-coloured': a very dark blue/black), lined with silk, and it may be this that appears in the second Sanders miniature (fig. 19), which Byron commissioned at around this time.[55] He may have intended the new painting to mark his delivery of his maiden speech in the House of Lords on 27 February 1812 (opposing the introduction of the death penalty for the wreckers of industrial weaving machines, known as 'frame-breakers' or Luddites). Or he may have wished to record the moment in March 1812 when he 'awoke one morning and found [him]self famous' on the publication of the first two cantos of *Childe Harold's Pilgrimage*.[56]

This 1812 Sanders image (fig. 19) shows Byron full-face, but still with a central curl falling over his forehead and a pelisse draped over his chest and shoulders. Here, however, the collar is open to reveal Byron's handsome neck. As used again in the famous Thomas Phillips portrait of 1813 (see figure 44, page 59) and elsewhere, this white open collar went on to become in effect a Byronic 'uniform', defining Byron's image as a poet through hundreds of prints and reproductions and – by crossing the divide between fact and fiction – also becoming established as the characteristic dress of his most famous poetic protagonist, Childe Harold (fig. 24).

Byron was pleased with Sanders' 1812 miniature, describing it as 'the best picture of *me*', and, during their tempestuous and short-lived affair that year, Lady Caroline Lamb fell in love with this image as well as with Byron himself, writing in her commonplace book 'That beautiful pale face is my fate.'[57] When the relationship soured (leading

Fig. 23 Byron was pleased with Sanders' 1812 miniature, describing it as 'the best picture of me', but he claimed that his friends and family hated this engraving by Henry Hoppner Meyer and he forbade John Murray to reproduce it. Only a single print remains in the Murray collection.

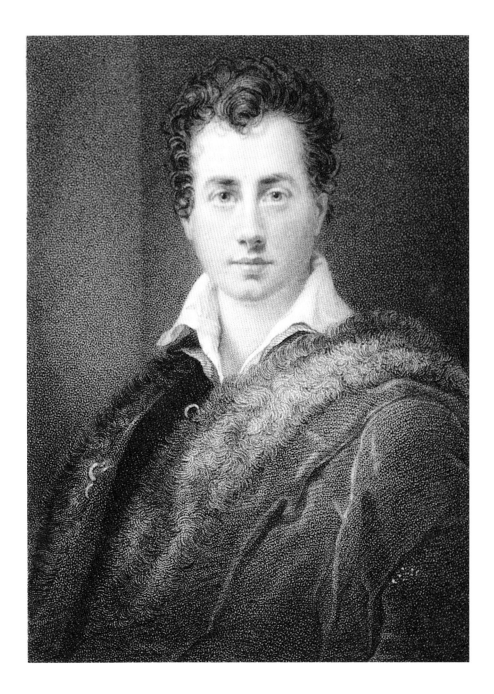

Lady Caroline to immortalise Byron as 'Mad – bad – and dangerous to know'), she still desired the picture, forging a letter in Byron's handwriting in order to deceive his publisher John Murray into giving up the miniature to her in January 1813.[58]

At this stage or later it was copied for her, probably by Sanders himself (fig. 19) (in a version that Lady Caroline bequeathed to Lady Morgan), and also by Emma Eleanora Kendrick. The copy by Kendrick (fig. 25) is set in a gold oval locket, inscribed on the front 'san fedele alla mia / Biondetta / non posso vivere senza te / August 14th. 1812', and, on the back, 'ne crede Byron'. The reference is to Jacques Cazotte's novel of 1772, *Le Diable Amoureux*, translated into English as *Biondetta, or*

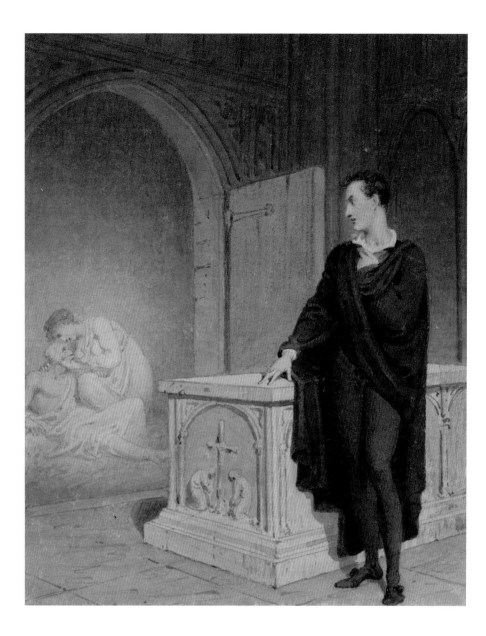

Fig. 24 (left) **The Byronic profile, curly hair and the 'uniform' of dark cloak and open white shirt collar, which had been shown in the miniatures, were well-established by the time of this 1818 illustration to** *Childe Harold's Pilgrimage*, **Canto 4, stanzas 150–51 by Richard Westall. Westall transferred these characteristics from Byron to his protagonist Childe Harold.**

Fig. 25 (opposite) **This locket with a copy of the 1812 Sanders' miniature of Byron was created for Lady Caroline Lamb by Emma Eleanora Kendrick after Lamb purloined the original from John Murray. The back of the locket satirically gives Byron's family motto in the negative: 'ne crede Byron' (do** *not* **believe [him]').**

the Enamoured Spirit. The story plays on cross-dressing and demonic seduction, and Lady Caroline also referred to it in a note sending Byron a clipping of her pubic hair in August 1812.[59] 'Faithful saint to my / Biondetta / I cannot live without you' proclaims the front of the locket's Italian inscription: perhaps a reproachful repetition of something Byron had once declared to the 'biondetta' (small, fair-haired, sometimes cross-dressed) Lady Caroline, since the other side of the locket case satirically reproduces Byron's family motto but in the negative: 'ne crede Byron' (do *not* believe [him]').[60]

For an image that was much prized by its subject and by others, this portrait has fared particularly badly physically, both in the original and in reproduction. The version of the miniature reproduced here (fig. 19) is very faded, and is probably a copy by Sanders, while what seems to be the 'prime' version was irreparably damaged, apparently by amateur

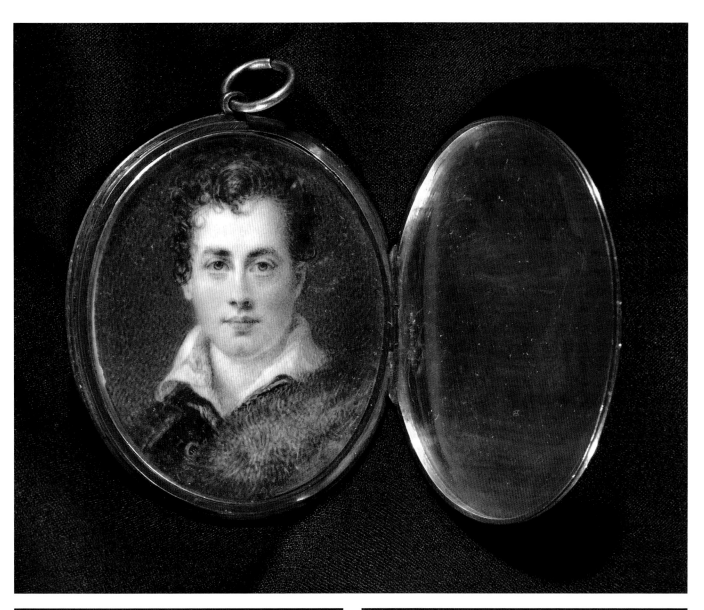

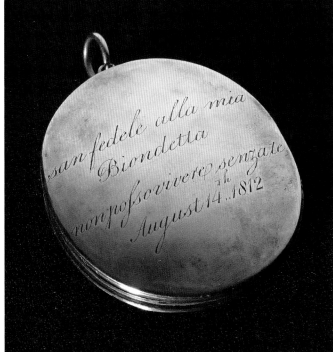

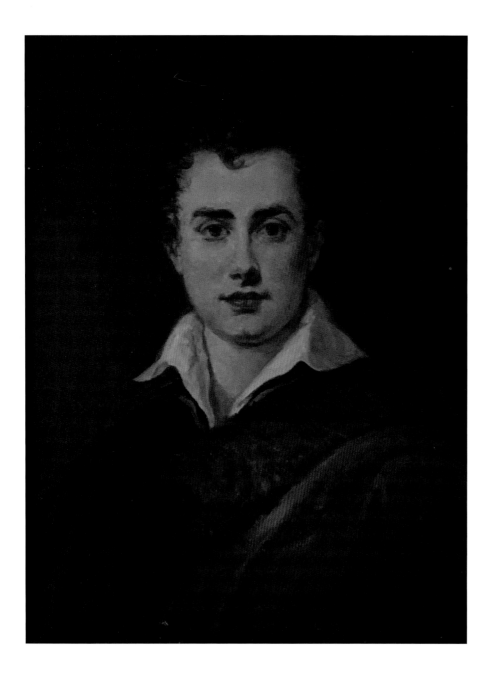

scraping and overpainting in the early twentieth century, probably by Byron's descendant Judith, Lady Wentworth (who also overpainted figure 28). A version in oil in the possession of the Byron family (fig. 26) seems to be a copy, perhaps made by Byron's granddaughter, Lady Anne Blunt. The original of this miniature was on loan from Byron to John Murray when Lady Caroline purloined it in January 1813. Murray was planning to have it engraved to be published as the proposed frontispiece to the fifth edition of *Childe Harold's Pilgrimage*. That publication, however, was never to happen. Although the engraving by Henry Hoppner Meyer (fig. 23) appears to resemble the original miniature reasonably closely, Byron claimed that his friends and family hated it, and he peremptorily forbade its reproduction. 'I have

a *very strong objection* to the engraving of the portrait', he wrote to Murray when the publisher sent him a proof, instructing that 'it may on no account be prefixed, but let *all* the proofs be burnt, & the plate broken'.[61] Murray reluctantly obeyed, although, contrary to Byron's instruction ('[H]ave the goodness to burn that detestable print from it immediately'), he did retain a single copy of the print (fig. 23) which is still in the John Murray Archive at 50 Albemarle Street, London.[62]

Had it been printed as planned, this would have been the first image of Byron to be made public, but it was to be by no means the last time that Byron would intervene in the reproduction of his portraits. Reflecting on how engravings altered painted images, subtly or substantially, Byron imagined that 'Sanders would not have survived the engraving' and, pondering on the way in which a visual image of the poet might influence readers' perception of his verse, he declared that 'the frontispiece of an author's visage is but a paltry exhibition'.[63] John Murray certainly disagreed; as a canny publisher he knew that pictures sell books as much as words do, if not more so, and that adding a frontispiece portrait of his handsome young author to his new edition would undoubtedly boost the sales of the poetry. Since, however, at this stage Byron was accepting no payment for his verse, making it in effect a free gift to his publisher, Murray was not in a position to argue with his aristocratic client, and Meyer's plate was duly dispatched to Byron to be destroyed.

If Sanders' miniature was Byron's favourite in 1812, it soon faced stiff competition from the work of another well-known London miniaturist, James Holmes, who painted Byron in 1813 and, according to Holmes's sons, again several times between then and 1816.[64] Holmes was the son of a wealthy diamond merchant in the City of London and his clients came from the top ranks of Regency society (including the Prince Regent himself).[65] He therefore had a fund of interesting anecdotes to share, gleaned from hours of face-to-face sittings with his subjects. Portrait painters in general provided an opportunity for royalty and aristocracy to mix with people outside their own class who were lively, creative and unconventional, and painters' studios could provide an ideal venue to pursue clandestine relationships of all sorts. Holmes's biographer Alfred Story describes Holmes as 'a trusted, if not exactly a confidential, friend of the poet', and Augusta Leigh stood godmother to one of his sons, although she and Byron shared jokes about the painter's airs and graces and use of French phrases: 'Let me know about Holmes – Oh La! – is he as affected a mountebank as ever?' Byron enquired of his half-sister in 1821.[66]

Story describes Holmes as having 'one of those frank and buoyant natures that throw off care and radiate the sunshine of a kindly heart wherever they go'. But even Holmes's good nature must have been tried by Byron's behaviour during their sittings.

> He could seldom continue seated or be still for more than a minute or two at a time. He would be for ever moving about, now rising and going to the window, now suddenly taking up a stick and beginning to fence. When the artist remonstrated and said he could not paint while he was moving about like that, he would exclaim with a frown, 'O blood and guts, do get on!' and resume his seat for a brief space.[67]

'I was always very civil & punctual with him,' Byron commented ruefully, when Holmes later declined an invitation to travel out to Italy to paint Byron's mistress, Teresa, Contessa Guiccioli, and his little daughter Allegra.[68] But Holmes was not alone in finding Byron a restless and difficult sitter, and many of the artists who painted him recorded the same problems.

We can now identify two distinct Holmes miniatures of Byron: one from 1813, which was reproduced in 1828 (fig. 27) as an engraved frontispiece to *Greece in 1823, 1824 & 1825* by Colonel Leicester Stanhope, and the other from 1815 or early 1816 (fig. 28).[69] Both show Byron in Renaissance costume, with a cloak draped over a slashed velvet doublet, and the 1813 version gives Byron an elaborately embroidered Elizabethan-style white collar, while the later one has a large open collar. The original of the 1813 miniature was first given by Byron to Lady Caroline Lamb (who copied it in watercolour) and then retrieved from her and passed on to Lady Frances Wedderburn Webster, with whom Byron was also romantically involved. The faces of the two miniatures are very different, but both are particularly boyish or feminine, making Byron appear much younger than his mid to late twenties, and much more serene in mood than he can actually have been, either in 1813, following the beginning of his probable affair with his half-sister Augusta (and his possible paternity of her third daughter Elizabeth Medora), or in early 1816, during the disintegration of his marriage and the breakup of his household. Byron himself wrote of the 1813 miniature: 'I happen to know that it was not a flatterer, but dark and stern, – even black as the mood in which my mind was scorching last July, when I sat for it.'[70]

Despite the circumstances in which they were created, however, Byron seems to have liked this look, since he later described the 1816 miniature, as '*I think the very best … one of me*', adding that he

Fig. 27 Another of Byron's favourite miniaturists was James Holmes. Byron gave the 1813 original of this 1828 engraving to Lady Caroline Lamb (who copied it in watercolour). '[I]t was not a flatterer, but dark and stern,' Byron wrote, 'even black as the mood in which my mind was scorching last July, when I sat for it.'

preferred 'that likeness to any that has been done of me by any artist whatsoever', and that 'I like [Holmes] because he takes such inveterate likenesses', although he did object to the fact that Holmes had 'cut my hair in his picture – (not quite so well as [his barber] Blake) I desired him to restore it'.[71]

The image shown at figure 28 is a late nineteenth-century photograph of the Holmes miniature by Sir Emery Walker, and, as with Byron's previous favourite miniature of 1812 by Sanders, the prime version of the 1816 Holmes painting is no longer available in its original state. It passed through the hands of Byron's friend Scrope Davies, to Hobhouse, and probably to Augusta and her heirs, and was recorded at the home of Byron's great-granddaughter Lady Wentworth just after her death in

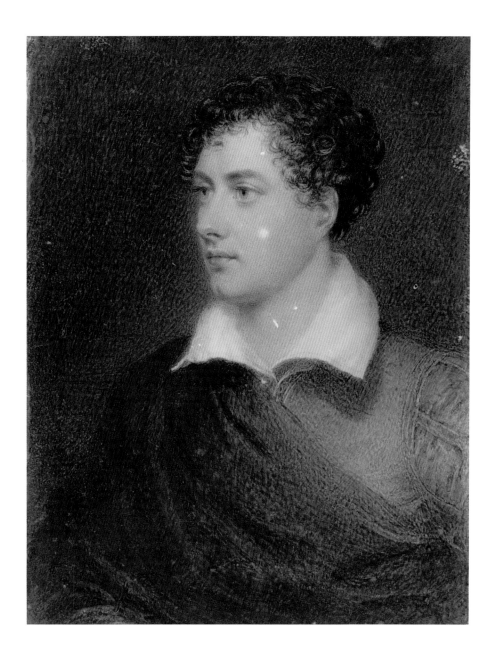

Figs 28–30 These are the three surviving versions of another of Byron's favourite miniatures, painted by James Holmes in 1815 or 1816 but damaged by amateur overpainting in the twentieth century. Figure 28 (left) is a late nineteenth-century photograph of the original by Sir Emery Walker, while figure 29 (opposite left) is a painted replica of about 1824 by Holmes, and figure 30 (opposite right) is an engraving by Henry Meyer. Prints from figure 30 were used by Byron almost as a modern celebrity would in response to fans requesting a photograph. One went to seventeen-year-old Isabel Harvey who had written him fan letters and sent him her own portrait.

1957.[72] As with the Sanders miniature, Lady Wentworth overpainted this one, adding heavy dark hair and altering the jawline, and this version with the overpainting has only been seen briefly in public when it was put up for auction in 2007 and then withdrawn. In its original state it is now known only through the Emery Walker photograph, through replicas (some by Holmes himself, such as figure 29) and through engravings. One of these, by Meyer (fig. 30), served as the basis from which prints were taken and sent in response to Byron's request to Murray in 1818 to despatch to Italy 'half a dozen of the coloured prints from Holmes's Miniature ... a picture of my upright Self – done for Scrope B D[avies] Esquire'.[73] Byron used these prints almost as a modern celebrity would do in response to fans requesting a photograph, asking Holmes in 1823, for instance, to supply a copy to the seventeen-year-old

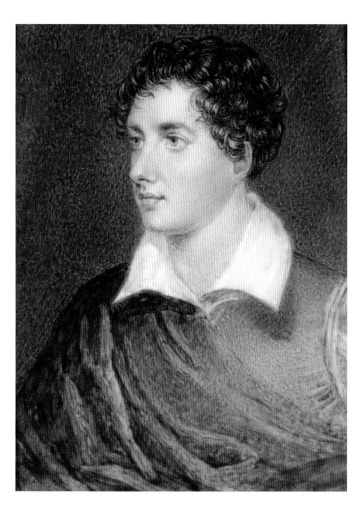

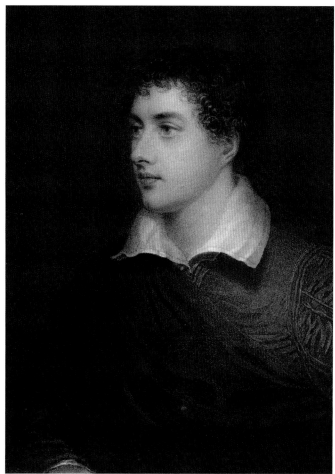

Isabel Harvey who had written him fan letters and sent him her own portrait.[74] But by that time, as the drawings of Byron at Genoa such as those by Count D'Orsay show (see figures 86 and 87), he certainly looked very different from the fresh-faced youth of Holmes's portraits.

If Lady Caroline Lamb had aimed to capture Byron for herself in 1812 by having an existing portrait of him copied for her own possession, his next lover, Lady Oxford, went one better by initiating the creation of an entirely new full-scale portrait (fig. 31), in oils, by the Royal Academician Richard Westall. Much patronised by the aesthete Thomas Hope and the antiquarian and critic Richard Payne Knight, who was a friend of Lady Oxford, Westall was primarily an illustrator rather than a portrait painter, famous for his illustrations for the John Boydell Shakespeare Gallery (1789–1805) and editions of Shakespeare, and for his collaboration in Henry Fuseli's Gallery of the Miltonic Sublime (1799 and 1800). The first artist to portray Byron publicly in the role of the author of *Childe Harold*'s *Pilgrimage*, Westall was also the first illustrator to deliberately blur the line between Byron and his protagonist(s), creating a hybrid romantic dreamer with contemplative chin on hand and an averted gaze, in marked contrast to the strong

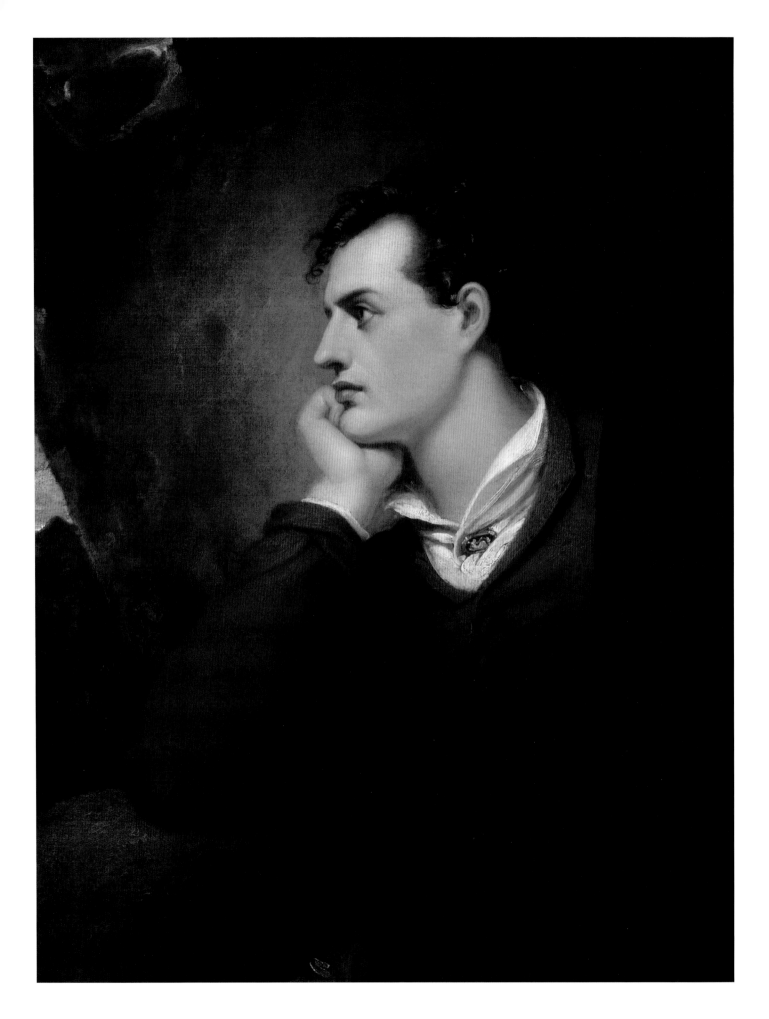

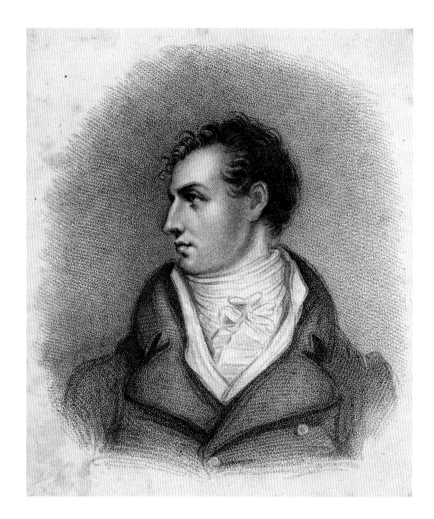

Fig. 31 (opposite) Byron's lover, Lady Oxford, chose Richard Westall RA to paint this portrait in 1813. Westall later illustrated Byron's works for Murray and here shows Byron as the author of *Childe Harold's Pilgrimage*: a romantic dreamer with contemplative chin on hand and an averted gaze.

Fig. 32 (right) Thomas Blood's 1814 engraving of the Westall portrait followed the picture style used by the *European Magazine*, resulting in a head in profile awkwardly tacked on to a frontal view of the neck and shoulders.

personality and direct eye contact of the 1812 Sanders miniature (page 32). Although Westall's work was highly regarded in fashionable circles, it was cordially disliked by the critic William Hazlitt, who found in it a 'hermaphroditic softness' and 'all that beauty of form which excludes the possibility of character ... the same classical purity and undeviating simplicity of idea – one sweet smile, one heightened bloom diffused over all'.[75]

Lady Oxford had already engaged Westall to paint portraits of her children, and it was evidently she who Byron meant when he reported to Murray in April 1813, 'I am to sit to him for a picture at the request of a friend of mine.'[76] This followed a letter a month earlier from Lady Oxford herself to Murray, informing him that she had in effect commissioned Westall on the publisher's behalf to produce a set of illustrations for Byron's works: 'I promise myself much pleasure in having the imagery so ably delineated. We think also of adding two or three more portraits,' she notified him.[77] Westall's illustrations of Byron's works were eventually issued by Murray as engravings, but the first print of the portrait appeared not in a publication by Murray but as prepared by Thomas Blood for the *European Magazine* in January 1814

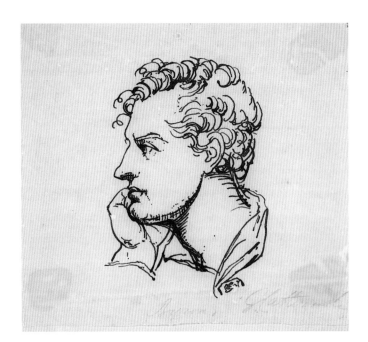

Fig. 33 **This mid-nineteenth century pencil and ink sketch 'after Westall' by George Cattermole is used by the London Byron Society as its logo.**

(fig. 32). It accompanied a brief memoir which may have been written by Byron's cousin Robert Dallas. It was in fact made with Byron's agreement, after he had been approached by the editor, James Asperne, to sit for his portrait, and had suggested instead that the magazine should commission an engraving of an existing portrait: either Westall's, or one of the ones by Phillips (see pages 56–58).[78] Ironically, by not involving Murray or making use of the potential control the publisher exerted on Byron's behalf over the engravers, this portrait initiated the process of unregulated and unlicensed reproduction of Byron's image, resulting in representations that became less and less like the original with each generation of recreation. One of the better drawings 'after Westall' is that by George Cattermole which is used by the London Byron Society as its logo (fig. 33).

Blood's engraving made radical changes to the Westall original, by eliminating Westall's contemplative 'chin on hand' pose and removing the open shirt neck (which Westall himself had also reworked), cameo brooch and crimson jacket, in order to dress Byron in a fashionable tailored coat, high-collared shirt and elaborate white cravat. This followed the style for portraits used by the *European Magazine* and resulted in a head in profile facing right, awkwardly tacked on to a frontal view of the neck and shoulders. Other engraved and painted indignities soon followed. John Doyle later copied the Westall chin-on-hand pose, but combined it awkwardly with a full-length figure in contemporary clothing, to show Byron in an imaginary scene at 'Breakfast at Samuel Rogers's Residence' (fig. 34).

Blood's version caused Westall to write plaintively to Byron about his 'repugnance to seeing the work with which I have taken considerable

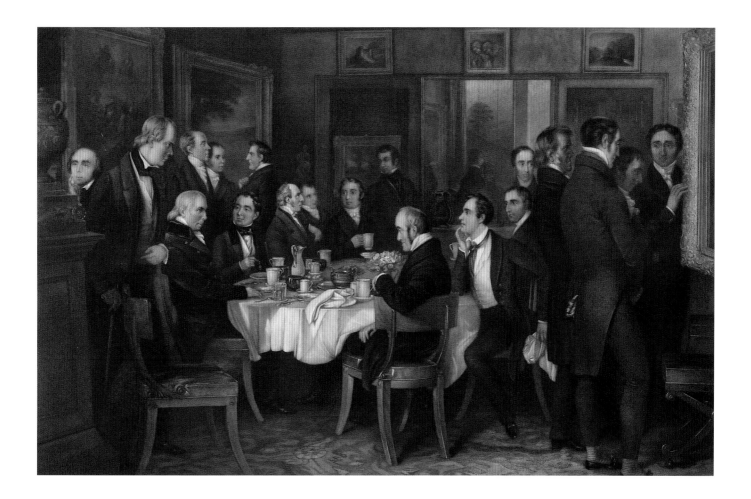

Fig. 34 **In the 1830s, John Doyle copied Westall's chin-on-hand pose to show Byron in an imaginary scene (on his host's right) at** *Breakfast at Samuel Rogers's Residence*. **Other guests include poets Walter Scott (second left), William Wordsworth (seated third left) and Thomas Moore (on his left), and the painter Thomas Lawrence (far right).**

pains, engraved in any other than the best manner'.[79] But however many 'pains' Westall may have taken with his portrait, he was nonetheless a somewhat inaccurate observer of Byron, giving him brown eyes instead of blue or grey, and centring the portrait around a large and unattractive fist, instead of the small, fine hand noted by Sanders and Ali Pasha (although he did correctly record the unusual shape of Byron's ears). Westall appears in fact to have had only one, rather short, sitting with Byron, and his verbal description of his subject seems more acute than his visual one.[80] According to his fellow Royal Academician Joseph Farington, Westall described Byron as 'a very singular character':

> He is abt. 25 years old, slender in person; perhaps five feet 10 inches high, and something of lameness abt. one of His (legs) or feet, which causes him always to wear trowsers. He is animated & chearful while speaking, but when not so occupied His look is grave and settled.[81]

'In his still earlier youth He made himself remarkable by some acts, deviations from propriety which would not have been excused at another period of life,' Farington added, probably referring to rumours about Byron's (and Westall's) sexuality.[82]

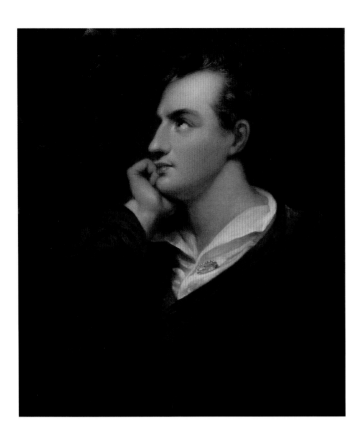

Fig. 35 **This version of the Byron portrait was painted by Westall in 1825, the year after Byron's death, with a heavenward gaze which perhaps imagines Byron's apotheosis.**

In June 1814 Westall showed either the portrait or a preparatory drawing for it as part of the fashionable exhibition of his work at the New Gallery in Pall Mall, London, but otherwise the painting seems to have remained in the artist's studio in Charlotte Street, London, until it was bought after Byron's death by the radical MP Sir Francis Burdett, another former lover of Lady Oxford.[83] It was sold from the estate of Byron's descendant Lady Wentworth to the National Portrait Gallery, London, in 1961.[84]

Although he objected to Blood's engraving for the *European Magazine,* Westall himself also used his own contact with Byron for maximum effect in various different guises and commercial enterprises. He painted an additional, even more romanticised, 'chin on hand' version of the portrait (fig. 35), in which the gaze is averted still further to point heavenwards (perhaps a gesture towards Byron's apotheosis, since it was created in 1825, the year after his death). The fusion of Childe Harold with Byron is also evident in Westall's more deliberately chivalric and active figure shown in figure 37, apparently also painted in 1813, dressed in a dark mediaeval costume and equipped with a sword. This version was purchased in 1875 by Benjamin Disraeli (by then Earl of Beaconsfield) who had idolised Byron in his youth, and who in the 1870s lent his support to the creation of the Byron statue by Richard Belt at London's Hyde Park Corner (see page 141).

Fig. 36 Westall quite deliberately
used his Byron portraits as the
basis for the illustrations he
created for Murray's three-volume
1819 edition of *The Works of
Lord Byron*. This representation
of Childe Harold (from Canto 1,
stanza 6 of the poem) exists as a
watercolour in the John Murray
Collection but was never in fact
engraved or published.

Westall also quite deliberately used his Byron portraits as the
basis for the illustrations he created for Murray's three-volume 1819
edition of *The Works of Lord Byron*, in particular his illustration to
the semi-autobiographical poem 'The Dream' (fig. 38) and also in
one representation of Childe Harold (from Canto 1, stanza 6) which
exists as a watercolour in the John Murray Collection but was never
in fact engraved for publishing (fig. 36).[85] This painting combines the
features of Westall's two 1813 portraits, by showing Byron wearing a
crimson jacket and a small collar, as in the portrait for Lady Oxford,
but also with the sword and mediaeval velvet costume of the version
later owned by Disraeli. Perhaps it was because this illustration so
obviously resembled portraits of Byron that Murray never published
it, although he did engrave and publish other Westall illustrations that
borrowed very obviously from portraits of Byron by himself and other
artists. Thomas Phillips' 'cloak' portrait (fig. 41) is clearly referenced

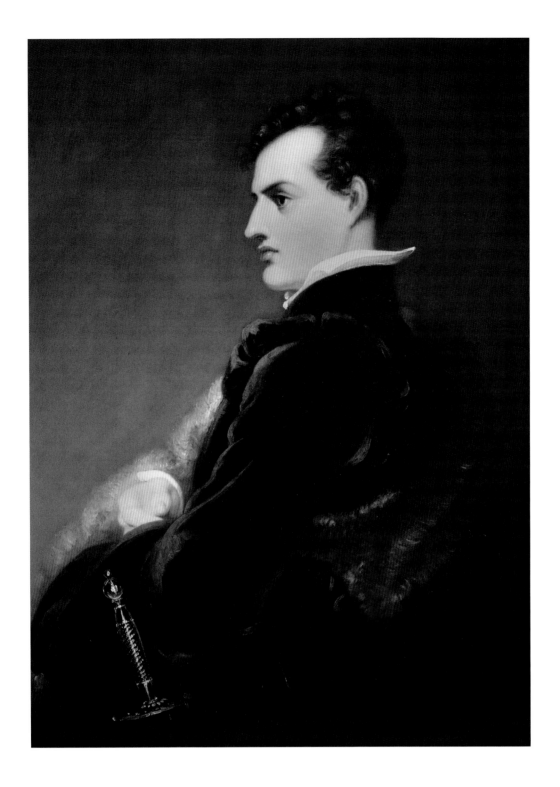

in Westall's illustration (fig. 24) to *Childe Harold*, Canto 4, stanzas
150–51, while Sanders' full-length 1807–9 portrait with Robert
Rushton (fig. 15) is alluded to in Westall's illustration for *Childe Harold*,
Canto 2, stanzas 67–8. (fig. 39). The borrowing from Sanders did,
and perhaps still does, pass unnoticed, because the portrait concerned
had not been made public, although Westall would very likely have
seen it at Murray's offices in Albemarle Street in 1813.[86] When Byron

Fig. 37 (opposite) The fusion of Childe Harold with Byron is also evident in the more chivalric figure in this portrait by Westall, where Byron is dressed in a dark Elizabethan costume and equipped with a sword. The painting was acquired in 1875 by Benjamin Disraeli, who idolised Byron in his youth, and it is now at Disraeli's home at Hughenden Manor, Buckinghamshire.

Fig. 38 (right) Westall's illustration (1818) to Byron's semi-autobiographical poem 'The Dream' also borrowed the features of his 1813 portrait of Byron.

was sent engravings of Westall's illustrations in 1820 he was highly complimentary about them, responding enthusiastically to Murray, 'the drawings for Juan are superb – the brush has beat the poetry'.[87]

We can now see how Westall and other early illustrators of Byron's works such as Thomas Stothard (fig. 40) were playing tricks with viewers 'in the know' about what Byron himself looked like, by including visual clues and references that would not, at this early stage, have been picked up by the wider public. In this they took their lead from the verbal games Byron had already begun to play with his readers in the early poems and *Childe Harold*, Cantos 1 and 2; this would continue in his commission of the Phillips 'Albanian' portrait, half revealing and half concealing autobiographical details. It is little wonder that, by the time the heroes of the 'Oriental Tales' made their appearance, readers were primed to relate their characteristics to those of the poet. Byron's 'Journal' entry for 10 March 1814 describes how

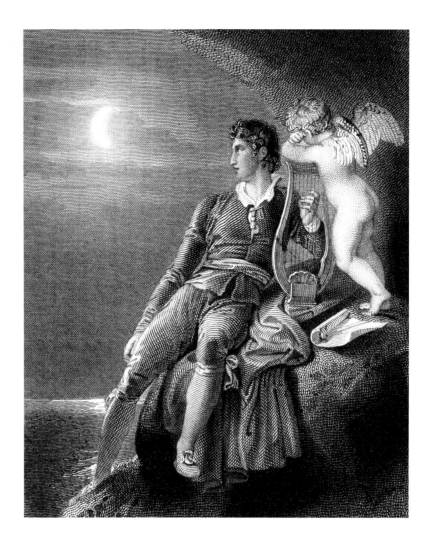

Fig. 39 (opposite) **George Sanders' 1807–9 portrait of Byron embarking in a boat (figure 15, page 27) is alluded to by Westall in this 1818 illustration for *Childe Harold*, Canto 2, stanzas 67–8. Although Sanders' portrait had not yet been made public, Westall could have seen it at Murray's offices in 1813.**

Fig. 40 (right) **Thomas Stothard was the first artist employed by Murray to illustrate Byron's collected works (in 1814). He was also the first to use aspects of Byron's portraiture to represent the protagonists of his works, as here in his illustration to 'Thyrza' (engraved by Charles Heath). He and other illustrators took their lead from the verbal games Byron played with his readers in the early poems and in *Childe Harold*: half-revealing and half-concealing personal traits. By the time the heroes of the 'Oriental Tales' made their appearance in 1813, readers were primed to relate their characteristics to those of the poet.**

Hobhouse had 'told me an odd report, – that *I* am the actual Conrad, the veritable Corsair ... people sometimes hit near the truth; but never the whole truth'.[88] And in the 'Dedication' to the poem he wrote, 'I should have been glad to have rendered my personages more perfect and amiable, if possible, inasmuch as I have been sometimes criticised, and considered no less responsible for their deeds and qualities than if all had been personal. Be it so – if I have deviated into the gloomy vanity of "drawing from self".'[89]

The distinctly pictorial metaphor of 'drawing from self' prophesied only too well how 'Byron' and his 'heroes' would come to be conflated, and the way in which the visual illustrations of his works would lead the way in this process, to a degree that, as Byron remarked, was unprecedented for any other writer. By 1818 and the 'Dedication' to Canto 4 of *Childe Harold*, Byron, too, had 'become weary of drawing a line which every one seemed determined not to perceive ... between the author and the pilgrim', and he had in effect 'come out' as Childe Harold.[90]

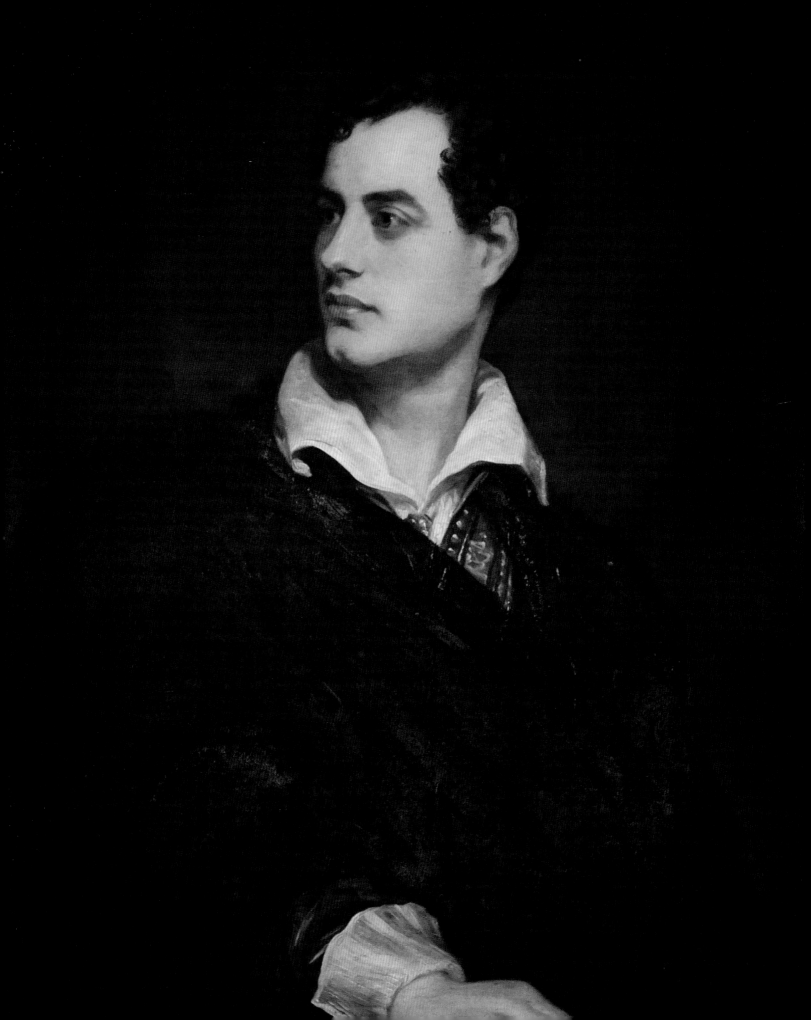

Establishing 'brand Byron'

1813–16

The wild Albanian kirtled to his knee
With shawl-girt head and ornamental gun,
And gold-embroider'd garments, fair to see.
Childe Harold's Pilgrimage, Canto 2, lines 514–15.[91]

PERHAPS THE TWO MOST FAMOUS images of Byron today are the oil paintings created by Thomas Phillips RA in 1813–14 (figs 41 and 47). They both made an anonymous debut in the Royal Academy summer exhibition in London's Somerset House in 1814 (entitled respectively *Portrait of a Nobleman* and *Portrait of a Nobleman in the Dress of an Albanian*, although it was an open secret as to who the famous sitter was). But while the plainer 'Cloak' version went on to become extremely well known as one of the classic images of Byron during his lifetime, the 'Albanian' had to wait until the 1840s to be published in engraving.

Both Phillips' portraits provide a marked contrast to the miniatures and Sanders' full-length portrait, which were primarily intended for Byron's personal use, and they are both also very different from Westall's 1813 portrait which conflated Byron with his creation, Childe Harold. Phillips was a close friend of John Murray, and the commission for the 'Cloak' portrait originated with Murray in June 1813 as the intended basis for an engraved print to display Byron as the author of the edition of the collected works that Murray was planning. But for the same reason that Byron declined to be paid at this stage for his poetry (that it would identify him as a professional author – a distinct step down in social class from his status as a peer) he was anxious for the portrait *not* to include the outward signs of authorship. 'I dont [sic] care

Fig. 41 In 1813–14, Thomas Phillips RA created two famous portraits of Byron: this one (the 'Cloak') and the 'Albanian' (see page 62). They were shown at London's Royal Academy summer exhibition in 1814 as *Portrait of a Nobleman* and *Portrait of a Nobleman in the Dress of an Albanian*, although the identity of the sitter was an open secret.

what becomes of the arms,' he wrote to Phillips in September 1813, 'so that *pens* [&] *books* are *not* upon ye. canvas.'[92] Despite this omission of the tools of the poetic trade, the 'Cloak' portrait does participate in a long tradition of representing male writers and poets, including Shakespeare (the Chandos portrait), Dryden (by John Michael Wright) and Pope (by Godfrey Kneller), in dark clothes with glimpses of white linen, somewhat 'déshabillé', indicating their withdrawal to a private study, perhaps to await the attentions of the (female) muse to assist them in writing their work.

Byron's veto of the pens and books was only the first of his interventions in Murray's and Phillips' plans. He diverted one of the early versions of the 'Cloak' portrait as a gift for Augusta, and paid for Phillips to create a second version of it to be used as a basis for Murray's proposed engraving. And, as if to assert his status as a traveller and a man of action rather than a sedentary poet, he commissioned the portrait in 'Albanian' costume (but with the same face) (fig. 47) for himself. The Albanian costume included a kilt, and the fact that this portrait is three-quarter-length rather than full-length perhaps reflects Byron's lifelong wish to disguise his lameness, as reported by the specialist bootmaker he had consulted some years before:

Figs 42 and 43 There are at least four versions of Phillips' 'Cloak' portrait of Byron, and it is difficult to establish their order of creation. Figure 41 (page 56), which belongs to the Byron family, appears to be the earliest and is reproduced here in colour for the first time. Figure 42 was painted for John Murray in 1814, and figure 43 (now at Newstead Abbey) is an artist's replica painted around 1818 for Colonel Thomas Wildman who bought the Abbey from Byron. There is a fourth version by Phillips in a private collection in South Africa. Byron's close friend Hobhouse commented that he saw 'no resemblance' to Byron in any of them.

Fig. 44 The 'Cloak' portrait
was originally commissioned
by Murray to be engraved as
an illustration to an edition of
Byron's collected works, but as
with figure 23 (page 37), Byron
again objected to the engraving.
'We positively will not have that
same print by Phillips's engraver,'
he wrote. Murray did, however,
publish this engraving by John
Samuel Agar in December 1814,
and in April 1815 Byron asked for
the plate so that he could – and
did – destroy it to prevent further
prints being made.

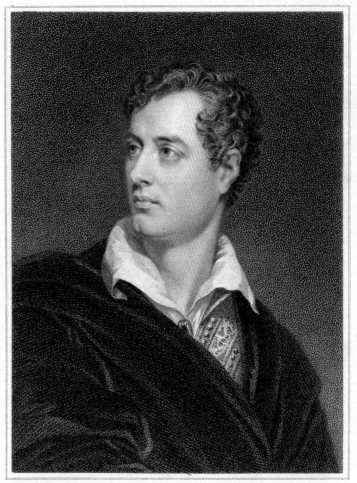

Thomas Phillips R.A. I. S. Agar.

I told him that by peculiar management I could conceal the defect
completely, but to do this it would require much personal exertion on
his part ... He did not mind that, he said: he would gladly submit to that,
and more, to gain a point which, in his unfortunate situation, was of
paramount importance.[93]

Byron's first sitting to Phillips was on 2 July 1813, with subsequent
sittings later in 1813 and in 1814, and at least four early examples of
the 'Cloak' portrait created by Phillips himself are extant: three shown
here and another which is in South Africa.[94] It is, however, difficult to
establish the precise order in which they were painted and then altered

to accommodate comments by Byron's family and friends, or to say which of these versions was the one exhibited at the Royal Academy in 1814. Annette Peach argues convincingly that figure 41 (page 56) is the one exhibited at the Academy, that the version at John Murray's (fig. 42) was created during the same period, and that the portrait displayed at Newstead Abbey (fig. 43), which is now the best known, is a replica created by Phillips a few years later at Byron's request. It was given to his former schoolfellow, Colonel Thomas Wildman, and seems to have been created in or after 1818 when Wildman purchased the Abbey.[95] Hobhouse, in 1814, was unenthusiastic about all of Phillips' portraits, commenting that he saw 'no resemblance' to Byron in any of them.[96]

In the same way that he had objected to the engraving which Murray had commissioned of the Sanders 1812 miniature, Byron also strongly contested an engraving of the Phillips portrait Murray had made to be issued with his forthcoming works. '[T]he print is by no means approved of by those who have seen it – who are pretty conversant with the original as well as the picture,' Byron wrote to

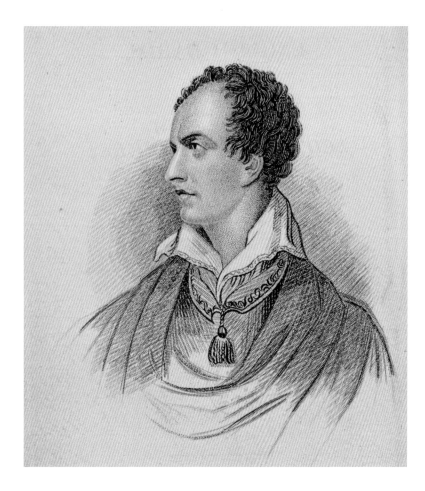

Fig. 45 'Lord Byron, from a sketch taken on his leaving England' (an engraving by Joseph West, around 1816). Portraits such as this, created for pirated editions of Byron's work, often deliberately made changes from the images they copied in order to avoid falling foul of copyright laws. Some prints looked nothing like the original portraits of the poet, while still using the props that signified 'Byron': a white collar, curly hair and a distinctive hairline, and a profile or three-quarter face with a strong nose, eyebrows and chin.

Murray in late July 1814, before insisting '*we positively will not have that same print* by Phillips's engraver'.[97] Murray did publish an engraving in December 1814, by the distinguished artist John Samuel Agar (fig. 44), which in fact improves on the composition of the Phillips portrait by leaving out part of the cloak and the awkward right hand, but it is not clear whether it was this one that Byron and his friends and family objected to so vehemently, or another one mentioned by Byron in November 1813 when he wrote that two of Phillips' portraits were 'now at Mr Sharpe's for the purpose of engraving'. No prints from an engraving by 'Sharpe' (probably William Sharp, 1749–1824) have yet been identified.[98] Byron persisted in his strong objections, and in April 1815 he asked Murray for the engraver's plate to be 'given up' to him, so that he could – and did – destroy it to prevent any further prints being made.

Murray had, however, by then printed and sold over 1,000 copies, and the 'Cloak' depiction went on to become one of the best-known images of Byron.[99] The engraved version was much borrowed from for

Fig. 46 'George Gordon, Lord Byron, To Chandos Leigh Esqr.', a lithograph by Maxim Gauci (from around 1819) is supposedly based on one of the Phillips' 'Cloak' portraits which belonged to Chandos Leigh.

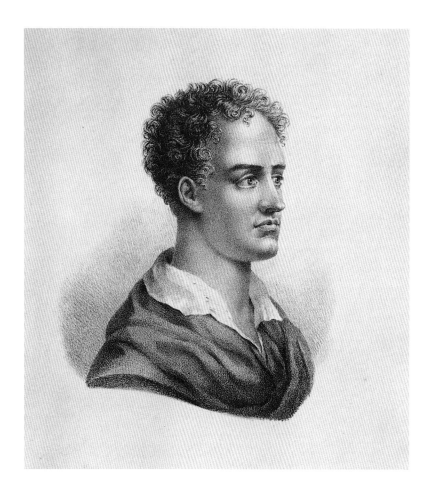

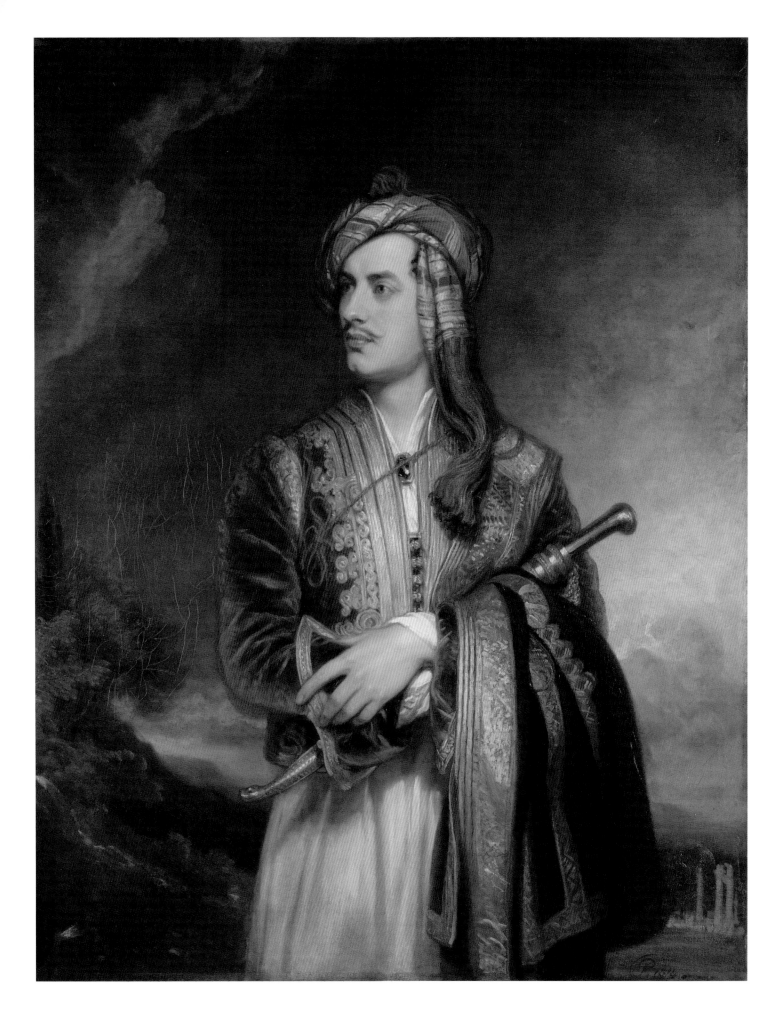

second-generation and later representations, including those by Westall in his illustrations to *Childe Harold* (see figure 24, page 38) and Adam Friedel in his celebration of Byron's role in the liberation of Greece (see figure 120, page 130). The portraits created for pirated editions of Byron's work often deliberately made changes from the images they copied, so as not to fall foul of copyright laws. The effect was to accelerate the move further and further away from the original, until these images (figs 45 and 46) looked nothing like the original portraits of the poet, while still retaining the props that signified 'Byron': a white collar, a distinctive hairline, a profile or three-quarter face with a strong nose, eyebrow and chin.[100] 'I have often seen engravings prefixed to the works of his Lordship,' remarked Captain Forrester, who met Byron in Greece in 1824, 'but great was my astonishment, although prepared to make a fair allowance to artists, to see before me a being bearing as little resemblance to the pretended fac-simile, as I to Apollo.'[101]

The way in which the 'Cloak' and the 'Albanian' were created from the same sittings with Phillips is evident not only from the almost identical face in the two portraits but also from the glimpse under the cloak of the bright gold trimmings and red octagonal brooch that are shown fully in the 'Albanian' (fig. 47). The 'Albanian' portrait is, however, on a different scale from the 'Cloak': it is some 30 cm larger in each direction and it also includes a landscape background with a stormy sky and classical terrain. It was something of a departure from the norm for Phillips, who was known for his rather conservative style and his respectable images of eminent men of literature, science and the Church. 'Phillips shall paint my wife and [Thomas] Lawrence my mistress,' a 'witty poet' of the day is said to have remarked (although Phillips did create a fine, rather unorthodox portrait of Lady Caroline Lamb dressed as a pageboy, perhaps under Byron's influence).[102]

Many critics have regretted that Lawrence never painted Byron, especially as he left a detailed verbal description of him:

Lavater's system never asserted its truth more forcibly than in Lord Byron's Countenance, in which you see all the character. Its keen and rapid Genius – its pale Intelligence – its profligacy and its bitterness, its original symmetry distorted by the Passions, his laugh of mingled merriment and scorn. The forehead, clear and open, the brow boldly prominent, the Eyes bright and *dissimilar*, – the Nose finely cut, and the Nostril *acutely* form'd – the Mouth well form'd but wide, and contemptuous even in its smile; falling singularly at the corners, and its

Fig. 47 Thomas Phillips' 1814 portrait of Byron wearing his 'Albanian' costume has the same face as in the 'Cloak' portrait (figure 41, page 56) but is some 30 cm larger in each direction and includes a landscape background with a stormy sky and classical terrain. It is now in the British Ambassador's residence in Athens.

Fig. 48 **Byron gave his 'Albanian' costume to his friend Margaret Mercer Elphinstone to wear at a masquerade in 1814. In the 1960s it was rediscovered at Bowood House, Wiltshire, the home of Miss Elphinstone's descendant the Marquess of Lansdowne, and it is now on show there on a specially-made waxwork. The costume is one of the two 'magnifique Albanian dresses' that Byron bought in Epirus in 1809 for fifty guineas each, and the rendering of its colours and details in Phillips' original portrait (figure 47, page 62) are remarkably accurate.**

vindictive and disdainful expression, heighten'd by the massive firmness of the Chin, which springs at once from the centre of the full under Lip, – the Hair dark and curling, but irregular in its growth. All this presents to you the poet and the man, and the general effect is aided by a thin spare form, and, as you may have heard, by a deformity of limb.[103]

Johann Caspar Lavater's 'system' aimed to read character through the shape of the facial features, and Byron did in fact have his head examined in 1814 by Johann Caspar Spurzheim, who developed the closely related pseudo-scientific system of phrenology. According to Byron, Spurzheim told him that all his 'faculties & dispositions' were 'strongly marked – but very antithetical for everything developed in & on this same skull of mine has its *opposite* in great force so that to believe him my good & evil are at perpetual war'.[104]

Byron's sitting to Lawrence seems to have come tantalisingly close, and Lawrence's nephew recorded that 'a communication had once passed between them on the subject but as [Lawrence's] engagements prevented him from acceding to the time of the Noble Bard's appointment the opportunity was broken off and never resumed'.[105]

The Phillips 'Albanian' is perhaps as near as we come to the kind of image Lawrence might have created of Byron, and, although much more static than Lawrence's in style, it is brought to life by the colours and rich details of the costume. This was one of the two 'magnifique Albanian dresses' that Byron had bought in Epirus in 1809 for fifty guineas each: 'the most magnificent in the world' as he described them to his mother,

Fig. 49 In *The Old Curiosity Shop* (1840–41), Charles Dickens and his illustrator 'Phiz' imagined a waxwork of Mary Queen of Scots cross-dressed and repurposed as Byron (third left) for a group of young ladies from a boarding-school, who 'quite screamed when they saw it'.

detailing 'the long *white kilt*, gold worked cloak, crimson velvet gold laced jacket & waistcoat, silver mounted pistols & daggers'.[106]

The use of the sash as a turban in the portrait reflects Hobhouse's comment that, although Albanian soldiers generally wore a 'small red cap, resembling the cup of an acorn ... those who can afford it, add a shawl, bound round in the turban fashion'.[107] Another authentic detail is the Albanian-style moustache. Although in early 1813 Byron mentioned 'his dear mustachios', hoping that they would 'have the good manners to grow blacker than they did formerly', it seems likely that this feature in the painting was an imaginary one, added by Phillips.[108] Despite the facial hair, Hazlitt described the portrait as 'too smooth' and seeming as if '"barbered ten times o'er"', while also commenting that 'here is, however, much that conveys the softness and the wildness of character of the popular poet of the East'.[109] Sir David Piper in

1982 more forthrightly described Phillips' portrayal as having 'a very unconvincing whiff of fancy-dress ball, or of Hollywood spectacular, almost Errol Flynn playing Byron', and in fact the 'fancy-dress' element soon became a real part of the costume's history, when Byron gave it to his friend Margaret Mercer Elphinstone to wear at a masquerade in 1814, telling her that he had worn it only 'for half an hour to Phillips'.[110] It remained with Miss Elphinstone and her family for 150 years until unearthed by chance in the 1960s by Doris Langley Moore, an expert on both the history of costume and on Byron, in a dressing-up box at Bowood House, the Wiltshire home of Miss Elphinstone's descendant the Marquess of Lansdowne.[111] The waxwork model on which the costume is now displayed for visitors to Bowood (fig. 48) was modelled after the marble version of the Bartolini bust of Byron at London's National Portrait Gallery (see figure 79, page 97). It is a modern take on the 'Byron' that was apparently made by Madame Tussaud in the 1820s, 'from a Bust, for which he gave Sittings, in Italy'.[112] 'Mrs Jarley's Waxworks', in Charles Dickens' *The Old Curiosity Shop* (1840–41) (fig. 49), meanwhile, features Little Nell and a cross-dressed model who starts out as Mary Queen of Scots but is repurposed as Byron 'in a dark wig, white shirt-collar, and male attire'. S/he is put on display for a party of young ladies from a boarding school who 'quite screamed when they saw it'. Their teacher Miss Monflathers, however, reproves Mrs Jarley for not keeping her collection more select, observing that 'his Lordship had held certain opinions incompatible with wax-work honours'.[113]

Three versions of the 'Albanian' portrait by Phillips are now extant. The original painting of 1814 – like so many of Byron's portraits – has had a far from straightforward life. It was bought from Phillips for 120 guineas in 1815 by Lady Noel, who had become Byron's mother-in-law when he married her daughter Anne Isabella (Annabella) Milbanke on 2 January that year. It was hung over a chimney piece at her home at Kirkby Mallory, Leicestershire, covered with a green curtain – much to Byron's annoyance – although not in fact because of the reputation of the subject but as a precaution against smoke.[114] When the Byron marriage fell apart with great acrimony a year later, however, Lady Noel had the portrait shut up in a wooden case and later wrote a clause in her will that it was to remain 'inclosed and shut up' until her granddaughter (Byron's daughter Ada, later Ada Lovelace) 'shall attain her age of twenty one years'.[115] Even then the portrait was to be 'delivered' to Ada only if that was the wish of Ada's mother, Byron's estranged wife Lady Byron. When Lady Noel died and her will was published in 1822, Byron commented bitterly to John

Murray about the 'interdiction for my daughter to see her father's portrait for many years'.[116]

Ada in fact received the portrait when she married at the age of nineteen in July 1835, and at this point it was sent back to Phillips' studio, probably for restoration. Phillips made a half-length copy of it (fig. 50) which was sold to the National Portrait Gallery by his son in 1862. John Murray also asked Phillips to make him a copy, which was painted on a smaller wooden panel and is in the John Murray Collection in London. It was not delivered to Murray until 1840, and prints did not appear until 1841, so that this image of Byron was unknown to the general public until a generation after his death. Those who

Fig. 50 This version of Thomas Phillips' 'Albanian' portrait (now in the National Portrait Gallery, London) is an 1835 copy by Phillips of his 1814 original painting, which between 1816 and 1835 was shut up in a wooden case by Byron's hostile mother-in-law Lady Noel. The colours here are richer and less accurate than those in the first version (figure 47, page 62).

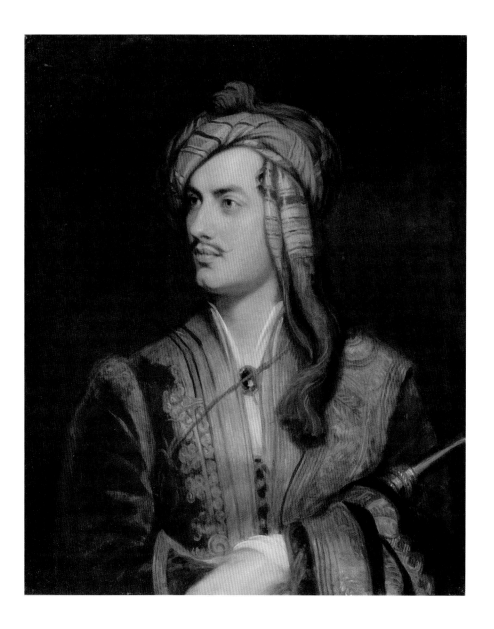

Fig. 51 (opposite) When illustrating Byron's poem 'The Giaour' in 1814, Thomas Stothard copied the costume from Byron's 'Albanian' portrait (figure 47, page 62) to portray the Giaour himself. This initiated the long tradition among nineteenth-century illustrators, including Eugène Delacroix and Ford Madox Brown, of showing Byron's fictional oriental heroes as resembling this image of Byron.

Fig. 52 (right) A rare, harmonious memento of the brief and strife-ridden Byron marriage is this informal profile sketch of the poet made by his wife, Annabella, Lady Byron, in 1815. It is inscribed 'Pip – Pip – Pip – ', his affectionate nickname for her. In the centre of the paper is an unusual example of a sketch by Byron himself, showing a ship at sea. Judging from this it seems unlikely Byron had any pretensions to artistic skill, although several members of his grandfather's family were good artists.

viewed the 1814 illustrations made for Byron's works by Thomas Stothard would, however, have seen Byron's Giaour (fig. 51) depicted almost as a replica of the Phillips 'Albanian' portrait of the poet. Stothard, as a Royal Academician, would have had ample opportunity to view it and sketch it at the Academy's exhibition in 1814, before it was bought by Lady Noel. It was Stothard's representation of the Giaour, printed and copied over and over again, which instituted the long tradition (stretching via Eugène Delacroix through to Ford Madox Brown and numerous other nineteenth-century Byron illustrators) whereby Byron's fictional oriental figures were portrayed as resembling this image of Byron. The original portrait, meanwhile, remained in the Lovelace family until Ada's great-grandson, the fourth Earl of Lytton, sold it to the Ministry of Works in 1952, and it is now in the British Ambassador's Residence in Athens, as part of the Government Art Collection.

A more harmonious memento of the brief and strife-ridden Byron marriage is the informal profile sketch of Byron made by Lady Byron in 1815 (fig. 52), inscribed (apparently in Byron's handwriting)

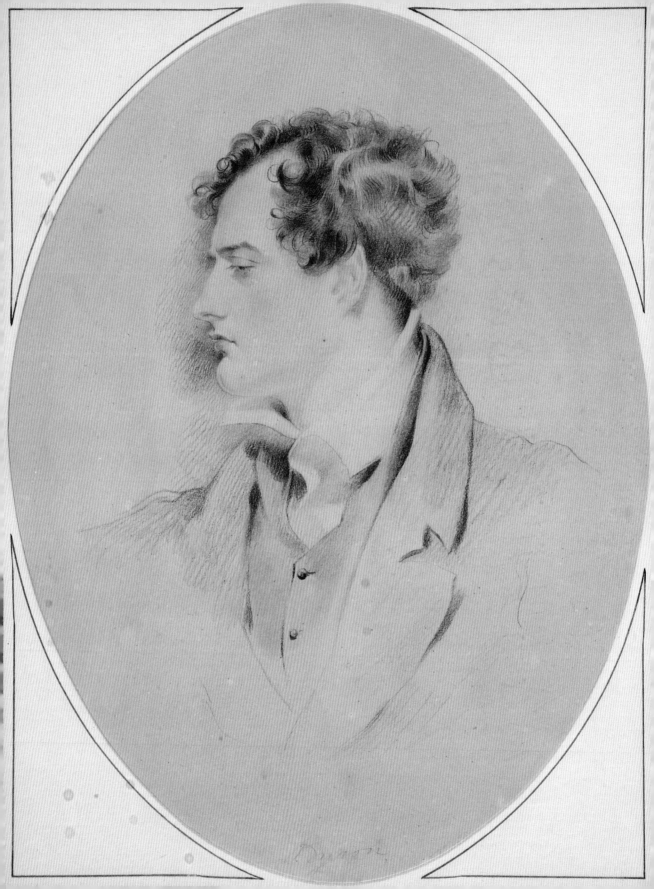

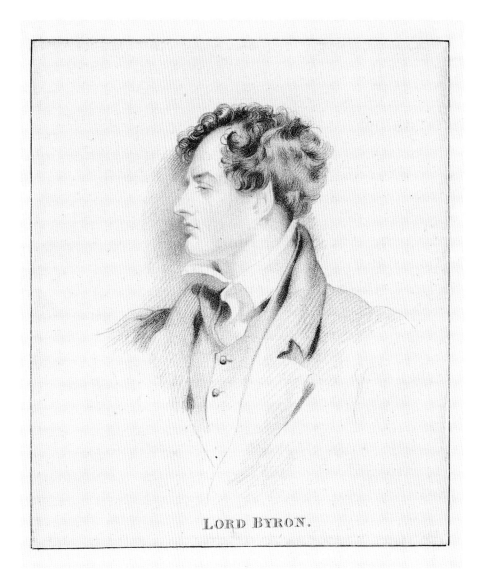

LORD BYRON.

'Pip – Pip – Pip – ': his affectionate nickname for her. Also on the paper is a rare sketch made by Byron, showing a ship at sea. It is very roughly drawn and, judging from this, it seems unlikely Byron himself had any pretensions to artistic skill. Another 1815 profile is a portrayal of Byron which has become famous through its reproduction in print, apparently originating from a beautifully executed sketch (fig. 53) which is now accepted as being by the gifted young artist George Henry Harlow, a former pupil of Lawrence. There is no record of payment for the original drawing, which remained unknown to the public until the twentieth century, and was in fact not identified until 1968.[117]

In Byron's time the version of this image that became famous was the engraving made by Henry Meyer for the August 1815 edition of Henry Colburn's *New Monthly Magazine and Universal Register* (fig. 54). Meyer, however, introduced a small but significant change to the original sketch which crucially affected the tone of Byron's expression

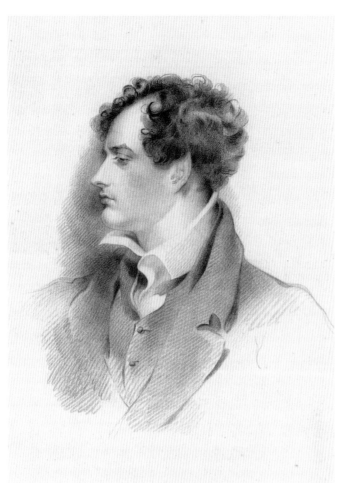

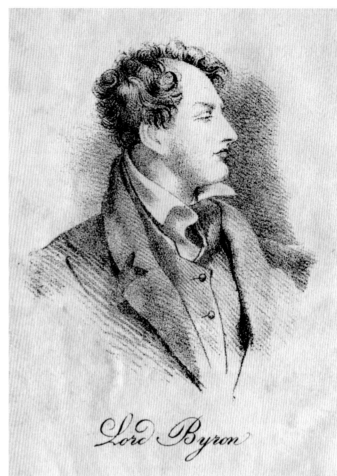

and (since it was replicated in generations of other prints after Meyer) even the general perception of his character. This was a very minor alteration to the angle of the head, so that, while in Harlow's original Byron is shown inclining his head forward and lowering his eyes to read, in the Meyer version his chin is raised slightly, giving it a haughty upward angle, while his eyes seem to look down disdainfully.[118] Leigh Hunt described it as 'the fastidious, scornful portrait of him, affectedly looking down'.[119]

It was also in 1815 that Byron and Walter Scott first met, at John Murray's house in Albemarle Street, as imagined in 1850 by L. Werner (fig. 58). Scott described Byron's physical appearance in flattering terms, commenting that

> [t]he predominating expression was that of deep and habitual thought, which gave way to the most rapid play of features when he engaged in interesting discussion; so that a brother poet compared them to the sculpture of a beautiful alabaster vase, only seen to perfection when lighted up from within. The flashes of mirth, gaiety, indignation, or satirical dislike which frequently animated Lord

Fig. 55 (above left) In January 1816, Meyer contributed his second engraving based on the Harlow portrait of Byron to a publication named *The British Gallery of Contemporary Portraits*. The disdainful look of both Meyer's prints coincided with the dramatic fall in Byron's social reputation in the aftermath of his marriage breakdown in early 1816. The supercilious, sneering cast of Byron's features appeared to confirm the accusations of cruelty, infidelity, sexual deviance and other depravities that had led the marriage to fail. Marianne Hunt (wife of Leigh Hunt), designated this Byron as a 'great schoolboy who had had a plain bun given him instead of a plum one', while the Shelleys used it to scare their little son when he was naughty, threatening that 'the great Poet is coming'.

Fig. 56 (opposite right) Later generations of Byron prints copying Harlow and Meyer, such as this one of 1819 by Gottfried Engelmann, made Byron appear even more haughty and affected.

Fig. 57 (above) This ring, set with a cornelian carved with an intaglio image of Byron's head after Harlow and Meyer, was commissioned by John Murray. It was used for the wax seals on Murray's letters, and when Byron received one of these he described it as looking like 'a Saracen's head'. Murray agreed that it was 'vile'.

Byron's countenance, might, during an evening's conversation, be mistaken by a stranger, for the habitual expression ... [but] ... their proper language was that of melancholy.[120]

The disdainful look of the Meyer print, however, coincided with the dramatic fall in Byron's social reputation in the aftermath of his marriage breakup in early 1816, and the anger and bitterness expressed in his verses 'Fare Thee Well', addressed to Lady Byron, and the vicious satire of 'A Sketch from Private Life', which savaged her companion, Mary Ann Clermont. Fifty copies of each poem were printed for Byron by John Murray on a private basis, but they both soon became public. Meyer's engraved representation appeared to confirm, through the supercilious, sneering cast of Byron's features, the accusations of infidelity, sexual deviance and other depravities that had led the marriage to fail, contributing to his being ostracised in society and, in April 1816, to his leaving England, never to return.

Alluding to these poems and rumours, affirming his role as a political rebel and a philanderer, and also undoubtedly contributing to the swift decline of Byron's reputation, were a series of satirical prints by the

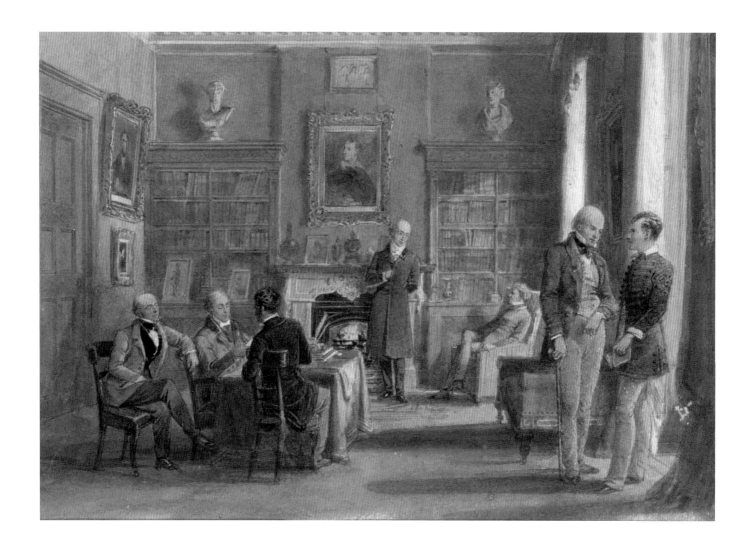

brothers Isaac Robert and George Cruikshank, discussed in Chapter Six. Meanwhile the non-satirical but ferocious look of the print of Byron after Harlow by Meyer became something of a joke among the circle in and around Geneva that Byron was to join in spring 1816, which included Percy Bysshe Shelley, his then mistress (later wife) Mary Wollstonecraft Godwin, and her step-sister Claire Clairmont. Claire, for instance (with whom Byron had a brief affair and a daughter, born in January 1817) wrote to Byron, 'the portrait dear has made you look so proud it almost frightens one even to peep. We use it to frighten little Will [Percy and Mary Shelley's infant son] when he is naughty, telling him the "great Poet is coming".'[121]

Marianne Hunt (wife of Leigh Hunt), meanwhile, memorably designated the Byron of the print as a 'great schoolboy who had had a plain bun given him instead of a plum one'.[122] Although, as we have seen, Thomas Lawrence commented on the 'contemptuous' look of Byron's mouth, and its 'vindictive, disdainful expression', Henry Angelo, Byron's fencing instructor, who had encouraged him to sit for Harlow, described the print as 'not at all a favourable likeness, having

Fig. 58 **Byron's and Walter Scott's first meeting in 1815 at Murray's house in Albemarle Street, London, as imagined in 1850 by L. Werner. Scott (perhaps quoting Coleridge) compared Byron's features to 'a beautiful alabaster vase, only seen to perfection when lighted up from within'.**

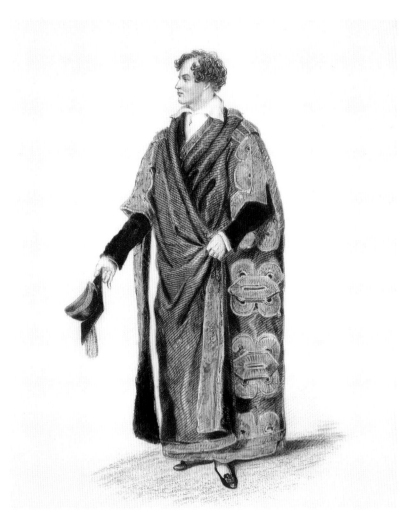

Fig. 59 (above left) **The Harlow/ Meyer image was also copied by Gilchrist in the 1870s for this image of Byron in the University of Cambridge academic dress gown of a nobleman.**

Fig. 60 (above right) **In April 1816, Byron left England for the continent of Europe, never to return. The Harlow/Meyer image perhaps found its most appropriate use as the basis for the supercilious expression given to Byron by Max Beerbohm in his 1904 cartoon of 'Lord Byron, shaking the dust of England from his shoes'.**

by far too much of a proud, downcast look: not in the least a trait of the original'.[123] For many members of the public, however, the printed image seemed to combine with the shocking rumours about Byron's private life to reveal the 'real' Byron, and Meyer's second, more refined, engraving, published in January 1816 in Cadell and Davies' *British Gallery of Contemporary Portraits* (fig. 55), only led to a spate of further pirated prints, sometimes presenting little more than a caricature of Byron's appearance (fig. 56). Byron described the impression from a ring (fig. 57) that Murray made from this print as looking like 'a Saracen's head', and Murray agreed that it was 'vile'.[124] It was also copied, less controversially, by Gilchrist for his image of Byron in the University of Cambridge's academic dress gown of a nobleman (fig. 59), but it perhaps found its most appropriate use in the supercilious expression given to Byron by Max Beerbohm in his 1904 cartoon of 'Lord Byron, shaking the dust of England from his shoes' (fig. 60).[125]

CHAPTER 4

Citizen of the world

1816–21

My Native Land – Good Night!
Childe Harold's Pilgrimage, Canto 1, line 125.[126]

BYRON LEFT ENGLAND for the last time on 25 April 1816, bidding his farewells to Hobhouse and Scrope Davies on the quay at Dover. Loaded on board the boat to Ostend with him was his huge new travelling coach, modelled on that of Napoleon (and for which the bill was still unpaid). His travelling companions included Robert Rushton and William Fletcher, his valet, who had been with him in Greece and was to continue in this role until Byron's death in 1824. Also in the party was the young Dr John William Polidori, or 'Pollydolly', as Byron called him. He had been hired by Byron in the role of personal physician and companion, but their relationship was an uneasy one from the start, especially when Byron discovered that Polidori had been offered £500 for his account of the tour. Polidori also went on to make money from his Byronic novella *The Vampyre*, published in 1819. It was based on a short draft of a story ('Augustus Darvell') begun by Byron in the stormy summer of 1816 at the Villa Diodati on Lake Geneva, as part of the ghost story competition which also produced Mary Shelley's *Frankenstein*.[127] Polidori's revision and completion of Byron's draft presented his mysterious vampire protagonist Lord Ruthven with Byronic as well as Gothic features. When published in the *New Monthly Magazine* in 1819 as 'A Tale by Lord Byron' (allegedly without Polidori's permission) it originated the modern vampire 'genre' and added yet another layer of mysterious and sinister complexity to Byron's public image.

From now on, all the portraits of Byron to be taken from life were produced outside England, opening up the possibility of many different

Fig. 61 **This marble bust was created in Rome by the Danish sculptor Bertel Thorvaldsen, following a commission in 1817 by Byron's friend John Cam Hobhouse. Hobhouse wanted to add a (marble) laurel wreath to the head but Byron strenuously objected. 'I won't have my head garnished like a Xmas pie with Holly – or a Cod's head and Fennel … . I wonder that you should want me to be such a mountebank,' he wrote. This copy of the bust was made for John Murray by Thorvaldsen in about 1822.**

styles of representation by artists and sculptors from a variety of
different backgrounds and nationalities – Italian, French, Danish and
American as well as British – with approaches varying from neoclassical
to Romantic, and from the most formal to the highly personal.

Byron himself at this stage was still highly suspicious of visual art.
'I know nothing of painting,' he wrote to Murray. 'I detest it – unless
it reminds me of something I have seen or think it possible to see. ...
Depend upon it of all the arts it is the most artificial & unnatural – &
that by which the nonsense of mankind is the most imposed upon.'[128]
His reaction to the baroque religious art of Antwerp was positively
visceral; Rubens, he told Hobhouse, was 'the most glaring – flaring –
staring – harlotry impostor that ever passed a trick upon the senses of
mankind', while his impression of Rubens's women was that they 'have
all red gowns and red shoulders – to say nothing of necks – of which
they are more liberal than charming'.[129]

It was not until he reached Italy late in 1816 that Byron started to
enjoy some of the paintings he saw. In 1817 in the Manfrini Palace
in Venice a portrait of the poet Ariosto by Titian 'surpass[ed] all my
anticipation of the power of painting – or human expression – it is
the poetry of portrait – & the portrait of poetry'.[130] It was also in the
Manfrini collection that he came across the triple portrait by a follower
of Titian which became famous after he celebrated it in *Beppo* (1817):

> 'Tis but a portrait of his son and wife
> And self; but *such* a woman! love in life!
> *(Beppo*, lines 95–6).[131]

And in the same place he fell in love with an (unidentified) portrait of
'some learned lady ... the kind of face to go mad for – because it cannot
walk out of its frame'.[132]

Byron continued to prefer classical or Renaissance portraits over
baroque or rococo works, and this is perhaps reflected in the next
portrait that he sat for himself: the white marble bust created in Rome
in 1817 for Hobhouse by the Danish sculptor Bertel Thorvaldsen
(second only to Antonio Canova for his fame as a neoclassicist)
(fig. 61). Hobhouse in fact wanted to make the bust even more
classical by adding a (marble) laurel wreath to the head, but Byron
objected in strenuous terms. 'I protest against & prohibit the "laurels"
– which would be a most awkward assumption and anticipation of
that which may never come to pass,' he wrote, referring to the British
official 'Poet Laureate' title. 'I won't have my head garnished like a

Fig. 62 Thorvaldsen's neoclassical style of portraiture was also used by Belgian artist Josef Odevaere in his imaginary portrait of 1826 of Byron on his deathbed, complete with a Grecian temple and laurel wreath.

Xmas pie with Holly – or a Cod's head and Fennel – or whatever the damned weed is they strew round it. – I wonder that you should want me to be such a mountebank.'[133]

Thorvaldsen did, however, impose his neoclassical preferences by portraying Byron (at least in the version of the bust he kept himself, see figure 63) draped in a classical toga. And in 1826 another classicising artist, Josef Odevaere, would create an imaginary portrait of Byron on his deathbed (fig. 62), complete with the full classical attributes of a Grecian temple, broken-stringed lyre, sword – and a laurel wreath.

Meanwhile, when Byron heard in 1822 that the young American Thomas Coolidge had asked Thorvaldsen to make him a copy of this bust, he declared that he was 'more flattered by this young enthusiasm of a solitary trans-atlantic traveller than if they had decreed me a Statue in the Paris Pantheon'.[134] Coolidge's request set Byron pondering about the whole question of what busts – and indeed portraits in general – were *for*. 'I would not pay the price of a Thorwaldsen [sic] bust for any human head & shoulders – except Napoleon's – or my children's … or my Sister's,' he continued. 'A *picture* is a different matter – every body

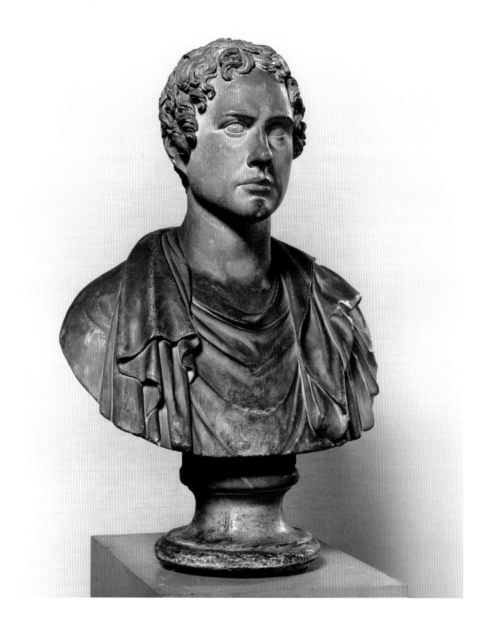

Fig. 63 The plaster version of Thorvaldsen's bust portrayed Byron draped in a classical toga. 'I would not pay the price of a Thorwaldsen [sic] bust for any human head & shoulders,' Byron wrote, 'except Napoleon's – or my children's … or my Sister's.'

sits for their picture – but a bust looks like putting up pretensions to permanency – and smacks something of a hankering for *public* fame rather than private remembrance'. And he recurred to this idea a few years later when, according to Thomas Medwin, he maintained that the English mania for busts was ridiculous. Portraits, he told Medwin, 'may be burnt or hung in effigy – or rot in attics – but of what use are these busts but to make lime of?'.[135]

The process of creating a bust such as Thorvaldsen's would have begun with the subject providing a number of sittings for the sculptor to make a model in clay (although in this case the clay model appears not to have survived). Like Holmes, Thorvaldsen seems to have found Byron a restless sitter and one who 'put … on a quite different expression from

that usual to him'. 'Will you not sit still You need not assume that look,' Thorvaldsen told him. 'That is my expression,' Byron is said to have replied.[136] From the clay model a mould would have been made and then a plaster bust would be cast from this (fig. 63), which the sculptor and his workshop could copy to produce a number of marble busts as they were commissioned, with differing socles or plinths, and with or without shoulders. The 'first copy' of Thorvaldsen's bust in marble, commissioned by Hobhouse, eventually arrived in London in August 1821. It was bequeathed by Hobhouse to his daughter in 1869 and she later gave it to the Royal Collection. There are several other Byron busts in existence that were made by Thorvaldsen and/or his workshop, including the one in the John Murray Collection in London (fig. 61), another in the Scottish National Portrait Gallery, Edinburgh, commissioned by Byron's friend Douglas Kinnaird in Italy in 1817, and a third in the Thorvaldsens Museum, which was brought to Copenhagen from the studio in Rome.[137] Yet another was given by the sculptor to his shoemaker, who left it to the Biblioteca Ambrosiana in Milan.[138]

Thorvaldsen's other great, and much later, Byronic creation was the memorial statue now at Trinity College, Cambridge (figs 64 and 65), but originally intended for Westminster Abbey or St Paul's Cathedral in London. After Byron's death in 1824 an application was made to the Dean of the Abbey, Dr John Ireland, for Byron's body to be interred there, but permission was refused, leading Thomas Babington Macaulay to observe that 'we know no spectacle so ridiculous as the British public in one of its periodical fits of morality'.[139] Five years later a committee was formed to raise funds to create a memorial for Byron and, after the refusal of the sculptor Sir Francis Chantrey to undertake the work, Hobhouse turned again to Thorvaldsen. For a fee of £1,000, between 1830 and 1834 the Danish sculptor generously created a very fine, fully life-size, seated marble statue, and also contributed at his own expense a sculpted relief panel to go on the base, portraying 'The Genius of Poetry'.[140] Given Byron's earlier dislike of being shown with the attributes of a poet, he might have objected to the pose, which shows him sitting in contemplation with a book and pencil in hand, but overall the portrayal, although idealised, appears to be a lifelike one. Augusta commented that she had 'seen nothing so satisfactory as to resemblance since I saw the original', although she also said she was not happy with the body as a whole nor with the representation of Byron's distinctive earlobes.[141]

Thorvaldsen had in fact received a detailed description from Hobhouse of Byron's physique, to assist him in turning his 1816 bust

into a full-length statue. 'I don't know whether it will be necessary to advise you that Byron's right foot was a little misshapen,' Hobhouse wrote. 'Otherwise his proportions were handsome and broad, especially the chest and the shoulders, as no doubt you would have noticed.'[142] Oddly, while Thorvaldsen took account of some of Hobhouse's comments, by showing Byron with muscular shoulders and chest, he completely ignored the point about the deformity of the right foot, giving it, indeed, a rather noticeable perfection and prominence in the finished statue.

The statue's location in the Wren Library at Trinity sites it at the end of an 'avenue' of busts portraying ancient and modern authors and the College's most distinguished alumni, including Isaac Newton and Francis Bacon. Although in the 1820s Hobhouse had been angry and disappointed not to be able to honour his friend with a memorial in Westminster Abbey, when he saw Thorvaldsen's work in situ in Cambridge in 1847 he expressed his satisfaction, calling it 'a beautiful work of art ... in an admirable position'. 'Little did [Byron] or I think, when we used to idle about the college,' he recorded in his diary (and,

Figs 64a and 64b (above) and 65 (opposite) Thorvaldsen's other great Byronic creation was the memorial statue in the Wren Library at Trinity College, Cambridge (1830–34). It was originally intended for Westminster Abbey but the Dean refused permission for Byron to be buried there or a place for the statue. Thorvaldsen's work includes a fallen column, the owl of Minerva and a skull, together with a relief plaque of 'The Genius of Poetry' on the pedestal.

Fig. 66 Westminster Abbey
continued to refuse to
commemorate Byron in Poets'
Corner in 1924, the centenary
year of his death. '[Y]ou've
saved me from the company
of that damned old noodle, Mr
Wordsworth,' Max Beerbohm
imagines a grateful Byron saying
to the Dean. Only in 1969 did the
Abbey finally rescind its refusal
to memorialise Byron.

he might have added, when Byron brought a tame bear there as a pet, as
a protest against the prohibition for undergraduates to keep dogs) 'that
he would have a statue, and the only statue, in that splendid building.'[143]

In 1924, in the centenary year of Byron's death, Max Beerbohm
satirised the continuing refusal of Westminster Abbey to allow a
memorial to Byron alongside those of his fellow Romantic poets in
Poets' Corner (fig. 66). 'Mr Dean,' a portly Byron is imagined saying to
the 1924 incumbent, Herbert Edward Ryle, 'you're a man of sense and
pluck: you've defied all England, just as *I* did, and you've saved me from
the company of that damned old noodle, Mr Wordsworth.'[144] Only in
1969 did the Abbey finally rescind its refusal to memorialise Byron, and
he is now commemorated in a simple white marble stone in the floor,
adjoining those of Dylan Thomas, Lewis Carroll and D.H. Lawrence.

Fig. 67 George Henry Harlow's drawing of Byron in Venice, dated 6 August 1818, hints, through the flowing, unkempt hair and the obliqueness of the glance, at the wildness of Byron's sexual life at this point.

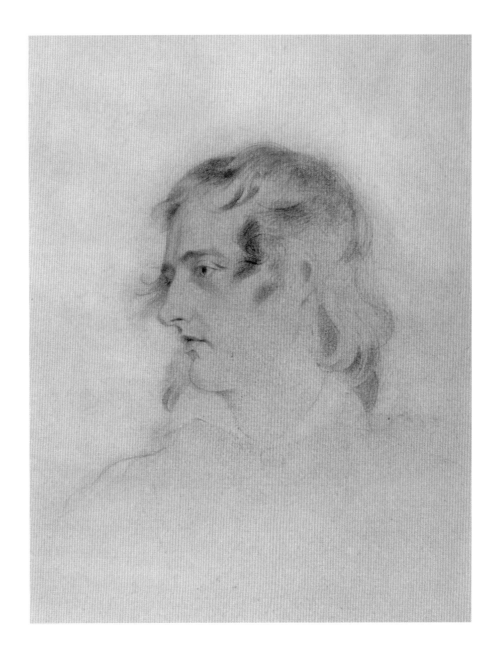

Back in early 1817, Byron was settling into quarters in the Frezzeria, Venice, with a mistress, Marianna Segati, the young wife of a complaisant 'Merchant of Venice'. From August 1817 Marianna was in competition for Byron's favour with the ferocious but loyal Margarita Cogni, 'La Fornarina' or baker's wife – 'tall & energetic as a Pythoness' according to Byron's description – who kept house for him when he moved to the Palazzo Mocenigo on the Grand Canal in 1818.[145] Despite her formidable reputation, Margarita appears demure and doe-eyed in the drawing of her done for Byron by George Henry Harlow in 1818, while the Harlow drawing of Byron himself dated 6 August 1818 (fig. 67) only hints, through the flowing, unkempt hair, and the obliqueness of the glance, at the wildness of Byron's own sexual life at this point. A later, imaginary, representation by John Scarlett Davies (fig. 68)

shows Byron reclining in the main salon of the palazzo, chin on hand, in a pose that may have been based on Westall's portrait and illustrations (see pages 46 and 53).

Given Margarita Cogni's fierce competition with Byron's other lovers, however, and the arrival of Byron's and Claire Clairmont's one-year-old daughter Allegra in April 1818, life at the Palazzo Mocenigo is unlikely to have been quietly contemplative, or even as simply fatherly as portrayed in Westall's imaginary portrait of Byron with his young daughter (fig. 69). Allegra lived and travelled with Byron for much of the next three years, but in March 1821, much against her mother's wishes, she was sent to be educated at a convent school at Bagnacavallo (some twelve miles from Ravenna, where Byron was now living). Byron justified this move on the grounds that an uprising against the Austrians was expected, and his home had become a storage depot for arms and explosives; that a convent education would best fit Allegra to find a suitable Italian, Catholic, husband and that she was 'above the control of the servants'.[146] But it proved a disastrous choice, and in 1822

Fig. 68 This imaginary representation from the 1840s by John Scarlett Davies shows Byron reclining in the main salon of the Palazzo Mocenigo on the Grand Canal in Venice, chin on hand as in Westall's 1813 portrait (fig. 31).

Fig. 69 Westall in London
imagined Byron in Venice
(dressed like Childe Harold) with
his younger daughter Allegra,
born in 1817 after Byron's
short affair with Mary Shelley's
step-sister Claire Clairmont.
Allegra died of fever in 1822 at a
convent school in Bagnacavallo,
near Ravenna.

Allegra died of fever in the convent at the age of five. Byron sent her body to be interred in Harrow Church, which he had frequented as a schoolboy; even there his memorial to her was not welcome, and she was buried in an unmarked grave.

Not only the sexual wildness but also his extensive poetic activities were, however, completely absent from the portraits of himself that Byron was commissioning at this time – which were also very different from the grand, classical Thorvaldsen bust. They consisted of a series of miniatures by the Venetian artist Girolamo Prepiani, who may have been born as early as the 1750s, and lived until after 1835. Very little is known about Prepiani, but he also executed portraits of the opera singer Carolina Cortesi and of Conte Giambattista Orazio Porto and – notably – of Prince Eugène de Beauharnais, Napoleon's Viceroy in Italy. This appears to have been one of the reasons that Byron chose to be portrayed by him; he told Augusta that Prepiani 'is reckoned very good – he made some fine ones of the Viceroy Eugene'.[147] As with Byron's earlier commissions of miniature portraits, Prepiani's were intended

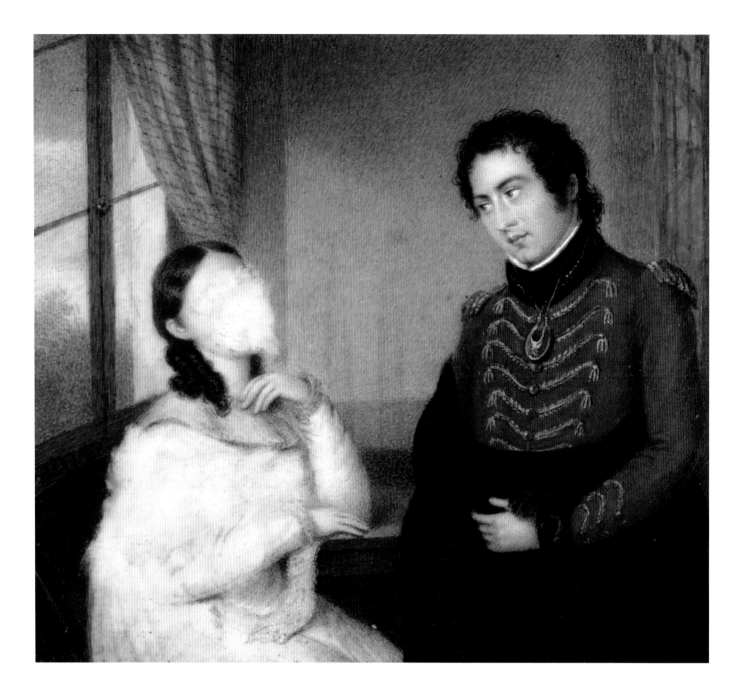

to be given to those to whom Byron was close in feeling but perhaps separated in distance, in particular to Augusta and later to Teresa, Contessa Guiccioli, who was to become his mistress in 1819.

At least five Byron miniatures attributed to Prepiani exist today, including one which is a joint portrait with Teresa, in which she appears to have scratched out the representation of her own face (fig. 70) (probably because she did not like the way it was painted, not because she was afraid of 'going public' about her relationship with Byron). This and two other Prepiani miniatures (figs 71 and 72) are now in the Biblioteca Classense in Ravenna where they are part of the collection left by Teresa on her death in 1873 to her great-nephew, Conte Carlo

Fig. 70 **Byron with his mistress Teresa, Contessa Guiccioli, around 1819, by Venetian artist Girolamo Prepiani. Teresa scratched out the painting of her own face.**

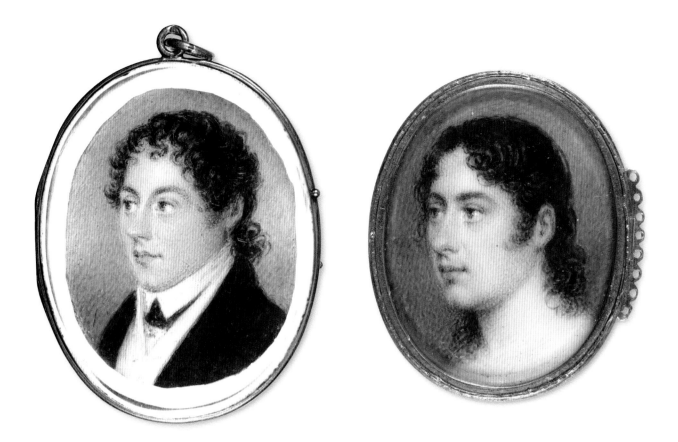

Figs 71 and 72 **Miniatures of Byron in around 1817 and 1819 by Girolamo Prepiani. Teresa described figure 72 (right) as 'the most striking likeness I ever saw' of Byron, although she added that there was 'a total want of the expression which formed one of the peculiar beauties of Lord Byron's countenance'.**

Gamba Ghiselli, and given to the library in 1950. Two others are at Newstead Abbey (figs 73 and 74). The quality of the work varies greatly from one to another of these paintings; fig. 73 is one of the very best of the Byron portraits taken from life, with fine brushstrokes and subtle colouring, and a noted three-dimensionality. It is in oil on ivory, whereas the others are in watercolour. This small picture (just over six by five centimetres) conveys a real sense of energy, personality and directness, not only because Byron is shown looking straight at the viewer but also perhaps because it is the only close-up depiction where Byron is facing right, so that the supposedly 'weaker' side of his face, with its smaller right eye, is evident. It was perhaps this portrait that Byron was referring to when he wrote to Augusta that 'I have been sitting for *two* miniatures for *you* – one the view of the face – which you like – & the other different – but *both* in my *usual* dress.'[148] No attempt seems to have been made by the artist to flatter or romanticise his features. Although the hair has the fashionable style of the time, combed forward around the face, and tamed by applying hair-oil (Byron refers to 'thine "incomparable Oil", Macassar' in *Don Juan)*, the features nevertheless look highly individual and rather self-conscious: one can believe that this is a man who bites his nails, as Byron did.[149] Figure 71, by contrast, has much coarser brushstrokes and appears almost a caricature, while figure 74 is somewhat more detailed, but lacks the

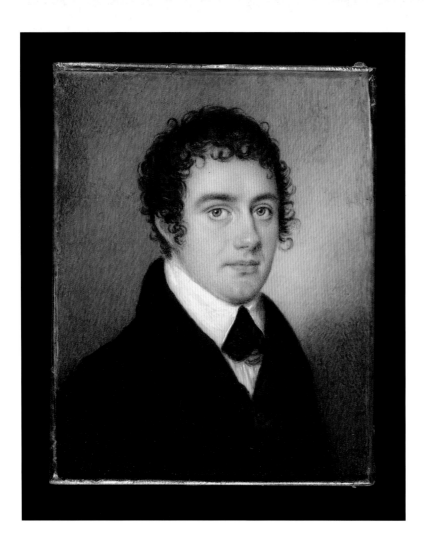

Fig. 73 (left) **This very fine miniature by Girolamo Prepiani, painted around 1817, is the only close-up depiction from life where Byron is facing left, showing his smaller right eye and what his family identified as the weaker side of his face. His curly hair is in the fashionable style of the time, combed forward around the face and tamed by applying hair-oil.**

Fig. 74 (opposite) **Miniature by Prepiani, around 1817. The two miniatures of Byron in scarlet military costume (this and figure 70, page 88) actually show two different styles. 'Regimentals are the best travelling dress,' Byron advised.**

directness and sense of personality of figure 73. It seems likely that Prepiani had a studio, with assistants who would have copied or contributed to his work with more or less skill and finesse.

The two miniatures of Byron in scarlet military costume actually show two different uniforms, one of which (perhaps the one in figure 74, which looks slightly earlier in style) he had worn in the presence of Ali Pasha, and of the Sultan in Constantinople in 1809–10. The other was newly commissioned by him in 1813, with fifty-eight rows of gold-twist buttons, twenty-five yards of gold lacing and a pair of 'very rich gold epaulettes'.[150] Both of these suits are extremely expensive, but neither were 'real' uniforms – Byron was never a member of the armed forces or received an officer's commission. Instead they constitute the kind of military-style costume that British peers and gentlemen were expected to wear on ceremonial occasions, especially abroad and during the Napoleonic Wars. 'Regimentals are the best travelling dress,' Byron advised in a note to *Childe Harold*.[151] In Italy, apart from the sittings for these portraits, Byron actually seems to have worn his 'regimentals' very little, although he did agree to do so in July 1819 in Ravenna,

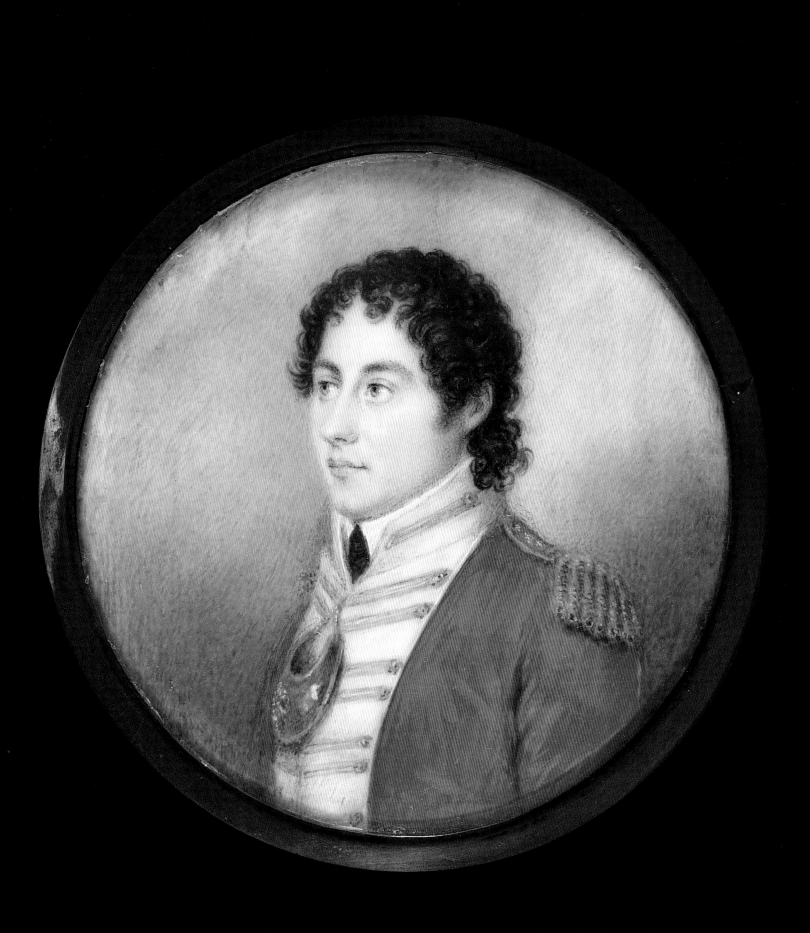

when he paid his respects to the Cardinal Legate Malvasia. 'A noonday presentation in the month of an Italian July – in our English scarlet uniform – would be an operation of active service not necessary in time of Peace, to anyone but a Field Marshall,' he complained.[152]

The smallest of the Prepiani miniatures (fig. 72) is the one that Teresa preferred over all the others, describing it to Lady Blessington as '*the most striking likeness* I ever saw of him', although she went on to denounce Prepiani as 'a man without a spark of genius, but only considered as a good painter for likeness'.[153] 'As pictures they are very bad,' she added, 'and with a total want of the expression which formed

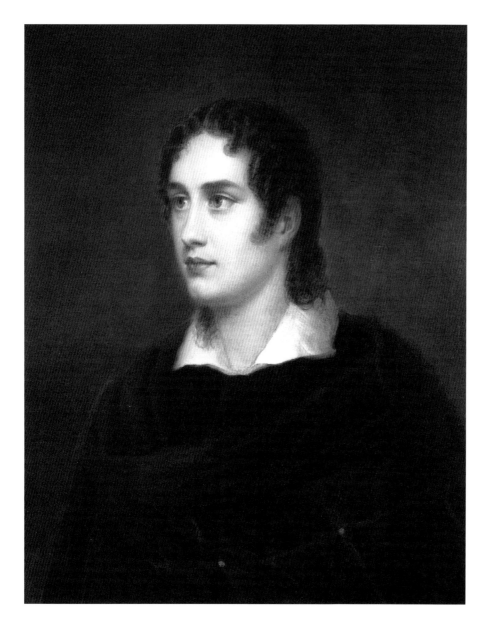

Fig. 75 This life-size posthumous portrait was commissioned by Teresa in 1860 from Giuseppe Fagnani, to be modelled on Prepiani's small miniature of 1819 (figure 72, page 89) but altered according to Teresa's directions. Byron sports a Gordon family plaid and an angelic expression.

one of the peculiar beauties of Lord Byron's countenance. But after all they are like ... and for that account I prize them very much.'

As with the Holmes and Phillips portraits, it is difficult to date all these miniatures precisely, or to relate them securely to references in Byron's and other people's letters, although the varying length of Byron's hair may give an indication of the sequence in which they were painted. Judging from Harlow's drawing of Byron, by August 1818 his hair was already growing long, especially at the back, and Teresa later specified that figure 72, which shows even longer hair over the shoulders, had been executed in 1819. By December 1819, however, the long hair had been cut off, and Byron had sent it to Augusta, while Teresa wrote much later that Byron 'wore his hair long, as was then the fashion in Venice' but 'later at Ravenna he wore it short behind'.[154] Byron moved from Venice to Ravenna in late 1819, and by early in 1820 he was installed on one floor of the Palazzo Guiccioli, with Teresa and her husband living on another. The long hair shown in figure 72 was replicated in the full-size posthumous portrait (fig. 75) which Teresa commissioned in 1860, to be modelled by Giuseppe Fagnani on the miniature of 1819, but altered according to Teresa's directions, as she 'sat by Fagnani and watched every stroke of the pencil'.[155] Here Byron sports a Gordon family plaid and a positively angelic expression, no doubt reflecting Teresa's conviction, gained from 'séance and automatic writing', that Byron was now in heaven, and very good friends with her second husband, the Marquis de Boissy.[156]

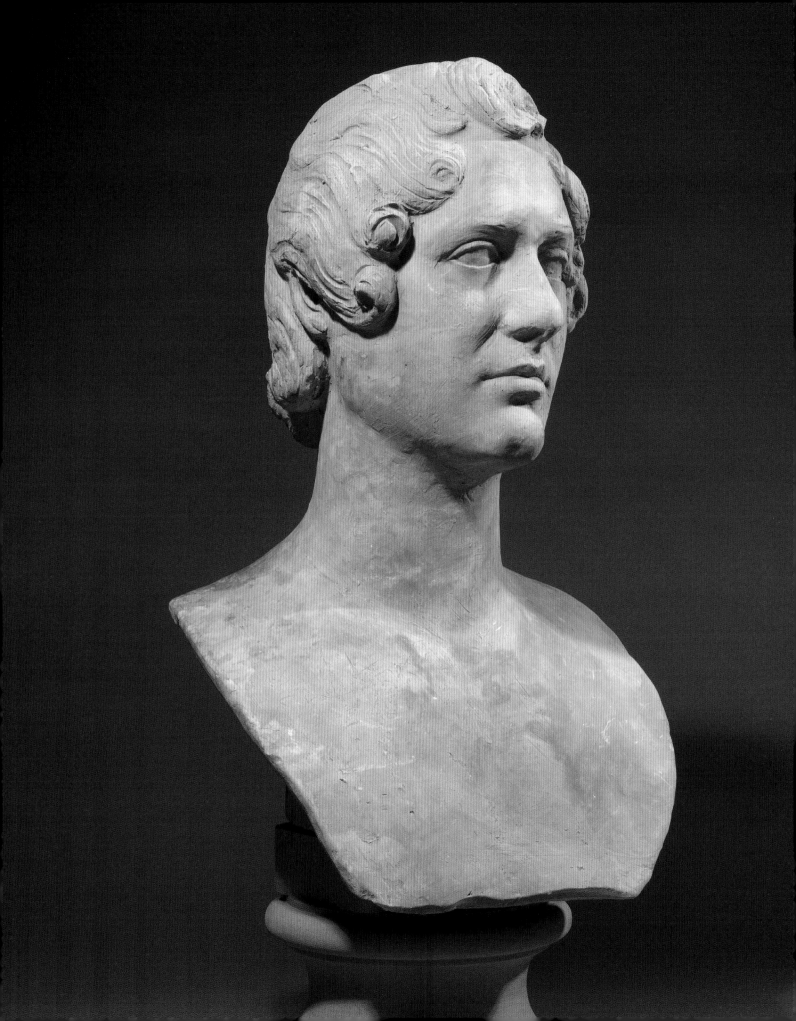

From Italy to Greece

1822–4 (and 1938)

'Who would write, who had any thing better to do?'[157]

BYRON'S ITALIAN PERIOD had been the most productive of his life as a poet and dramatist, and his fame grew worldwide in these years, beginning with the publication of Canto 3 of *Childe Harold's Pilgrimage* in late 1816. His first drama, *Manfred*, was written in 1816–17 and published in 1817, and his first (humorous) *ottava rima* poem, *Beppo*, and Canto 4 of *Childe Harold* appeared in 1818. *Mazeppa* and the first two cantos of *Don Juan* were published in 1819. Five more dramas – *Marino Faliero*, *Sardanapalus*, *The Two Foscari*, *Cain* and *Heaven and Earth* – followed in 1820–21, together with the brilliant comic satire of *The Vision of Judgment*. Cantos 3 to 5 of *Don Juan* were published in 1821; the dramas *Werner* and *The Deformed Transformed* in 1822, and *The Age of Bronze*, *The Island* and Cantos 6 to 14 of *Don Juan* in 1823, with Cantos 15 and 16 following in 1824.

This growing celebrity outside Britain led two artists – one Italian and the other American – to make approaches to Byron in 1821–2, one seeking to portray him in sculpture and the other in painting. Despite his resolve to 'sit no more for such vanities', Byron was particularly flattered by the approach of the Florentine sculptor Lorenzo Bartolini.[158] Born in 1777, Bartolini succeeded Canova as Italy's most distinguished sculptor after the latter's death in 1822, but his work differed markedly from Canova's in being inspired more by Renaissance Italian work than antique classical models, and by including naturalistic and sentimental elements. An attraction for Byron was that Bartolini had trained in Paris in the studio of Jacques-Louis David and had become Napoleon's

Fig. 76 The Florentine sculptor Lorenzo Bartolini asked Byron to sit for him in 1822 and Byron agreed on condition that he would also sculpt a bust of Teresa. This fine *terracruda* (unfired clay) bust, which was unknown publicly until it was auctioned from a private collection in Milan in 2019, was created by Bartolini face-to-face with Byron during the course of many sittings. It shows Byron with his head slightly turned, as if in conversation, and appears much more animated and naturalistic than the marble versions of the bust.

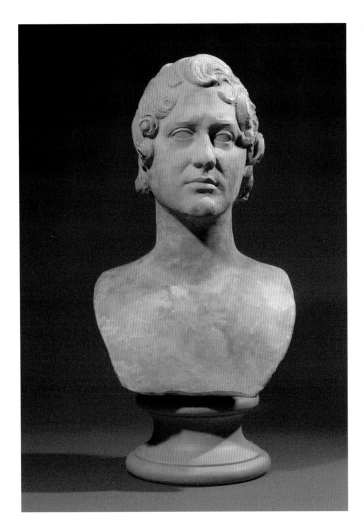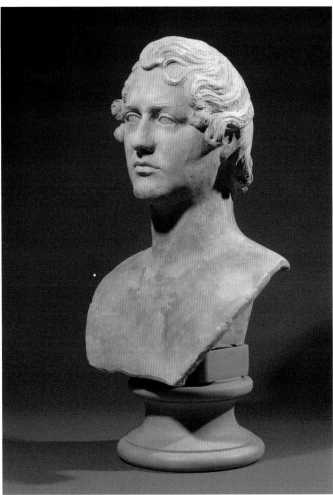

semi-official sculptor, completing many busts of the Emperor and his family from 1802 onwards. And, as an additional incentive, Bartolini agreed to sculpt a bust of Teresa as well as one of the poet himself.[159]

In July 1820 Teresa had received Papal permission to separate from her husband, but the following year she and her father and brother, followed by Byron, were driven out of Ravenna by the authorities because of their active support for the 'Carbonari' and other groups plotting to oust the Austrians from Italy. By November Byron had joined Shelley in Pisa and was living in the Casa Lanfranchi, socialising with the circle of friends that Shelley had gathered around him. In particular, Shelley's cousin Thomas Medwin spent 'day after day' watching Bartolini modelling his clay bust (figs 76–78) and observing Byron's features. 'I saw a man of about five feet eight, apparently forty years of age,' Medwin wrote.

> His face was fine, and the lower part symmetrically moulded; for the lips and chin had that curved and definite outline that distinguishes Grecian beauty. His forehead was high, and his temples broad; and he had a

Fig. 79 The marble version of the bust in the National Portrait Gallery, London, is the only one signed by Bartolini and may be the original marble made by the artist himself. Another marble version with classically draped shoulders, and Bartolini's bust of Teresa, are now in the National Library of South Africa in Cape Town.

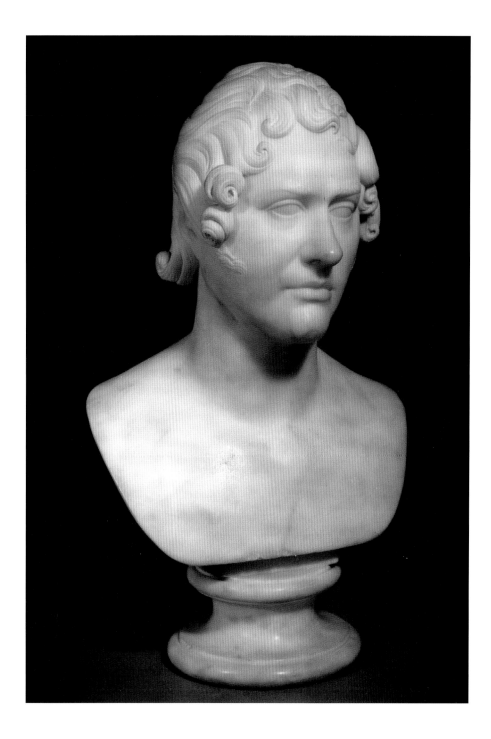

paleness in his complexion, almost to wanness. His hair thin and fine, had almost become grey, and waved in natural and graceful curves over his head, that was assimilating itself fast to the 'bald first Caesar's'. ... It might, perhaps, be said that his eyes were placed too near his nose, and that one was rather smaller than the other; they were of a greyish brown, but of a particular clearness, and when animated possessed a fire which seemed to look through and penetrate the thoughts of others, while they marked the inspirations of his own. ... On the whole his figure was manly, and his countenance handsome and prepossessing, and very expressive.[160]

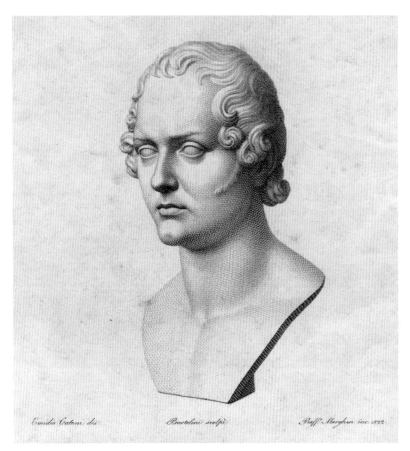

Opinions vary greatly as to the quality or likeness of Bartolini's bust of Byron. Medwin recorded that 'the sculptor destroyed his ébauches [sketches] more than once before he could please himself', describing the final product as 'an admirable likeness, at least ... in the clay model', while commenting that 'I have not seen it since it was copied in marble.'[161] Shelley's friend Edward Ellerker Williams, who also saw the sculptor at work during these sittings, called the clay model 'a fine bust'.[162] Teresa apparently later described it as 'the best likeness of Byron she knew of'.[163]

The sculpture's reputation did, however, suffer greatly because of the way it was portrayed in an engraving by Raphael Morghen in 1822 (fig. 80). Byron (who had not yet seen the marble version) was horrified by the print, maintaining that it 'exactly resembles a superannuated Jesuit ... my mind misgives me that it is hideously like. If it is – I cannot be long for this world – for it overlooks seventy.'[164] Hobhouse, when he saw the bust in Bartolini's studio in September 1822, thought it was 'much better than Morghen's engraving has made it'.[165] But Teresa, who had intervened in the sittings by trying to get Byron to tuck his hair behind his ears, described herself in old age as having been 'pétrifiée' and 'affligée' ('distressed') by the work when Bartolini showed it to her, although she commented that there were fewer problems in the 'moule' ('mould' or plaster cast) than in the marble version.[166]

Fig. 80 (above left) **The reputation of Bartolini's sculpture suffered greatly because of the way it was portrayed in this engraving by Raphael Morghen in 1822. Byron (who had not yet seen the marble version) was horrified by the print, maintaining that it 'exactly resembles a superannuated Jesuit ... my mind misgives me that it is hideously like. If it is – I cannot be long for this world – for it overlooks seventy.'**

Fig. 81 (above right) **This plaster cast (or *gesso*) of the bust was acquired by the Italian state in 1883. It would have been cast from a mould made from an original clay model and shows the holes in the plaster where the mould had been broken off. It is slightly different in detail from the surviving terracruda bust, showing the face as slimmer and more oval than round. At this stage Byron was particularly sensitive about his increasing weight.**

Several marble copies, made by Bartolini and his studio and others, are still extant. The one in the National Portrait Gallery, London (fig. 79), is the only one signed by Bartolini and may be the 'original' marble version made by the artist himself.[167] The version with draped shoulders that Byron eventually received from Bartolini was left in the Casa Saluzzo at Albaro, near Genoa, where he lived before he sailed for Greece in July 1823. After Byron's death, it and Bartolini's bust of Teresa were taken by Byron's banker Charles Barry when he travelled to South Africa, and they are now in the National Library of South Africa in Cape Town. And, in 2019, a very fine previously unpublished *terracruda* (raw, unfired clay) bust of Byron by Bartolini became publicly available for auction from a private collection in Milan (figs 76–78).

Preserved in excellent condition, this bust appears to have been sculpted by Bartolini face-to-face with Byron in Pisa in early 1822, and can claim to be one of the most important life studies of the poet to survive. It shows Byron with his head slightly turned, as if in conversation, and it appears much more animated and naturalistic than the marble versions of the bust. There is also a plaster cast (or *gesso*) of the bust which came from Bartolini's plaster workshop; it was acquired by the Italian state in 1883 and deposited in the Galleria d'Arte Moderna in the Pitti Palace, Florence (fig. 81). This would have been cast from a mould made from an original clay model, and shows the holes in the plaster where the mould was broken off. It is slightly different in detail from the surviving *terracruda* bust, showing the face as slimmer and more oval than round. Byron at this stage was particularly sensitive about his weight: Leigh Hunt, on meeting him again at this time after six years, claimed that 'I hardly knew him, he was grown so fat,' while Hobhouse noted that 'he is much changed – his face fatter, and the expression of it injured'.[168] It was probably for this reason that Bartolini made the alterations that Medwin and Teresa recorded, trying to produce a version that would please her and Byron, as well as himself. In fact, as we can now see from comparison with the *terracruda* bust, he also continued to refine and alter the composition for the finished marble, by adding whiskers to Byron's cheeks and slimming down the jaw.[169]

Byron was to lose the weight he had gained, suddenly and dramatically, later the same year, but before that two further records of his somewhat tubby appearance were made. One of these was a silhouette cut out of paper (fig. 82) by Marianne Hunt who, with Leigh Hunt and their family of six unruly children, lodged with Byron between 1822 and 1823. The other (fig. 83) was a large oil portrait by the young American artist William Edward West that was intended

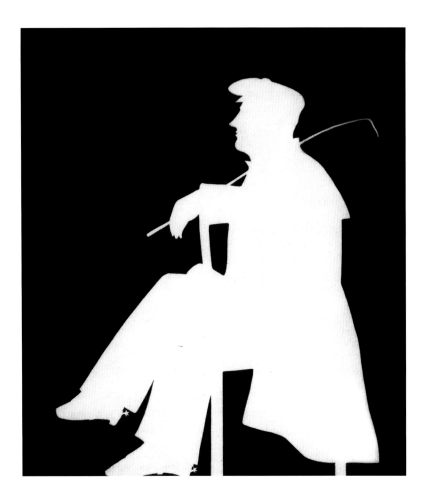

Fig. 82 (left) Marianne Hunt's silhouette shows Byron in Pisa or Genoa in riding dress, with a peaked cap and a frock coat with a short cape, loose trousers and boots with spurs, and carrying a riding crop. Mary Shelley described it as 'cut from memory' by Mrs Hunt with scissors, but added that 'the likeness is striking'.

Fig. 83 (opposite) This large oil portrait by the young American artist William Edward West shows Byron as distinctly portly in early 1822. It was intended for the Academy of Fine Arts in New York and is now in the Scottish National Portrait Gallery in Edinburgh.

for the Academy of Fine Arts in New York and is now in the Scottish National Portrait Gallery in Edinburgh.

Marianne Hunt's silhouette shows Byron seated in his riding dress, in Pisa or Genoa, wearing a peaked cap and frock coat (said to have been 'mazarin' or marine blue in colour), with a short cape, loose trousers and boots with spurs, and carrying a riding crop.[170] Mary Shelley described it as 'cut from memory' by Mrs Hunt with scissors, but added that 'the likeness is striking'. 'I fancy the very tones he used to utter when he wore that fastidious upturned expression of countenance', she added.[171]

The twenty-one-year-old West was introduced to Byron after Byron had visited the American frigates *Constitution* and *Ontario*, anchored in Leghorn Roads in May 1822. West's sittings with Byron began in June at the Villa Dupuy at Montenero where Byron, Teresa and her family were staying for the summer. It was continued briefly in Pisa, and again a portrait of Teresa was commissioned as well as the one of Byron. Like Holmes and Thorvaldsen, West found Byron a bad sitter. 'He talked all the time,' West reported. '[W]hen he was silent, he was a worse sitter than before; for he assumed a countenance that did not belong to him as though he were thinking of a frontispiece for "Childe Harold".'[172]

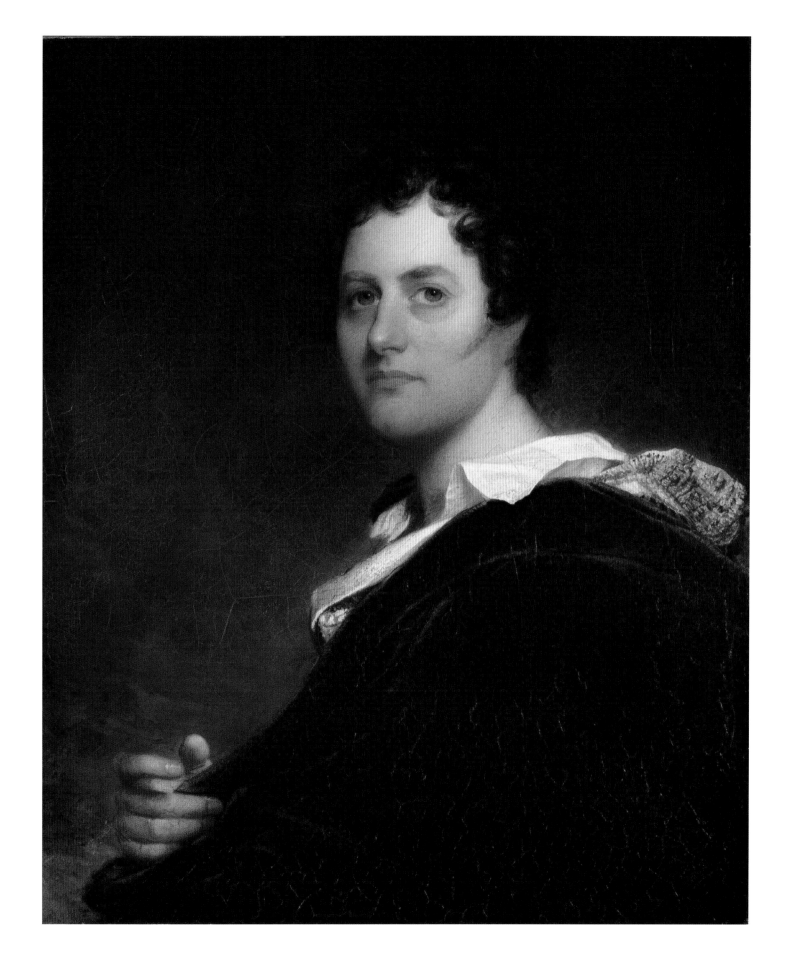

101 FROM ITALY TO GREECE, 1822–4 (AND 1938)

Fig. 84 **Byron fell seriously ill after being badly sunburnt when he swam out to sea in the scorching heat after attending Shelley's cremation on the beach at Viareggio in August 1822. Teresa carefully collected and saved the flakes of skin that peeled off his back and shoulders.**

Despite Byron's chattiness and fidgetiness, West presented him in the painting as static almost to the point of somnolence, and the open-necked shirt and dark-cloaked shoulders, with hints of a brighter garment underneath, making obvious reference to the Phillips 'Cloak' portrait of 1813–14, mean that there is little that is original here.

Writing to Lady Hardy in June 1823, Byron acknowledged that 'Mr West is not in fault ... for I was then – what it appears – but since that time ... I am very much reduced.'[173] The reduction in weight occurred when he fell seriously ill after being badly sunburnt when he swam out to sea in the scorching heat after attending Shelley's cremation. One of the more bizarre mementoes of Byron from this time is a collection of the flakes of skin that peeled off his back and shoulders, which Teresa carefully saved and left to her nephew (fig. 84).[174] More personal and intimate than any portrait, these and other physical remnants of Byron such as locks of his hair (see figure 99) carry the frisson of religious relics and remind us of Byron's corporeality more strongly than any artwork could do.

Shelley and his companions Edward Williams and Charles Vivian had been drowned in Shelley's sailing boat the *Don Juan* on their way back from Leghorn to Lerici on 8 July 1822. Louis Edward Fournier's imaginary representation of *The Funeral of Shelley* (fig. 85), painted nearly sixty years later in 1889 and now in Liverpool's Walker Art Gallery, is one of the better-known of the many imaginative visual responses to Byron's life and biography which are studied more fully in Chapter Six. Often based on eye-witness accounts, these illustrations in the form of painting, sculpture, film and other media generally reflect the

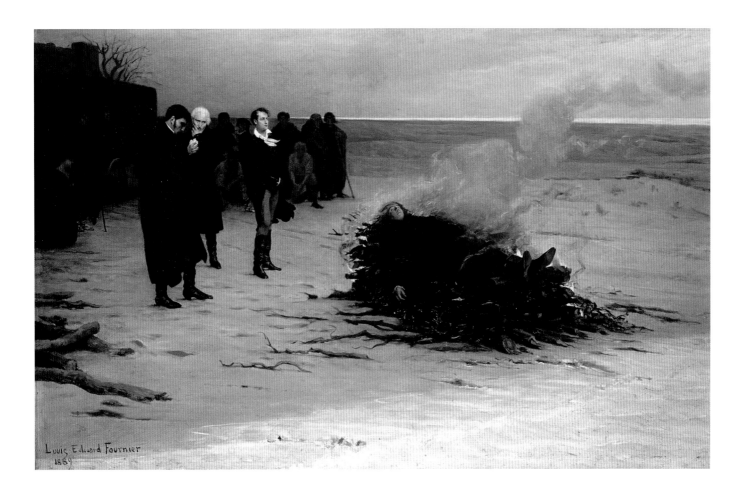

Fig. 85 Louis Fournier's imaginary recreation of *The Funeral of Shelley* was painted nearly sixty years after the event, in 1889. It wrongly sets the scene in a wintery landscape and misrepresents many other details.

artist's own 'spin' on the scene or events portrayed, adding, for instance, a more romantic, poetic or heroic pose or aspect to Byron's activities.

In this case, Fournier deliberately misrepresents the grim scene on the beach at Viareggio on 15 August 1822. He sets the cremation in a wintery, melancholy landscape, as opposed to the baking hot day it actually was; it includes Mary Shelley kneeling in the background (in fact she was not present at all) and shows Leigh Hunt as an elderly man (he was only thirty-seven at the time of Shelley's death). He has Shelley's intact corpse lying stretched on a romantic funeral pyre, when in reality it was 'a shapeless mass of bones and flesh' that could only be identified through the clothes and the copy of Keats's poems in the jacket pocket.[175] The bodies were burnt in furnaces on the beach by order of the Italian authorities on the grounds of hygiene, an event organised by Edward Trelawny (shown front left in this imaginary scene), who was Shelley's friend and then Byron's right-hand man in the preparations for and journey to Greece the following year. According to Trelawny's own rather unreliable memoirs, he staged the cremation as a kind of pagan ceremony, with libations of wine, oil and frankincense poured over the corpses.[176]

In order to escape from the horrors of the scene, Byron left the beach and swam out to his schooner the *Bolivar*, was badly sunburnt

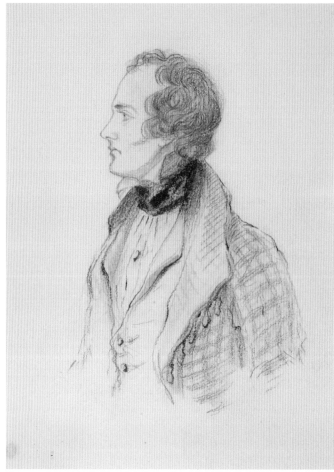

and subsequently very ill for several weeks. The dramatic results of his weight loss are shown in some of the drawings by Count Alfred D'Orsay made in Genoa in April and May 1823. In D'Orsay's full-length sketch (fig. 86) Byron appears distinctly emaciated, and also prematurely aged and stooped for his thirty-three years, leaning on a stick and with his hair receding fast from his forehead. In another of the sketches attributed to D'Orsay (fig. 87), however, Byron looks younger and more lively and upright, wearing a braided tartan jacket. Some of these differences may be due to D'Orsay's limited drawing skills; the quality of the work ascribed to him varies greatly, and there were allegations at the time that he employed a 'ghost' artist who hid behind a screen during sittings and produced more accomplished work than D'Orsay himself was capable of. It is just possible that two other images of Byron were captured in this way, by an artist named 'And.' (probably Andrea) Isola, whose painted miniature and associated small pencil and red chalk drawing (fig. 88) dated 2 June 1823 show Byron wearing the same cap and military-style jacket as in one of D'Orsay's drawings. Annette Peach suggests that the 'J.W. Mackie' who gave the Isola pencil sketch to John Murray may be the same person as the 'Mackie' named

Fig. 86 (above left) **In some of the drawings by Count Alfred D'Orsay made in Genoa in April and May 1823, Byron appears distinctly emaciated, and also prematurely aged and stooped for his thirty-three years, leaning on a stick and with his hair receding fast from his forehead.**

Fig. 87 (above right) **In another of the sketches attributed to D'Orsay, however, Byron looks younger and more lively and upright, wearing a braided tartan jacket. Some of these differences may have been due to D'Orsay's limited drawing skills.**

by James Holmes's biographer Alfred T. Story as having worked for a long time for D'Orsay as a 'ghost' artist.[177]

Another account of Byron's looks at this time is given by the Countess of Blessington, in whose company Count D'Orsay made the journey to Italy and met Byron. '[H]is eyes are grey and full of expression, but one is visibly larger than the other,' Lady Blessington wrote.

> [T]he nose is large and well shaped, but from being a little too *thick* it looks better in profile than in front-face: his mouth is the most remarkable feature in his face, the upper lip of Grecian shortness, and the corners descending; the lips full, and finely cut. In speaking he shows his teeth very much and they are white and even; but I observed that even in his smile – and he smiles frequently – there is something of a scornful expression in his mouth that is evidently natural, and not, as many suppose, affected.

'He is extremely thin,' she added,

> indeed so much so, that his figure has almost a boyish air; his face is peculiarly pale but not the paleness of ill-health, as its character is that of fairness, the fairness of a dark-haired person – and his hair (which is getting rapidly grey) is of a very dark brown and curls naturally: he uses a good deal of oil on it which makes it look still darker. ... His whole appearance is remarkably gentlemanlike, and he owes nothing of this to his toilette, as his coat appears to have been many years made, and is much too large – and all his garments convey the idea of having been purchased ready-made, so ill do they fit him.[178]

When Lady Blessington went riding with Byron she recorded further details of his riding costume that were to be memorably caricatured many years later by Gustave Moreau (fig. 89): 'a dark blue velvet cap with a shade, and a very rich gold band and large gold tassel at the crown, nankeen gaiters, and a pair of blue spectacles': an outfit which she considered 'any thing but becoming'.[179]

Byron was always inclined to dismiss the possibility that he knew what he really looked like – preferring to quote others (Augusta, Lady Byron, Teresa, Hobhouse, his cousin) as better able to tell than he could whether a portrait was 'like' him or not. 'One can never tell the truth of one's own features,' he claimed; 'for my own part I have no opinion at all', and 'of my own [bust] I can hardly speak, except that it is thought very like what I *now* am'.[180] '[I]f I know myself, I should say that I have

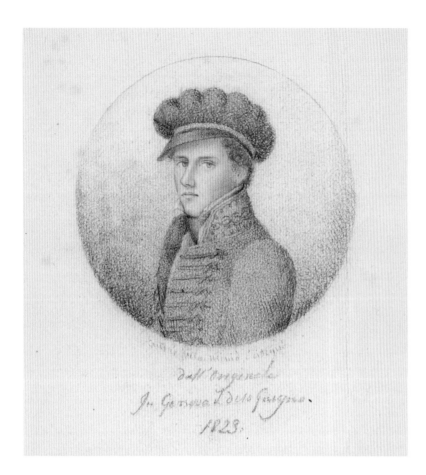

no character at all ... I am so changeable, being everything by turns and nothing long ... that it would be difficult to describe me,' he told Lady Blessington.[181] Like Keats and Shelley, Byron was a self-declared 'chameleon poet', fascinated by the concept of *mobilité*, in himself, as much as in his protagonists such as Lady Adeline.[182] His epic *Don Juan* is, amongst other things, a deliberate exercise in inconsistency and self-contradiction, in the light of Byron's scepticism (strongly expressed in Canto 15, which was completed in 1823) about 'systems' of all kinds, be they religious, philosophical, political, aesthetic or critical.

> But if a writer should be quite consistent,
> How could he possibly show of things existent?
> If people contradict themselves, can I
> Help contradicting them and every body,
> Even my veracious self? – But that's a lie;
> I never did so, never will – how should I?
> He who doubts all things nothing can deny.
> *(Don Juan*, Canto 15, lines 695–701[183]

The portraits by D'Orsay and Isola are the final ones in which we can realistically search for this 'consistency' (or lack of it), since they are the

Fig. 89 **Some of the same details are used in this caricature of around 1880 by Gustave Moreau, which is also based on an account of a riding expedition Byron made in 1823 with Lady Blessington. He wore, she said, 'a dark blue velvet cap with a shade, and a very rich gold band and large gold tassel at the crown, nankeen gaiters, and a pair of blue spectacles': an outfit which she considered 'any thing but becoming'.**

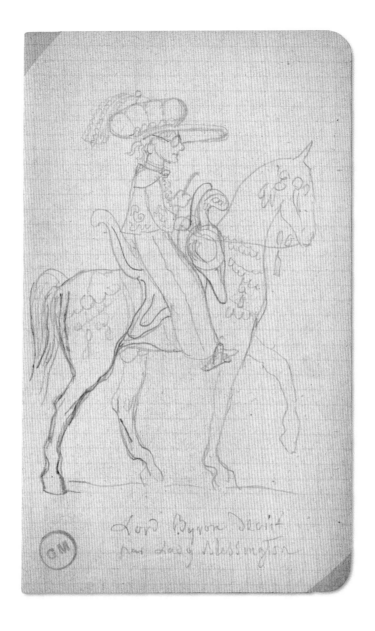

last that can be strictly described as 'taken from life' – although aspects of Byron's activities in Missolonghi and his death there in April 1824 are represented, vividly and apparently accurately, in the illustrations to Major William Parry's book *The Last Days of Lord Byron*. These were drawn by Robert Seymour, based on sketches and descriptions provided by Parry, the 'firemaster' or artillery specialist who was sent out to Greece by the London Greek Committee and became one of Byron's companions during the last few weeks of his life. The engraving of the deathbed scene (fig. 90) shows Parry at Byron's bedside after Byron had been bled from the head by his doctors (almost certainly hastening his death), while his servant, the former gondolier Tita Falcieri, anxiously carries away a plate, bowl and spoon.[184]

Particularly poignant is the illustration of a slightly earlier scene, showing Byron playing with his huge Newfoundland dog among the

Souliot soldiers in the house in Missolonghi where he was to die on 19 April (fig. 91). '[H]e was almost always accompanied by his favourite dog Lyon, who was perhaps his dearest and most affectionate friend,' Parry wrote.

> With Lyon Lord Byron was accustomed, not only to associate, but to commune very much, and very often. His most usual phrase was, 'Lyon, you are no rogue, Lyon;' or 'Lyon,' his Lordship would say, 'thou art an honest fellow, Lyon.' The dog's eyes sparkled, and his tail swept the floor, as he sat with his haunches on the ground. 'Thou art more faithful than men, Lyon; I trust thee more.' Lyon sprang up, and barked and bounded round his master, as much as to say, 'You may trust me, I will watch actively on every side.' 'Lyon, I love thee, thou art my faithful dog!' and Lyon jumped up and kissed his master's hand as an acknowledgment of his homage. In this sort of mingled talk and gambol Lord Byron passed a good deal of time ... In conversation and in company he was animated and brilliant; but with Lyon and in stillness he was pleased and perfectly happy.[185]

Byron's body was eviscerated, embalmed and brought back to England on the brig *Florida*, arriving in the Medway at the beginning of July 1824, when Hobhouse had the unhappy task of formally identifying it. It was then transported to London and lay in state for two days at 20 Great George Street, Westminster. In something like a prequel to the funeral of Diana, Princess of Wales, the route was lined with very large, but respectful, crowds as the coffin was taken in a horse-drawn hearse through London and up to Nottinghamshire.[186] On 16 July 1824 the funeral was held at St Mary Magdalene, the Parish Church of Hucknall Torkard, some six miles from Newstead Abbey. Byron's coffin and the urn containing his organs were placed in the Byron family vault in the chancel of the church, Hobhouse commenting that Byron was 'buried like a nobleman – since we could not bury him as a poet' (i.e. in Westminster Abbey).[187] A memorial tablet on the chancel wall was commissioned not long after in the name of Augusta, and several other memorials followed, including the round medallion above Augusta's tablet by John Adams-Acton after George Harlow, dated 1893 (fig. 92).[188] There is also a life-size statue of Byron erected by Hucknall artist Elias Lacey on 30 May 1902 on Hucknall's former Co-op building, and a 'Byron Bingo hall' in the town.[189]

By a strange twist of fate, some 114 years after Byron's death, a small group of privileged observers had the opportunity to compare his

Fig. 90 **Aspects of Byron's activities in Missolonghi, western Greece, and his death there on 19 April 1824, are represented in the illustrations by Robert Seymour to Major William Parry's 1825 book *The Last Days of Lord Byron*. The deathbed scene shows Parry at Byron's bedside, after he had been bled from the head, with Byron's servant, the former gondolier Tita Falcieri.**

painted and sculpted portraits with what amounted to the 'real' Byron, in the flesh. In 1938, the Vicar of Hucknall, Canon Thomas Barber, obtained permission from the Byron family and the Home Office to open the vault in the church, supposedly in order to allay doubts that Byron really was buried there.[190] He and several other men climbed down and found three tiers of coffins in the vault, including those of Byron, his mother and his daughter Ada, Countess of Lovelace, who had died in 1852. Canon Barber then left the church and, while he was away, in the dead of night, the Churchwarden Arnold Houldsworth, the Church Fireman Jim Betteridge, and workman Geoffrey Johnstone opened the coffin with relative ease – and found themselves gazing at a very familiar Lord Byron. 'No decomposition had taken place and the head, torso and limbs were quite solid,' Arnold Houldsworth reported.

Fig. 91 (opposite) **Parry and Seymour also showed Byron playing with his large Newfoundland dog among the Souliot soldiers in Missolonghi. '[H]e was almost always accompanied by his favourite dog Lyon, who was perhaps his dearest and most affectionate friend,' Parry wrote.**

Fig. 92 (right) **This medallion by John Adams-Acton after George Harlow was placed in 1893 on the chancel wall of the Parish Church of Hucknall Torkard, Nottinghamshire, where Byron's coffin had been interred in the family vault in July 1824. In 1938, his coffin was opened and his embalmed face and body were compared with this portrayal.**

'The only parts skeletonised were the forearms, hands, lower shins, ankles and feet. ... The hair on his head, body and limbs was intact, though grey.' 'The sculptured medallion on the Church chancel wall', he added, 'is an excellent representation of Lord Byron as he still appeared in 1938'.[191] And when he was interviewed by the journalist Byron Rogers for the *Sheffield Star* in the mid-1960s, Houldsworth described his encounter with the poet almost as if he had met him in the pub: 'Good-looking man putting on a bit of weight, he'd gone bald.'[192]

Later the Vicar returned, and when he went down into the vault to see the body, he too noted that Byron's 'features and hair [were] easily recognisable from the portraits with which I was so familiar'. 'The serene, almost happy expression on his face made a profound impression on me,' he commented.[193] What the Vicar did not report, although Houldsworth did, with awed admiration, was that Byron's 'sexual organ showed quite abnormal development' – 'built like a pony'.[194] Alas for Byron's posthumous reputation, however, this phenomenon is, as Rogers noted, the all-too-normal effect of injecting embalming fluid into a male corpse.[195] Curiosity satisfied, the small group of interlopers took pictures of the coffins, but decided not to photograph the body, and then left the church in the early hours of the morning.

Imagining Byron

What is the end of Fame? 'tis but to fill
A certain portion of uncertain paper:
Some liken it to climbing up a hill,
Whose summit, like all hills', is lost in vapour;
For this men write, speak, preach, and heroes kill,
And bards burn what they call their 'midnight taper',
To have, when the original is dust,
A name, a wretched picture, and worse bust.
Don Juan, Canto 1, lines 1737–44.[196]

HAD BYRON LIVED another twenty years he might, like some of his contemporaries, have been photographed, and we would now be examining a daguerreotype of an elderly gentleman looking perhaps something like Max Beerbohm's 1911 caricature in his novel *Zuleika Dobson* (fig. 94). 'Byron! – he would be all forgotten today if he had lived to be a florid old gentleman with iron-grey whiskers, writing very long, very able letters to "The Times",' Beerbohm's narrator conjectures. 'Yes, it was lucky to perish leaving much to the imagination and posterity.'[197] Byron's friend and fellow poet Thomas Moore (nine years older than Byron) was caught on camera in 1844 by Henry Fox Talbot, pioneer of the new art, and the Duke of Wellington (twenty years Byron's senior) was photographed in the same year at the age of seventy-five by Antoine Claudet.[198] Life- and death-masks were taken of three of Byron's fellow Romantic poets – William Blake, William Wordsworth and John Keats – and a recent study has used advanced computer graphics to compare Horatio Nelson's wax effigy and life-masks with his other portraits and medallions to examine which most resemble him.[199]

Fig. 93 This collection of twenty-four porcelain smoking-pipes, sporting portraits of Byron with his family, friends and associates, was made in Bavaria in the 1860s. Byron is flanked by his daughter Ada and his wife Lady Byron, with Teresa, Contessa Guiccioli, Madame de Staël, Margarita Cogni, Hobhouse, Scott, Shelley, Thomas Moore, Lady Caroline Lamb and the Maid of Athens also in the party.

But no such images or masks exist for Byron, to enable us to check his painted or sculpted portraits for accuracy, although, as we have seen, a version of 'Byron', in terms of his embalmed body, existed at least until the late 1930s. During his lifetime Byron's family and friends expressed widely differing views about which of his portraits were most like him, while he himself tended to prefer those that flattered him, such as the 1812 miniature by George Sanders (fig. 19) and the 1816 one by James Holmes (fig. 28), which both made him look younger and less complex than he actually was.

The wide range of images in this book may enable readers to form a view of what Byron 'really' looked like, but their diversity also demonstrates the crucial role played by the conception and imagination of the artists who portrayed him, and by society in general, in interpreting him according to current fashions. This is true too of the many visual imaginative and biographical interpretations of Byron, based on his portraits but, like modern fan fiction, imagining him in different situations, scenes and stances. Some of these are loosely based on his life story, and show him with his family, lovers or friends, but some mix a historical Byron with the creatures of his imagination, showing him chatting with the Maid of Athens or embraced by the Spirit of Greece, and this process began during his lifetime and burgeoned after his death. Before he left England, printed caricatures satirically portrayed the scandals surrounding him through comic fictional scenes and confrontations. More romantic portrayals, beginning with Charles Eastlake's fantasy scene of Byron in Greece (fig. 95), and similar ones by William Purser of Byron at the Villa Diodati, and by James or Arthur Willmore at the Colosseum, show the Byron of *Childe Harold* reclining all over Europe, head on hand, deep in contemplation. What was perceived as Byron's heroic self-sacrifice in Greece was celebrated by Greeks and Philhellenes through imagined scenes of this aspect of his life and his death there, while mourning paintings, prints and medals commemorated his death using classical Greek iconography. In the decades after his death Byron's fame created an insatiable demand for depictions of him in virtually every medium, not only the more or less artistic paintings, sculptures, drawings and prints, but also memorabilia including the plates, jugs, rings, brooches, cravat pins, ceramic figures, snuff boxes, clocks and even smoking-pipes that were decorated with his picture.

Readers now can experience Byron in full colour through high-quality reproductions of the original portraits, but he and his contemporaries lived largely in a monochrome art world where

Fig. 94 **Max Beerbohm's 1911 caricature in his novel *Zuleika Dobson* imagines what would have happened if Byron had not died at Missolonghi, portraying him as 'a florid old gentleman with iron-grey whiskers'. 'It was lucky to perish leaving much to the imagination and posterity', Beerbohm's narrator conjectures.**

Fig. 95 Charles Eastlake's 1827 fantasy scene of Byron in Greece was part of a tradition showing Byron or Childe Harold reclining all over Europe, deep in contemplation.

engravings could only offer a black-and-white, more-or-less accurate version of the original made by someone else. Portrait prints produced in this way, often several generations away from the artwork created in the live sitting, were the medium in which most people encountered Byron, and it was the developments in printing processes during his lifetime and in the decades after his death that led to the widespread dissemination of his image. The Romantic period has been described as 'a crucial epoch in the history of print culture, which witnessed important changes in the production, circulation and reception of both letter press text and printed images'.[200] The steam press, for example, was first introduced in 1814 and initially used primarily for producing newspapers, but was also used increasingly during this period for books. Stereotypy (whereby a mould was taken from the type) made it possible to reprint books more easily as demand required, and eliminated the need to reset type for new editions. Thomas Davison, printer of most of Byron's works, was noted for his improvements in printing ink.[201] Later, the shift from paper made of cotton or linen rags to paper made of wood pulp further reduced costs. And the printed matter produced by these new technologies could be circulated

Fig. 96 **These Byron cravat pins (two in cameo relief and one painted on ceramic) date from around 1870.**

along radically improved distribution networks of roads, canals and, eventually, railways.[202]

The eighteenth century had seen the refinement of relief printing (where the raised areas of the block carry the ink and print black under pressure) as a particularly suitable medium for book illustration. Different materials could be used, including metals, but particularly wood, and Thomas Bewick, in the 1790s, developed wood engraving to a very high level by using the end of the wooden block rather than carving along the grain, initiating the possibility for much livelier and more subtle images, such as those of George Cruikshank (fig. 127).

In the intaglio processes, which were again becoming much more sophisticated during Byron's time, the printing areas are sunk beneath a surface that remains blank. In engravings the incisions to contain the ink are cut with a tool, while in etchings they are bitten out by acid. Use of a burin engraving tool produces a stippled effect, as shown in some of the best-known Byron engravings, such as figures 23, 30 and 55. Plates were generally of copper, but steel engraving was invented in 1792, enabling the reproduction of fine parallel and cross-hatched lines. Steel plates could also print many more impressions before wearing out, allowing publishers to produce large runs of cheap pictures.

Mezzotint, first developed in the seventeenth century, involves roughening and burnishing the surface to give areas of shade and light respectively, and allows for soft gradations of tone, such as in figure 34. Lithography, however, invented in 1796, not only allowed text and image to be presented together on one page, but could also create a sensuous and soft impression, such as in figures 98, 113 and 120. Oil,

Figs 97 and 98 So widely known were the visual props that signified 'Byron' (the white collar, and distinctive hairline and profile) that they could be used to test and intrigue viewers through 'puzzle prints' such as these, which show Byron's face hidden among the scenery of 'The Isles of Greece' (left) and (with Teresa Guiccioli, Byron's daughter Ada and the Maid of Athens) at Newstead Abbey (above).

Fig. 99 The deeply personal quality of some readers' relationship with Byron is clear in the handwritten inscription accompanying a few strands of Byron's hair mounted in an 1850 volume of Byron's poems: 'Ah Byron! yes, there beats a heart like thine / Too like in spirit and in sorrows, mine.'

grease or wax was used to draw lithographic images on a smooth limestone plate which was then etched with acid.

Byron was far and away the best-selling of the Romantic poets, and it has been calculated that he and Walter Scott sold more works in a normal afternoon than Shelley and Keats did during the whole of their lives.[203] This enormous popularity meant that John Murray did not, for his first editions of Byron's works, need to produce what were then usually called 'embellishments' (printed illustrations) in order to achieve high sales, although, as we have seen, as early as March 1813 Murray was in correspondence with Lady Oxford about the possibility of commissioning illustrations from Richard Westall RA. This project was delayed until 1818, perhaps because Westall broke his arm, and the first illustrations actually commissioned by Murray were the set of twelve by Thomas Stothard RA, published in 1814 (see figures 40 and 51). These became highly influential on later depictions of Byron's work and helped to blur the visual line between the poet and his protagonists.[204]

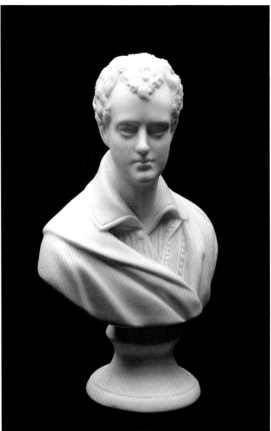

Fig. 100 (above left) **This hollow-cut paper silhouette (made around 1816) reproduces Byron's instantly recognisable attributes in an unusual way.**

Fig. 101 (above right) **This bust in Parian ware (a type of biscuit porcelain imitating marble, developed by the pottery manufacturer Minton and named after the Greek island of Paros) dates from around 1870.**

In subsequent decades, as printing developments allowed longer and cheaper runs, and the book-buying public grew especially among young middle-class women, the balance in Byron publications swung more and more away from the text towards pictures. In the early 1830s Murray issued new sets of engravings including 'sentimental' subjects by Edward Corbould and Henry Richter, and then (in 1836) published *Finden's Byron Beauties: or, the Principal Female Characters in Lord Byron's Poems*, which featured imaginary portraits of Byron's heroines, well-sanitised for a bourgeois, predominantly female, audience.[205] Thomas Makepeace Thackeray described the Findens' publication as 'that unfortunate collection of deformed Zuleikas and Medoras'; they were, he said, examples of art 'done by *machinery* ... to be found invariably upon the round rosewood brass-inlaid drawing room tables of the middle classes'.[206] The Findens' other enterprise placed the emphasis on landscapes associated with Byron and his works, and they recruited (among others) Joseph Mallord William Turner RA, who painted a total of twenty-six watercolours, mostly vignettes, to be engraved for *Finden's Illustrations of the Life and Works of Lord Byron*, edited by William Brockedon, issued by Murray in 1832–3. By the mid-nineteenth century, Byron volumes exclusively devoted to pictures were common, including *Thirty Illustrations of Childe Harold*, all engravings on steel,

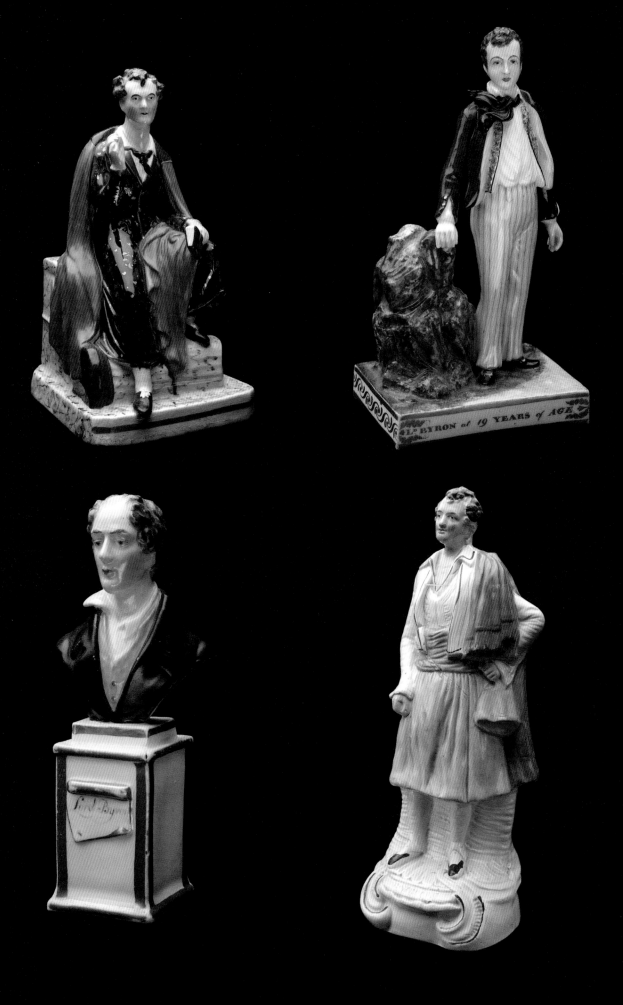

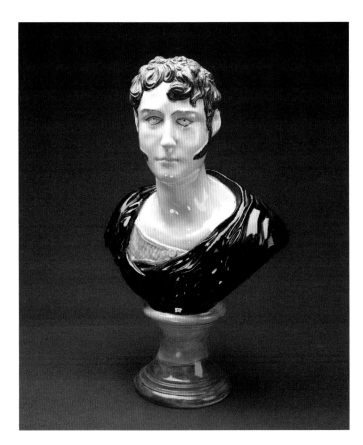

Fig. 102 (opposite) **Ceramic figures like these were made in the Staffordshire potteries in the mid-nineteenth century. This group includes one by Minton (top right, about 1865) and three in Staffordshire ware (top left, around 1848, and bottom left and bottom right, both from around 1850).**

Fig. 103 (above left) **This large Pratt ware ceramic bust (nearly 50 cm tall) dates from around 1820.**

Fig. 104 (above right) **A finely-carved ivory snuff box of unknown date with Byron's profile.**

produced by the Art Union of London in 1855, where each illustration is accompanied only by a short quotation of the relevant verse.

Thanks to these developments (and also to Byron's controversial personal reputation and the unorthodoxy and supposed seditiousness of his late works such as *Don Juan, Cain, The Vision of Judgment* and *Heaven and Earth)*, after his death his texts were further played down in fashionable society in favour not only of portraits and illustrations, but also the more anodyne presentation of Byron's own image through a wide variety of three-dimensional artefacts, memorabilia and merchandise carrying his picture. So widely known were the visual props that signified 'Byron' (the white collar, distinctive hairline and profile with a strong nose, eyebrow and chin) that they could be used to test and intrigue viewers through 'puzzle prints' such as figures 98 and 97, which show Byron's face hidden among the scenery of 'The Isles of Greece' and (with Teresa Guiccioli, Byron's daughter Ada and, facing her, the Maid of Athens) at Newstead Abbey. These prints also hint at what Byron's fans felt to be their special relationship with him: its often secret nature being part of its attraction, giving the owner 'a piece of Byron' that they did not necessarily have to share with others. The deeply personal quality of this relationship is also clear in a handwritten inscription accompanying a few strands of Byron's hair mounted in an 1850 volume of Byron's poems: 'Ah Byron! yes, there beats a heart

like thine / Too like in spirit and in sorrows mine' (fig. 99).[207] Other relatively inexpensive paper memorabilia included compressed paper 'cameos' showing Byron's profile, and hollow-cut silhouettes (fig. 100) which again took advantage of Byron's instantly recognisable features to reproduce them in a new way.

The Staffordshire pottery and porcelain manufacturers were quick to cash in on the desire of all classes for images of the poet. There were busts such as those in Parian ware (fig. 101) (a type of biscuit porcelain imitating marble, developed in the 1840s by the pottery manufacturer Minton and named after the Greek island of Paros, renowned for its fine-textured white marble). Other well-known Staffordshire figurines show Byron seated, or standing in Greek costume. A figurine by Minton is based on the full-length George Sanders portrait (see figure 15) of Byron as a young man – here, almost as a boy – while in another small Staffordshire bust from around 1850 he has aged and become distinctly bald. Figure 103 shows a rare under-glazed, multi-coloured bust, from the factory founded by Felix and Richard Pratt in the early nineteenth century at Fenton in Staffordshire. Presenting Byron in a brightly coloured toga-like garment, with brown curly hair and unlikely long sideburns, the artist has correctly shown him without earlobes but has added eyeliner around his blue-grey eyes. The Staffordshire porcelain plaque shown in figure 106, meanwhile, gives Byron the large white collar and dark cloak of the Phillips portrait, but also chubby cheeks and what looks like a perm. Another porcelain plaque (fig. 105) of

Figs 107 and 108 (opposite top) Some nineteenth- and twentieth-century British Masonic Lodges were formed in Byron's name, giving rise to items such as the Masonic Master's jewel made in Birmingham in 1926 and the lustreware jug of about 1820 with Byron's bust and Masonic symbols.

Fig. 109 (opposite bottom left) Bronze figures, such as this one by Benjamin Faulkner from 1824 depicting Byron wearing the cloak and open-necked shirt characterising the poet, were often sold with a matching figure of Sir Walter Scott.

Fig. 110 (opposite bottom right) This highly detailed small sculptural group (dating from around 1834–5), and about 36 cm high), in Parian ware, shows Byron with the Maid of Athens and a greyhound.

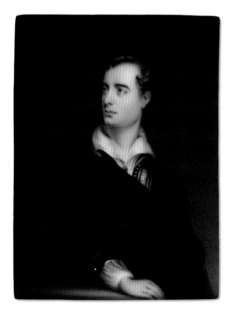

Figs 105 and 106 (left) Two miniature copies of the Thomas Phillips 'Cloak' portrait: one (left) was painted on a Derby porcelain plaque by John Haslem in 1836, and the other (right) on a Staffordshire ware porcelain plaque by an unknown artist around 1850. While the features changed with each presentation, and in figure 106 Byron has acquired a perm, the cloak and open collar still signify 'Byron'.

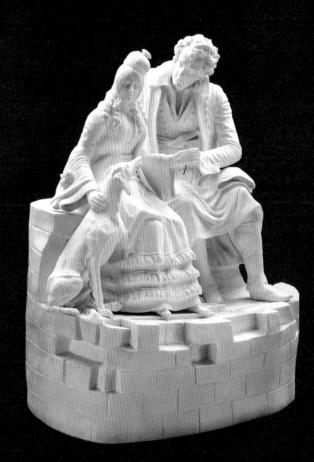

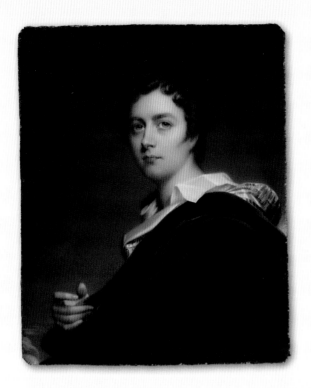

NON OMNIS MORIAR.

B is for Byron

Fig. 111 (opposite top left) **In the late 1820s Henry Bone painted this miniature in oil on copper after West's 1822 portrait (see figure 83, page 101), but showing a slimmer and more glamorous Byron than in West's painting.**

Fig. 112 (opposite top right) **Among the many commemorative medals struck following Byron's death in Greece in 1824 was this one in bronze by Benjamin Faulkner. The front depicts Byron in profile, and the reverse the poet as Apollo, playing a lyre, with lightning flashes and the date of his birth.**

Fig. 113 (opposite bottom left) **This mourning print drawn by Filippo Pistrucci in 1824 places Byron's profile beside a personified Greece rising from her broken shackles.**

Fig. 114 (opposite bottom right) **A 2009 linocut, 'B is for Byron' by Patricia Ferguson, is based on the Harlow portrait of 1815 (figure 53, page 70).**

1836, from the Derby factory, painted by John Haslem, also follows the Phillips portrait. Probably in the late 1820s Henry Bone RA painted a miniature in oil on copper (fig. 111) after West's 1822 portrait (see figure 83), but we can tell that this is based on the 1826 mezzotint by Charles Turner rather than the original since it shows a slimmer and more glamorous Byron than in West's painting.

For the wealthier collector, there was a wide range of merchandise to choose from, including busts in marble, bronze and other metals, and ivory snuff boxes such as the one shown in figure 104, with Byron's finely carved profile, perhaps after Westall. One highly detailed sculptural group (only about 36 cm high, in Parian ware) (fig. 110) shows Byron with the Maid of Athens and a dog, while bronze figures such as figure 109, depicting Byron wearing the cloak and open-necked shirt typical of a poet, were often sold with a matching figure of Sir Walter Scott. Also very expensive would have been the bizarre collection of twenty-four matching porcelain smoking-pipes sporting portraits of Byron with his family, friends, associates and fictional protagonists (fig. 93), made in Bavaria in the 1860s.

Some nineteenth- and twentieth-century British Masonic Lodges were formed in Byron's name, giving rise to items such as figure 108, the

Fig. 115 (right) **This snuff box featuring the 'Albanian' portrait (figure 47, page 62) was issued by Halcyon Days in 1988 to mark the bicentenary of Byron's birth.**

lusterware jug with Byron's bust and Masonic symbols, and figure 107 the Masonic Master's jewel made in Birmingham in 1926. Although there is no evidence to suggest that Byron was a Freemason, in Ravenna he was involved with the Carbonari, the revolutionary society dedicated to expelling the Austrians from Italy, which gained its name from the charcoal burners who frequented the woods at night and held Masonic-style meetings. The tradition of Byron memorabilia continued into the later twentieth century with anniversary objects such as the enamel box (fig. 115) produced for Byron's 1988 bicentenary by Halcyon Days, and in the twenty-first century by new interpretations such as Patricia Ferguson's linocut 'B is for Byron', created in 2009 (fig. 114). Online, Byron continues to be celebrated through portraits of almost every conceivable type and origin.

Byron's death in 1824 created shock waves that reverberated around Europe. Edward Lear recalled himself at age eleven 'stupefied & crying', and the young Alfred Tennyson wept and carved Byron's initials on a tree.[208] Victor Hugo's obituary, published in *La Muse Française*,

Fig. 116 **Lodovico Lipparini's 1850 oil painting of** *Lord Byron's Oath on the Grave of Marco Botzaris* **stages a fictional event with Byron in Greek costume asserting the inspiration of Markos Botsaris, the general and hero of the War of Independence who was killed in August 1823.**

Fig. 117 Theodoros Vryzakis'
painting of 1861 shows an
imaginary version of Byron's
reception at Missolonghi in
January 1824. Byron is shown
wearing the dark clothes of his
poetic portraits topped with a
Greek classical-style himation,
although in fact he donned his
scarlet uniform for the occasion.

contrasted Byron's liberal and sceptical attitudes with Chateaubriand's monarchical and traditionally religious views. Josef Odevaere of Bruges mourned Byron in his 1826 painting showing the poet on a classical deathbed (see figure 62), and the London-published mourning print 'Non omnis moriar' ('Not all of me shall die') by Filippo Pistrucci (fig. 113) places Byron's profile beside a personified Greece rising from her broken shackles. Among the many commemorative medals struck was a handsome one in bronze by Benjamin Rawlinson Faulkner (fig. 112), which on the front depicts Byron in profile and, on the reverse, the poet as Apollo, playing a lyre, with lightning flashes and the date of his birth.

The mourning was most intense in Greece. Huge crowds gathered along the shore as Byron's body was conveyed by boat from Missolonghi for return to England, and cannons, artillery and musketry were fired in salute. Almost every town had its own memorial service, and the many Greek streets, squares and buildings named after Byron testify to the continuing perception of him as a hero who gave his life for Greece. The nineteenth-century visual representations and illustrations of Byron's life

in Greece also reflect this heroic or patriotic aspect, imagining what an artist feels *ought* to have happened, or what is romantically imagined to have happened, rather than what actually did occur.

Lodovico Lipparini's 1850 oil painting of *Lord Byron's Oath on the Grave of Marco Botzaris* (fig. 116), for instance, stages a fictional event which has Byron in Greek costume asserting the inspiration of Markos Botsaris, the general and hero of the War of Independence who was killed in August 1823. Theodoros Vryzakis's canvas of 1861, similarly, shows an imaginary version of Byron's reception at Missolonghi in January 1824 (fig. 117), in a painting that certainly reflects the artist's own Greek patriotism. Vryzakis's father was hanged by the Ottomans during the early years of the war, leaving the young boy and his mother to escape into the mountains. Trained in Munich, where he absorbed aspects of classical 'historical' painting, Vryzakis shows Byron being formally greeted by a figure in Souliot dress (perhaps representing Botsaris, although he had by then been dead for some months) and by Prince Alexandros Mavrokordatos, distinguished by his European-style suit. Iosiph, Bishop of Rogon, attended by acolytes with ecclesiastical banners, gives his blessing, and Souliot chiefs in their swirling kilt-like fustanellas also wave flags and crucifixes, while women throw flowers and kneel as if to a saint. Ironically – since Byron in fact took the trouble to don scarlet regimentals for his arrival in Missolonghi – he is shown in the 'uniform' of a poet rather than that of a soldier or a statesman, with the dark jacket and white collar of the Phillips portrait, draped with a 'himation', or classical Greek style cloak or toga.[209] Behind him are figures probably meant to represent Teresa's brother Count Pietro Gamba (who wrote a memoir of Byron and died in Greece in 1827), or else Colonel Leicester Stanhope, and the profile of Trelawny (who had in fact left Byron by this time to transfer his loyalty to the more picturesque warlord Odysseus Androutsos in the Morea).

Two well-known nineteenth-century statues of Byron in Greece celebrate his legacy. The 1881 representation by Giorgios Vitalis in the Garden of the Heroes in Missolonghi is larger than life-size but, although not based on any *ad vivum* sittings, aims to be lifelike in features and pose (fig. 118). The statue in the Zappeion Gardens in Athens, however, designed by Henri-Michel-Antoine Chapu and executed in 1895 by Jean Alexandre Joseph Falguière (fig. 119), is much more extravagant in conception and scale, and shows Byron in the uncomfortable embrace of a much larger female personification of Greece, who towers rather menacingly over him as she crowns him with a laurel wreath.

Fig. 118 (above left) **Two well-known nineteenth-century statues of Byron in Greece celebrate his legacy. The 1881 representation by Giorgios Vitalis in the Garden of the Heroes in Missolonghi is larger than life-size but, although not based on any portrait from life, aims to be lifelike in features and pose.**

Fig. 119 (above right) **This statue in the Zappeion Gardens in Athens, designed by Henri-Michel-Antoine Chapu and executed in 1895 by Jean Alexandre Joseph Falguière, shows Byron with a female personification of Greece.**

In 1827 Adam Friedel published in London and Paris an illustrative print showing Byron as 'the advocate and supporter of the Greek Nation' (fig. 120). Friedel (or 'de Friedel', as he called himself, masquerading as a Danish baron) had met Byron in Greece, and Byron had written letters introducing him to the London Greek Committee and then defending him when he was unmasked in the press.[210] The print's artist, Thomas Fairland, based the face and general figure on the Phillips 'Cloak' portrait, but Byron is also portrayed with a Homeric helmet and Scots plaid, and for both of these there is a basis in reality, which Friedel might have reported from Greece. The Prepiani portrait miniature of Byron with Teresa (see figure 70), also shows him wearing the tartan plaid of the Gordons, his mother's family, and he did indeed commission three heroic helmets to take to Greece: two plumed, gilded and Homeric ones for himself and Trelawny, and the third a shako garnished with a figure of the goddess Minerva for Pietro Gamba.[211] This has been taken as fanciful and extravagant gesture,

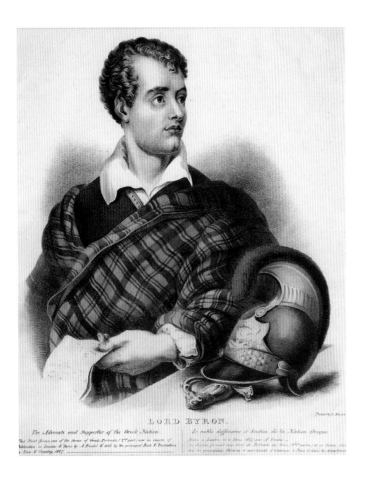

LORD BYRON.

The Advocate and Supporter of the Greek Nation. Le noble défenseur et Soutien de la Nation Grecque.

Fig. 120 (left) This print showing Byron as the 'advocate and supporter of the Greek Nation' was published in 1827 by Adam Friedel, who had met Byron in Greece. Byron is portrayed with a Scots plaid (such as the one he wears in figure 75, page 92) and a Homeric-style helmet, which he did indeed commission to take to Greece. Helmets of this kind had been worn at the Battle of Waterloo in 1815.

but it was, as so often with Byron's costume and self-presentation, a piece of considered performance art, both expressing the conception of Philhellenes such as himself that they were fighting for the revival of ancient Greek culture and also reflecting the Napoleonic aspect of the struggle through martial costume which had been worn on the battlefield as recently as at Waterloo in 1815.

A very different way of visually imagining Byron was that of the British satirical print-makers, especially around 1816. Black-and-white engravings of this kind, usually water-coloured by hand, were purchased by collectors (including the Prince Regent, who bought many satirical representations of himself) but also reached thousands of other viewers by being displayed in print shop windows. Interestingly, those of Byron are not 'caricatures' in the classic sense, since they do not 'load' (Italian 'caricare') or exaggerate his facial features to make them comic or grotesque, but instead imagine exaggeratedly dramatic scenes from his life or work to mock his personality and writing. Isaac Robert Cruikshank's first satire, *Lobby Loungers* (fig. 121), shows Byron and an unidentified male companion ogling the almost-bare-breasted actresses and courtesans in the lobby of the Theatre Royal, Drury Lane (where Byron was a member of the Sub-Committee of Management in 1815 and 1816). Byron's gaze is fixed on the actress Charlotte Mardyn,

Fig. 121 (opposite top) Byron was featured in several British satirical prints. Isaac Robert Cruikshank's *Lobby Loungers* (1816) shows Byron and an unidentified companion ogling the actresses at the Theatre Royal, Drury Lane. He wears the Napoleonic star of the Légion d'honneur (referring to his 1816 poem of that name). It is possible that Cruikshank had observed Byron 'from life', as he portrays him in the fashionably loose trousers that were Byron's characteristic wear.

Fig. 122 (opposite bottom) Cruikshank's *Fashionables of 1816, taking the air in Hyde Park!* imagines a confrontation between a heavily pregnant Lady Byron and her husband, who is strolling with two scantily-clad actresses.

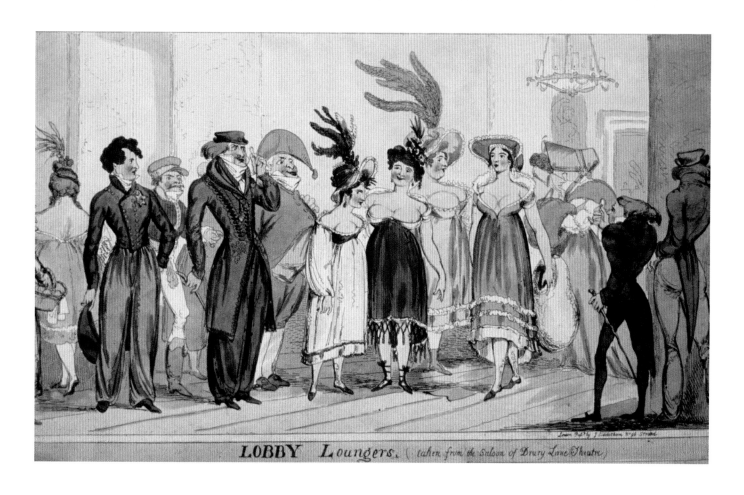

LOBBY *Loungers.* (*taken from the Saloon of Drury Lane Theatre.*)

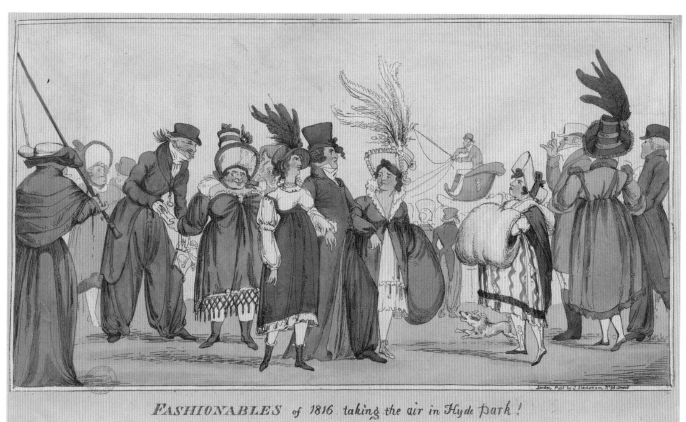

FASHIONABLES *of 1816 taking the air in Hyde Park !*

The Separation, a Sketch from the private life of Lord IRON who Panegyrized his Wife, but Satirized her Confidante !!

facing him in a blue bonnet, his handsome profile contrasting markedly with the ugliness of the other men. He wears a double-breasted coat with the Napoleonic star of the Légion d'honneur (referring to his anonymous poem of that name of 1816), and in his pocket is a paper headed 'Corsair, Farewell etc by Lord Byron'. His hatless head, with tumbling curls, has been copied from the Meyer engraving of the Harlow portrait, but it is possible that Cruikshank had also seen and observed Byron 'from life', as he portrays him in the very loose trousers that were Byron's characteristic wear, but could not then be seen in his portraits.[212] The bright blue and green of Byron's outfit would have been chosen by the colourist to give the print some lustre, although Byron's actual clothes were notably sombre in tone.

Cruikshank's second satire, *Fashionables of 1816, taking the air in Hyde Park!* (fig. 122), imagines a confrontation between a heavily pregnant Lady Byron and her top-hatted husband, who is strolling arm in arm with Mrs Mardyn and another scantily clad beauty. The same sinister, baggy-trousered companion who appears alongside Byron

Fig. 123 In *The Separation, a Sketch from the Private Life of Lord Iron who Panegyrized his Wife, but Satirized her Confidante!!* (1816), Cruikshank shows Byron leaving home in the embrace of actress Charlotte Mardyn. 'Fare thee well!' he pronounces, quoting his own poem, leaving behind Lady Byron with baby Ada in her arms and her confidante Mary Anne Clermont.

Fig. 124 This print of 1816 is the work of the younger Cruikshank brother, George. Byron stands in a small boat being rowed out to a ship, embraced by three highly attentive ladies (one identified as the 'Beauteous Mrs Mardyn') and accompanied by bottles of 'Old Hock' and his skull cup. 'I hopes he's got enough on 'em a'board!' one sailor comments, and his companion responds, 'Yes! & may I never take another bit of Shag if they ain't fine vessels'. Byron turns back to recite his notorious 'Fare thee well' poem to his wife and child left on the shore:

All my <u>faults</u> perchance thou knowest –
All my <u>Madness</u> – none can know; –
Fare thee well! – thus disunited –
Torn from every <u>nearer tie</u>,
Seared in heart – & <u>lone</u> – & blighted –
More than this I scarce can die!!!!!!

Drawn less than a year after Napoleon had similarly left by sea for exile, Byron has a profile that looks distinctly Napoleonic, with a pot belly and knee breeches that imitate the portraits of the Emperor to whom he was known to be sympathetic.

in *Lobby Loungers* is here again, passing money to an older woman, perhaps a madam. Again the possibility that Cruikshank drew Byron from life is demonstrated by his loose trousers and what seems to be his awkward gait, caused by his lameness. The third satire in the sequence, *The Separation, a Sketch from the Private Life of Lord Iron who Panegyrized his Wife, but Satirized her Confidante!!* (fig. 123) shows Byron leaving home in the embrace of a very décolletée Mrs Mardyn. 'Fare thee well!' he pronounces with a quote from his own poem and a gesture of dismissal, 'and if for ever – Still for ever fare thee well!' He leaves behind Lady Byron with baby Ada in her arms, in the protection of a man identified by the paper in his pocket as James Perry, proprietor of the *Morning Chronicle*. Scowling beside them is the elderly Mary Ann Clermont, Lady Byron's friend, whom Byron suspected of helping to engineer the separation and excoriated in his 'Sketch from Private Life' in March 1816.

Also weighing in visually on the scandals was Isaac Robert's younger brother, the more famous print satirist George Cruikshank, whose own 'Fare thee well' broadside (fig. 124) is probably the best known of this group. Byron stands in a small boat being rowed out to a ship, embraced by three highly attentive ladies (one identified as 'the Beauteous Mrs Mardyn') and accompanied by a stack of bottles of Hock and his skull cup. One sailor comments, 'I hopes he's got enough on 'em a'board' and his companion responds, 'Yes! & may I never take another bit of Shag if they ain't fine vessels'. Byron turns back to recite his notorious 'Fare thee well' poem (with added satirical underlining, and printed in full under the engraving) to the plaintive figures of his wife and child left on the shore:

> All my <u>faults</u> perchance thou knowest –
> All my <u>Madness</u> – none can know; –
> Fare thee well! – thus disunited –
> Torn from every <u>nearer tie</u>,
> Seared in heart – & <u>lone</u> – & blighted –
> More than this I scarce can die!!!!!![213]

Drawn less than a year after Napoleon had similarly left by sea for exile (although without the female companions), Byron is given a profile that looks distinctly Napoleonic and a pot belly and knee breeches (never worn by Byron) that imitate the portraits of the Emperor to whom he was known to be sympathetic. Byron's short-lived affair in 1815–16 had in fact been with another actress, Susan Boyce, rather than with

Fig. 125 In *A Noble Poet – Scratching up his Ideas* (1823), Charles Williams presents Byron as the author of irreligious works, including *Cain* (shown in the painting on the wall), *Heaven and Earth* and *Don Juan*. Gazing at a Venetian scene through the window, Byron has a small devil (known as 'Old Scratch') perched on his shoulder and a large dog (also scratching) at his feet. 'Is His Lordship a'writing that note for me?' asks one of the servants in the top right-hand corner. 'No ... he is writing Poetry', the other replies, 'Because he is scratching his head'.

A NOBLE POET — Scratching up his Ideas.

Pray Jerome is his Lordship writing that note for me

No Sir he is writing Poetry —

How do you know that

Because he is scratching his head

L.d Byron.

Pub.d Jan.y 1. 1823 by J, Johnston 98 Cheapside.

– 1 Jan. 1823

Charlotte Mardyn, but the power of these satires can be judged by the way in which Mrs Mardyn was received at the Theatre Royal, Drury Lane in 1816 by 'a deafening ... burst of indignant vengeance' aiming to 'hoot her off the stage'. Her plaintive letter to the *Morning Chronicle* protested against a 'persecution the most unprovoked and unaccountable that the records of slander can supply', falsely associating her 'with the recent domestic disagreements of a Noble Family'.[214]

Byron continued to be featured in satirical prints even after his departure from England, and in 1820 George Cruikshank produced a strongly dramatic portrayal of him as 'The Lord of the Faithless' in an illustration to *The Men in the Moon*, a pamphlet by William Hone

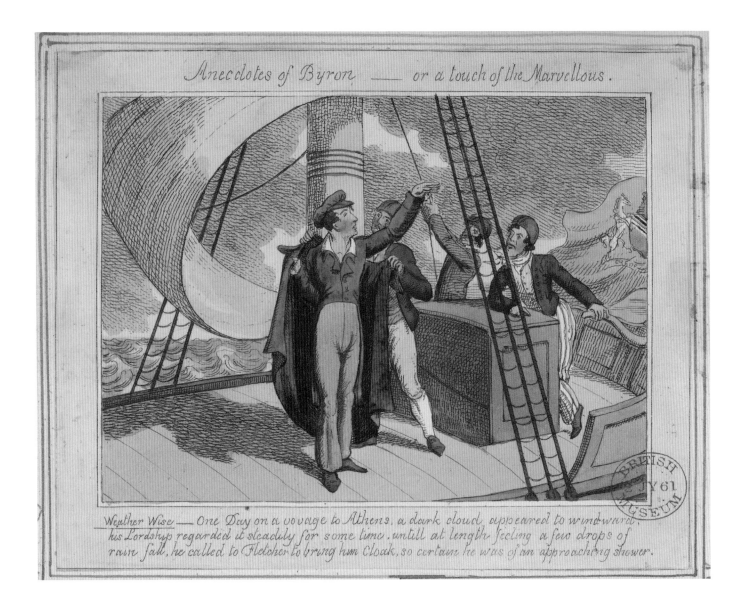

Anecdotes of Byron ____ or a touch of the Marvellous.

Weather Wise ____ One Day on a voyage to Athens, a dark cloud appeared to windward, his Lordship regarded it steadily for some time, untill at length feeling a few drops of rain fall, he called to Fletcher to bring him Cloak, so certain he was of an approaching shower.

(fig. 127).[215] Although a campaigner for press freedom, Hone decried *Don Juan* as a poem which 'turns decorum to jest ... bids defiance to the established decencies of life [and] ... wars with virtue, as resolutely as with vice'.[216] Cruikshank shows Byron, still handsome, but with a devil directing him from above, a cloven hoof and a quotation in the voice of Satan from Book Four of Milton's *Paradise Lost*. Later in the 1820s, both Cruikshank brothers went on to produce fine and sympathetic illustrations for the pirated editions of Byron's works, especially *Don Juan*.[217]

A Noble Poet – Scratching up his Ideas (1823) (fig. 125) picks up on George Cruikshank's devilish Byron theme and the popular nick-name for the Devil 'Old Scratch', by presenting Byron as the author of irreligious works, including *Cain* (shown in the painting on the wall) and *The Vision of Judgment* (which had mercilessly lampooned the Tory Poet Laureate, Robert Southey) and others that appeared in Leigh

Fig. 126 The visual satires also ridiculed the flourishing industry of Byron memoirs and memorabilia. Charles Williams' print *Anecdotes of Byron – or a touch of the Marvellous* mocks the banality of Alexander Kilgour's *Anecdotes of Lord Byron* (1825) by caricaturing Byron's supposedly not-very-exceptional powers of predicting the weather.

Hunt's journal *The Liberal*, published in London by his brother John Hunt. Shown sitting at a table in his dressing gown and gazing at a Venetian scene through the window, Byron has a small devil perched on his shoulder and a large dog (also scratching) at his feet. 'Is His Lordship a'writing that note for me?' asks one of the servants in the top right-hand corner. 'No ... he is writing Poetry', the other replies, 'Because he is scratching his head'.

The visual satires continued even after Byron's death, although now the butt of some of them was the flourishing industry of Byron memoirs and memorabilia rather than Byron himself. Charles Williams' print *Anecdotes of Byron – or a touch of the Marvellous* (fig. 126) features the poet on board a boat in a rather camp stance and an open collar and sailors' trousers, in order to mock the banality of Alexander Kilgour's *Anecdotes of Lord Byron* (1825) by caricaturing Byron's supposedly not-very-exceptional powers of predicting the weather. Another print by Jules Platier, published in Paris in the 1840s or later as part of a series on 'Amants célèbres' (fig. 128), shows Byron with a grotesquely deformed foot, gazing adoringly at Teresa Guiccioli, who is singing a nursery rhyme on similar lines to 'Humpty Dumpty' ('Cadet Roussel est bon enfant').

> The charming cripple, all entranced,
> Listened to his dear countess
> As she chirped a love song,
> While skilfully plucking the strings
> Of her twanging instrument,
> With such an enticing melody:
> 'Cadet Roussel is a good guy'.[218]

A third spin-off, published in London in 1836 and in French in Paris in 1837, is an illustrated work authored by the journalist John Mitford, *The Private Life of Lord Byron, comprising his voluptuous amours,* which chronicles an imaginary version of Byron's racy love life and 'close connections with various ladies of rank and fame, in Scotland and London, at Eaton [sic], Harrow, Cambridge, Paris, Rome, Venice, &c., &c.: With a particular account of the Countess Guiaccoli [sic]', and a supposed 'murder at Ravenna, which caused his Lordship to leave Italy'. A frontispiece to the French edition (fig. 129) shows Byron simultaneously fighting two duels and caught *in flagrante* with numerous ladies, and the copy of this work in the Bibliothèque Nationale de France was confined to 'l'Enfer' – the 'Hell' where naughty

"The Devil's in the Moon for mischief,
And yet she looks so modest all the while."

DON JUAN.

The LORD of the FAITHLESS.

" Me, miserable, which way shall I fly—
Infinite wrath, and infinite despair?
Which way I fly is Hell, myself am Hell;
And in the lowest depth, a lower deep
Still threat'ning to devour me, opens wide,
To which the Hell I suffer seems a Heaven.

Chez Pannier Edit. R. du Croissant, 16. Chez Aubert Pl de la Bourse, 29. Imp. d'Aubert & Cⁱᵉ

LORD BYRON ET LA COMTESSE GUCCIOLI.

Cet aimable boiteux, dans son ravissement,
Ecoutait sa chère comtesse,
Qui lui peignait son sentiment,
En lui pinçant avec adresse,

Sur son nazillard instrument.
Cet air si doux qui l'intéresse:
Cadet Roussel est bon enfant.

Fig. 127 (opposite top left) **George Cruikshank's woodcut *The Lord of the Faithless* appeared as an 1820 illustration to *The Men in the Moon* by William Hone. Under a quotation from *Don Juan*, Cruikshank shows Byron with a devil directing him from above, a cloven hoof, a gibbet, and a quotation in the voice of Satan from Book Four of Milton's *Paradise Lost*.**

Fig. 128 (opposite top right) **This print by Jules Platier, published in Paris in the 1840s or later as part of a series on 'Famous lovers', shows Byron with a grotesquely deformed foot and leg (incorrectly, the left) gazing adoringly at Teresa Guiccioli, who is singing a nursery rhyme on similar lines to 'Humpty Dumpty' ('Cadet Roussel est bon enfant').**

Fig. 129 (opposite bottom) **Published in London and Paris in 1836–7, John Mitford's *The Private Life of Lord Byron* chronicles an imaginary version of Byron's racy love life. A frontispiece to the French edition shows Byron simultaneously fighting two duels and caught *in flagrante* with numerous ladies.**

Fig. 130 (right) **Dennis Price as Byron in *The Bad Lord Byron* (1949), directed by David MacDonald, stands trial in a celestial court and manages to achieve a surprising verdict of 'not guilty' to charges of incest, adultery and other scandalous behaviour.**

books were locked away. Byron continued to attract visual cartoonists and satirists into the twentieth century, as those in this book by Max Beerbohm show (see figures 60, 66, and 94).

Byron on screen is a phenomenon that goes back at least to the 1922 silent film *The Prince of Lovers*, adapted from Alicia Ramsey's *Byron, A Play in Four Acts and an Epilogue*.[219] He was next featured briefly (played by Gavin Gordon) in the prologue to James Whale's *Bride of Frankenstein* (1935) and also appeared (as Mary Shelley's lover) in Roger Corman's *Frankenstein Unbound* (1990). Dennis Price as Byron in *The Bad Lord Byron* (1949) (fig. 130), directed by David MacDonald, stands trial in a celestial court and manages to achieve a surprising verdict of 'not guilty' to charges of incest, adultery and other scandalous behaviour. In Robert Bolt's 1972 *Lady Caroline Lamb*, however, as played by Richard Chamberlain, Byron becomes a

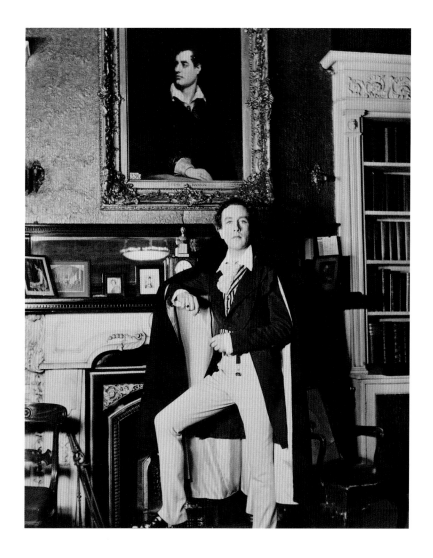

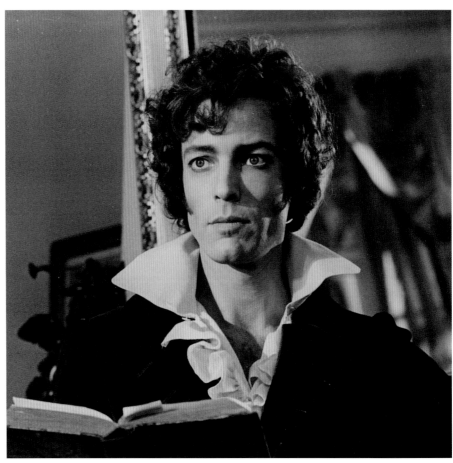

heartless boor (fig. 133), with Lady Caroline played by Bolt's wife Sarah Miles. Ken Russell in *Gothic* (1986) makes Gabriel Byrne's Byron an arch-manipulator of Mary and Percy Shelley and the other Villa Diodati residents, and the same scenario is explored with Philip Anglim as Byron in Ivan Passer's *Haunted Summer* of 1988. Also in 1988, Hugh Grant appeared as Byron in Gonzalo Suárez's *Remando al viento (Rowing with the Wind)* (fig. 131), which opens with a misquotation of the first line of Byron's 1816 poem 'Darkness'. Some television portrayals are a little more sympathetic, including the 1992 BBC2 *Dread Poets' Society* (with a screenplay by Benjamin Zephaniah, directed by David Stafford and starring Alex Jennings). Jonny Lee Miller in the title role of Nick Dear's well-researched two-part BBC2 2003 miniseries *Byron* (directed by Julian Farino) (fig. 132) is more appealing, and he does at least get to write and read poetry and to hear his verse performed. This is a rarity for on-screen Byrons who are very seldom portrayed as working poets.[220]

In 1868 Byron's birthplace in Holles Street (just off London's Oxford Street) was the first building to be marked with a blue plaque, when the Society of Arts initiated its scheme for commemorating famous people in the places connected with them.[221] The site is now part of the

Fig. 131 (top left) **Hugh Grant starred as Byron in Gonzalo Suárez's** *Remando al viento (Rowing with the Wind)* **(1988).**

Fig. 132 (above left) **Jonny Lee Miller in the title role of Nick Dear's two-part BBC2 2003 miniseries** *Byron* **(directed by Julian Farino) does at least get to write and read poetry and to hear his verse performed: a rarity for on-screen Byrons who are seldom portrayed as working poets.**

Fig. 133 (above right) **In Robert Bolt's 1972** *Lady Caroline Lamb,* **starring Sarah Miles and Richard Chamberlain, Byron becomes a handsome but vain and heartless boor.**

Fig. 134 This statue by Richard Belt was paid for with funds raised under the chairmanship of Prime Minister Lord Beaconsfield (Benjamin Disraeli) and unveiled in 1880. Showing a not-very-realistic Byron seated with a dog on a large red and white marble plinth presented by the Greek government, it stands at the south end of London's Park Lane.

ground floor of John Lewis's department store. Not far away a statue by Richard Belt (fig. 134), paid for with funds raised under the chairmanship of Prime Minister Lord Beaconsfield (Benjamin Disraeli) was unveiled in 1880. Showing a not-very-realistic Byron seated with a dog, on a large red and white marble plinth presented by the Greek government, it stands at the south end of London's Park Lane, on a traffic island now separated from Hyde Park by swirling streams of cars and buses, detached from twenty-first-century life in the remains of a haven of Victorian respectability. Elsewhere, however, on and offline, the poetic and the biographical Byron, and his visual and imaginative alter egos, with their variety, allure, energy, wit, challenge, subtlety and intelligence, are still very much connected and continue to live on.

Notes

1 Morgan 2.200.

2 Marchand 2.692.

3 Paston and Quennell page 264.

4 *Don Juan*, Canto 11, line 440. *LBCPW* 5.482.

5 'Detached Thoughts' (1821–2), 29, *BLJ* 9.22.

6 Letters to John Murray: 8 March 1822, *BLJ*. 9.122, and 23 October 1812, *BLJ* 2.234. 'Detached Thoughts' (1821–2), 25, *BLJ* 9.21.

7 Letter to Isabel Harvey, 19 May 1823, *BLJ* 10.175.

8 Letter to John Murray, 23 September 1822, *BLJ* 9.212.

9 Bearnes, Hampton and Littlewood, lot 499: 'the present portrait was for an unknown reason at a later date altered by Lady Wentworth with additions mainly to Byron's hair and chin'.

10 See https://artuk.org/discover/artworks/george-gordon-noel-17881824-lord-byron-poet-134757 (accessed 26 February 2020). The picture is also described as 'Byron in his late teens' on the Wikipedia site https://en.wikipedia.org/wiki/Early_life_of_Lord_Byron (accessed 22 February 2020).

11 Thomas Moore 1.347, quoting Byron's 'Memoranda'.

12 O'Connell pages 8–100.

13 *BLJ* 2.113.

14 Letter to Francis Hodgson, 18 October 1812, *BLJ* 2.113. Letter to John Murray, 23 August 1811, *BLJ* 2.78.

15 O'Connell pages 86–7. Rutherford page 36.

16 O'Connell page 78.

17 Letter to John Murray, 12 October 1812, *BLJ* 2.224.

18 Letters to John Murray, 23 and 28 July 1814, *BLJ* 4.144 and 4.146.

19 See Brand throughout.

20 See letters to John Murray, 8 January 1818, *BLJ* 6.3-6, and 1 August 1819, *BLJ* 6.192-8 (page 193).

21 *LBCPW* 5.593.

22 See Mulvey throughout.

23 Letter to Thomas Moore, *BLJ* 5.131. Letter to John Murray, *BLJ* 6:106.

24 Anne Isabella Milbanke's poem 'The Byromania', written in 1812, is quoted in Wilson page xii. In the same year Annabella described her future husband as 'a very bad, very good man', see Elwin page 109.

25 See Elfenbein, McDayter, Mole (2007 and 2017), Tuite and Wilson. Also exhibition at the National Portrait Gallery, London, November 2002–February 2003, 'Mad, Bad & Dangerous: The Cult of Lord Byron', curated by Fiona MacCarthy, and day conference there on 8 February 2003 in association with the Byron Society and King's College, London, with papers reported in Kenyon Jones (2008)).

26 *LBCPW* 7.40.

27 Peach page 18.

28 See examples by François Drouais, Nicolaes Maes and Joshua Reynolds.

29 Medwin (1966) page 228.

30 Peach page 18.

31 See *Don Juan*, Cantos 13, 14 and 16.

32 Johnson page 282.

33 Letter from Augusta Leigh to Lady Byron, 19 January 1816, quoted in Peach page 14.

34 Letter from Newton Hanson to John Murray, 6 April 1849, quoted in Peach page 11.

35 See Bond throughout.

36 Note from Dr Benjamin Hutchinson FRCS to Byron, John Murray Archive, National Library of Scotland, MS 43549.

37 Letter to John Hanson, 2 April 1807, *BLJ* 1.113–14.

38 See Matzneff, Peattie, Paterson and Jamison.

39 MacCarthy page 67.

40 Peach *ODNB online*. Letter to Mrs Catherine Byron, 28 June 1810, *BLJ* 1.251.

41 Peach page 31.

42 Letter to Elizabeth Pigot, 26 October 1807, *BLJ* 1.135.

43 See John Byron (1767).

44 Letter from Mrs Catherine Byron to Byron, 26 October 1810, quoted in Peach pages 31–2.

45 *LBCPW* 2.186.

46 Letter to Hobhouse, 15 May 1811, *BLJ* 2.46.

47 Beevers page 22.

48 *LBCPW* 5.561.

49 Peach pages 32–40.

50 Hobhouse's diary, 6 October 1809, quoted in Cochran (2010) page 76: 'Tried on Albanese dresses as fine as pheasants.'

51 Letter to Mrs Catherine Gordon Byron, 12 November 1809, *BLJ* 1.227. Ali's reaction was in contrast to that of the traveller Lady Hester Stanhope, who met and disliked Byron a little later. '[H]e had a great deal of vice in his looks, his eyes set close together and a contracted brow,' she commented (Peach page 12). Byron did not much like Lady Hester, either, and he had received unwelcome sexual advances from her partner, Michael Bruce, which may explain the 'contracted brow'. See MacCarthy pages 130-31.

52 Letter to John Murray, *c.* 1814, quoted in Paston and Quennel page 65.

53 Letter to William Harness, 18 March 1809, *BLJ* 1.197 8.

54 'Report on a Miniature of George Gordon Byron, 6th Baron Byron. *c.* 1809' by Annette Peach, 2011. Private collection.

55 D.L. Moore (1974) page 191.

56 T. Moore 1.347, quoting Byron's 'Memoranda'.

57 Letter to Hobhouse, 17 January 1813, *BLJ* 3.15. Douglass page 104.

58 Morgan 2.200.

59 Peach page 47.

60 Cazotte also presents Biondetta as the devil disguised as a small white spaniel, and in her commonplace book intended for Byron (though apparently not seen by him) Lamb characterised herself as 'a small spaniel Bitch whom Lord Byron took a fancy for as he saw it bounding wildly along in company with a thousand other dogs'. See Lamb Commonplace Book (Blue), John Murray Archive, National Library of Scotland .

61 Letter to John Murray, 12 October 1812, *BLJ* 2.224.

62 Letter to John Murray, 17 November 1813, *BLJ* 3.167.

63 Letter to John Murray, 23 October 1812, *BLJ* 2.234.

64 Story (throughout).

65 Beevers page 41.

66 Story page 49. Letter to Augusta Leigh, 22 June 1821, *BLJ* 8.139.

67 Story page 50.

68 Letter to John Murray, 16 August 1821, *BLJ* 8.181.

69 Peach page 47. Byron described the later miniature as having been painted 'shortly before I left your country' (letter to John Murray, 11 April 1818, *BLJ* 6.26). Story cites one version of the portrait, which belonged in 1894 to a Mr Falke, as having inscribed on the back 'Taken by James Holmes, 12th April 1816'.

70 'Journal', 27 November 1813, *BLJ* 3.224

71 Letter to Isabel Harvey, 19 May 1823, *BLJ* 10.175. Letter to James Holmes, 19 May 1823, *BLJ* 10.176. Letter to John Murray, 13–16(?) March 1821, *BLJ* 8.95. Letter to Augusta Leigh, 25 March 1817, *BLJ* 5.190.

72 Peach pages 72 and 77.

73 Letter to John Murray, 11 April 1818, *BLJ* 6.26.

74 Letter to James Holmes, 19 May 1823, *BLJ* 10.176.

75 Hazlitt 18.29.

76 Letter to John Murray, 21 April 1813, *BLJ* 3.41.

77 Letter to John Murray, 29 March 1813, John Murray Archive, National Library of Scotland MS.43517.

78 Beevers page 57. Letter to James Asperne, 14 December 1813, *BLJ* 3.198.

79 Letter to Byron, 11 January 1814, quoted in Peach page 44.

80 Beevers page 54, quoting Disraeli Papers, Bodleian Library Dep. Hughenden folios 15 and 16.

81 'Journal', 17 March 1814, *BLJ* 3.251. Peach page 43, quoting Farington 12.4377.

82 Clubbe pages 42–3.

83 Peach page 43.

84 Peach page 40.

85 John R. Murray pages 82–5 and 4–7.

86 Letter to John Murray, 21 April 1813, *BLJ* 3.41.

87 Letter to John Murray, 31 August 1820, *BLJ* 7.168.

88 'Journal', 10 March 1814, *BLJ* 3.250.

89 *LBCPW* 3.149.

90 *LBCPW* 2.122.

91 *LBCPW* 2.62.

92 Letter to Thomas Phillips, 9 September 1813, *BLJ* 3.113.

93 T. Sheldrake quoted in Lovell page 16.

94 Peach page 50.

95 Peach pages 49–65.

96 Hobhouse (1909–11) 1.98.

97 Letters to John Murray, 23 and 28 July 1814, *BLJ* 4.144 and 4.146.

98 Letter to an unknown person, 20 November 1814, *BLJ* 11.187, and Peach pages 57 and 59.

99 John Murray Archive, National Library of Scotland, *Copies Ledger A* (MS.42724), page 41.

100 Mole in Kenyon Jones (2008) pages 68–77, page 68.

101 Medwin (1834) 2.200.

102 Cunningham 6.185.

103 Williams 2.70–71.

104 Letter to Annabella Milbanke, 26 September 1814, *BLJ* 4.182.

105 Garlick page 46, citing J.R. Bloxham.

106 Letter to Mrs Catherine Gordon Byron, 12 November 1809, *BLJ* 1.227.

107 Hobhouse (1813) 1.134. The red cap with a black tassel is with the rest of Byron's costume at Bowood House, Wiltshire.

108 Letter to Lady Melbourne, 18 March 1813, *BLJ* 3.28.

109 Hazlitt, 18.18–19 (first published in *The Morning Chronicle*, 3 May 1814).

110 Piper page 130. Letter to Margaret Mercer Elphinstone, 3 May 1814, *BLJ* 4.112-13.

111 Moore (1971) pages 1–13.

112 Peach page 81.

113 Pilbeam page 130, quoting Benjamin Moran. Dickens page 131.

114 Moore (1961), page 429, quoting a note by Lady Byron in her copy of Medwin's *Conversations*. The Hon. Judith Noel (1751–1822) became Lady Milbanke on her marriage in 1777, and assumed the name Lady Noel in March 1815.

115 Elwin (1975) page 228.

116 Letter to John Murray, 26 May 1822, *BLJ* 9.164.

117 Peach pages 66–70.

118 Peach pages 70 and 72.

119 Hunt 1.27.

120 Scott page 177. The 'brother poet' was probably Samuel Taylor Coleridge, who wrote of Byron on 10 April 1816: 'so beautiful, a countenance I scarcely ever saw', describing his eyes as 'the open portals of the sun – things of light, and for light': Coleridge page 641.

121 Stocking 1.77.

122 Hunt 1.46.

123 Angelo 2.131.

124 Letter to John Murray, 16 February 1821, *BLJ* 8. 79. Letter from Murray to Byron, 30 January 1821, John Murray Archive, NLS Ms. 43497.

125 Beerbohm ed. Hart-Davis page 38.

126 *LBCPW* 2.13.

127 *LBCMP* 329-34.

128 Letter to John Murray, 14 April 1817, *BLJ* 5.213.

129 Letter to Hobhouse, 1 May 1816, *BLJ* 5.73. Letter to Augusta Leigh, 1 May 1816, *BLJ* 5.74.

130 Letter to John Murray, 14 April 1817, *BLJ* 5.213.

131 *LBCPW* 4.133.

132 Letter to John Murray, 14 April 1817, *BLJ* 5.213.

133 Letter to Hobhouse, 20 June 1817, *BLJ* 5.243.

134 'Detached Thoughts' 25, 1821 or 1822, *BLJ* 9.21. Coolidge's bust is now in the Museum of Fine Arts, Boston, USA.

135 Medwin (1966) page 7.

136 Piper page 138.

137 Letter from Byron to John Murray (from Venice) 12 October 1817: 'Mr Kinnaird & his brother Lord K. have been here – and are now gone again' *(BLJ* 5.267). Hobhouse, in a letter to John Murray from Venice on 7 December 1817, offered Murray the opportunity to apply for his own copy of the bust from Thorvaldsen and added, 'with the exception of Mr. Kinnaird, who has applied, and Mr. Davies, who may apply, no other will be granted' (Smiles 1.391). See Kenyon Jones (2005).

138 Peach page 80.

139 Macaulay page 545.

140 Peach page 85.

141 Peach pages 85 and 87.

142 See Kenyon Jones (2005) page 110. R Sinker pages 422–3. Author's translation from Hobhouse's French, which reads: 'Je ne sais pas s'il sera nécessaire de vous avertir que le pied droit de Byron était un peu contrefait. Du reste ses proportions étaient belles et grandes, surtout la poitrine et les épaules, comme vous aurez, sans doute, remarqué. Son portrait, grâces [sic] à vos soins, est mieux connu que tout autre du monde. J'en ai l'original de votre main.'

143 Hobhouse, *Diary*, February 1847, quoted in Peach, page 86.

144 See Beerbohm (1972), ed. Hart-Davis, page 38.

145 Letter to Thomas Moore, 19 September 1819, *BLJ* 8.68.

146 Letters to Richard Belgrave Hoppner, 10 February 1821, *BLJ* 8.76; to Douglas Kinnaird, 26 February 1821, *BLJ* 8.87, and to Hoppner, 3 April 1821, *BLJ* 8.978.

147 Letter to Augusta, 25 March 1817, *BLJ* 5.191.

148 Letter to Augusta, 25 March 1817, *BLJ* 5.191.

149 *Don Juan*, Canto 1, line 136, *LBCPW* 5.14.

150 D.L. Moore (1974) page 200.

151 'Additional Note, on the Turks', *LBCPW* 2.210.

152 Letter to Count Giuseppe Alborghetti, 1 July 1819, *BLJ* 6.172.

153 Origo pages 404–5, quoted in Peach page 91.

154 Letter to Augusta, 23 December 1819, *BLJ* 6.259. Letter from Teresa, quoted in Peach page 97.

155 Fagnani page 52, quoted in Peach page 97.

156 Mary R Darby Smith, paraphrasing Teresa Guiccioli, see Guiccioli pages 1–2.

157 'Journal', 24 November 1813, *BLJ* 3.220.

158 Letter to John Murray, 8 March 1822, *BLJ* 9.122.

159 A marble version of Bartolini's bust of Teresa Guiccioli belongs to the Biblioteca Classense, Ravenna.

160 Medwin (1966) pages 7–9.

161 Medwin (1966) page 7.

162 Edward Ellerker Williams page 34, quoted in Peach page 103.

163 Peach page 105.

164 Letter to John Murray, 23 September 1822, *BLJ* 9.212.

165 Hobhouse (1909–11) 3.8, quoted in Peach page 104.

166 Teresa's account of *La Vie de Lord Byron en Italie* was unfinished at the time of her death in 1873.

167 See National Portrait Gallery, London, overview of NPG 1367. https://www.npg.org.uk/collections/search/portraitExtended/mw00992/Lord-Byron (accessed 9 January 2020).

168 Leigh Hunt and Hobhouse quoted in Peach pages 111 and 105.

169 See Lowell Libson & Jonny Yarker Ltd., British Art, https://www.libson-yarker.com/pictures/lord-byron (accessed 28 December 2019).

170 Leigh Hunt quoted in Peach 114.

171 Mary Wollstonecraft Shelley, 1.352, letter to William Godwin, October-November 1826.

172 West page 243.

173 Letter to Lady Hardy, 10 June 1823, *BLJ* 10.198.

174 The writing on the scrap of paper accompanying the skin reads (with thanks to Dr Claudia Giuliani, Biblioteca Classense, Ravenna): 'Pelle di L. Byron cadutagli in una malattia presa per aver nuotato tre ore consecutive agli ardenti raggi del sole di agosto nell'anno 1822'. The translation (with thanks to Professor Carla Pomarè and Francesca Parinelli) reads: 'Skin of L. Byron lost in an illness caused by having swum three hours consecutively in the fiery rays of the August sun in the year 1822.'

175 Trelawny 1.208.

176 Trelawny 1.210.

177 Peach pages 119–21.

178 Blessington pages 6–7.

179 Blessington page 49.

180 Letter to Thomas Phillips, 6 March 1814, *BLJ* 4:79; letters to John Murray, 24 July 1814, *BLJ* 4:145 and 6 March 1822, *BLJ* .9.121.

181 Blessington page 220.

182 '[T]he camelion poet': letter to Richard Woodhouse, 27 October 1818, Keats page 157.

183 *LBCPW* 5.614.

184 Parry illustration between pages 126 and 127.

185 Parry page 75.

186 Ordoyno page 1.

187 Hobhouse *Diary*, 12 July 1824.

188 Barber (1925) and Beardsmore (1907).

189 The plaque on the statue reads: 'Erected in memory of Lord Byron by Elias Lacey of this town, May 30th 1902'.

190 Longford (1976), Appendix, pages 215–19: 'Opening of Lord Byron's Vault, 15 June 1938: notes by A.R. Houldsworth, People's Warden, 1938–42, Hucknall Parish Church'.

191 Longford/Houldsworth page 217–18.

192 Rogers page 134.

193 Barber page 137.

194 Longford/Houldsworth page 217. Rogers page 134.

195 See Dash https://aforteantinthearchives.wordpress.com/2010/10/16/erotic-secrets-of-lord-byrons-tomb/ (accessed 13 February 2020).

196 *LBCPW* 5.79.

197 Beerbohm (2002) page 268.

198 https://talbot.bodleian.ox.ac.uk/2016/09/16/thomas-moore-the-ladies-of-lacock/ and https://iconicphotos.wordpress.com/2013/09/15/5806/ (accessed 4 May 2020).

199 Wilkins, throughout.

200 Mole in Kenyon Jones (2008) page 69.

201 O'Connell page 78.

202 Mole (2017) page 17.

203 St Clair page 219.

204 See Christine Kenyon Jones, 'Byron's afterlife in visual art: illustration' in Jonathon Shears and Alan Rawes (eds), *The Oxford Handbook of Byron* (Oxford: Oxford University Press, forthcoming).

205 Garrett page 148.

206 Thackeray page 173.

207 Chiswick Auctions, Lot 1. https://auctions.chiswickauctions.co.uk/auctions/7365/srchis10694 (accessed 20 February 2020).

208 Noakes page 22, quoting Lear's diary.

209 Demetriou page 100.

210 Letter to the London Greek Committee, 4 March 1824, *BLJ* 11.127–8, and letter to the *Chronica Greca*, 23 March 1824, *BLJ* supplementary vol. pages 83–4.

211 Longford (1975) page 123.

212 Cruikshank could possibly have seen the George Sanders 1807–9 portrait of Byron, which was at John Murray's at this time, but the trousers in his print are different from those in Sanders' sailors' costume.

213 See *LBCPW* 3.380-82.

214 'Lord Byron' in *The Nic-Nac* pages 220–21.

215 Hone page 8.

216 '"Don John," or Don Juan unmasked' quoted in Cochran (ed.) *William Hone*. https://petercochran.files.wordpress.com/2011/08/william-hone-canto-thethird.pdf (accessed 23 February 2020).

217 Anonymous, illus. I.R. Cruikshank, and Clinton, illus. G. Cruikshank.

218 Thanks to Danièle Sarrat for this translation.

219 Garrett pages 44–5.

220 Cochran in Kenyon Jones (2008) throughout.

221 Mole in *Branch*, https://www.branchcollective.org/?ps_articles=tom-mole-romantic-memorials-in-the-victorian-city-the-inauguration-of-the-blue-plaque-scheme-1868 (accessed 23 February 2020).

Notes to illustrations

Image L, page 13 Artist unknown, '*Lord Byron circa 1804–6, from a portrait belonging to A.C. Benson Esqre.*', date unknown. Photographic reproduction (10.4 x 8.5 cm) of a painting now at Trinity College, Cambridge. Frontispiece to volume 1 of Rowland E. Prothero, *The Works of Lord Byron: Letters and Journals*, 6 vols (London: John Murray 1898–1904). Private collection.

Image M, page 14 Artist unknown, '*Byron as a boy*', date unknown. Watercolour on ivory? (8 x 6.5 cm). Byron family collection.

1 Published by Currier & Ives (print-makers *fl.* 1835–1907), *Byron in the Highlands*, *c.* 1865. Coloured engraving (34 x 23 cm). Private collection.

2 William Kay (*fl.* 1795), *Byron at the age of seven*, 1795. Watercolour on card (oval, 13.1 x 10.1 cm). © Agence Roger-Viollet, Paris.

3 Edward Finden (1791–1857) after William Kay, *Byron at the age of seven*, 1832. Line engraving, proof impression (22.1 x 15.1 cm). John Murray Collection.

4 John Leacroft or Robert Leacroft (*fl.* 1806), *Lord Byron aet: 18*, 1806. Pen and ink on card (24.8 x 19.7 cm). Private collection.

5 Elizabeth Pigot (1783–1866), *Lord Byron's right eye*, 1807. Pencil and watercolour miniature on paper (circular, diameter 2 cm). Private collection.

6 & 7 Elizabeth Pigot, *The Wonderful History of Lord Byron & His Dog*, 1807. 'Lord Byron look'd pleas'd, I know what he saw' and 'He went into the house & sat down to writing'. Pen, ink and watercolour on paper (11.5 x 9.8 cm). Harry Ransom Humanities Research Center, The University of Texas at Austin.

8–13 Elizabeth Pigot, *The Wonderful History of Lord Byron & His Dog*, 1807. 'He went out to cricket to make himself thinner'; 'He went into the Bath, to boil off his Fat'; 'He went down to Church, tho' without much devotion'; 'He thought he was dead, & began for to weep'; 'He went to the club to eat Oysters with Many' and 'So he call'd for his Carriage, drove off from the door'.

14 Scrope Berdmore Davies (1782–1852), *Ld B. as an Amatory Writer*, 1809. Pen and ink on paper (22.7 x 38.3 cm). John Murray Archive, National Library of Scotland.

15 George Sanders (1774–1846), *Lord Byron and Robert Rushton*, 1807–9. Oil on canvas (112.5 x 89.4 cm). © Royal Collection Trust. Her Majesty Queen Elizabeth II, 2019.

16 William Finden (1787–1852), *Lord Byron at the age of 19 Engraved from the original Picture in the possession of John Cam Hobhouse Esqr. M.P.*, 1830. Line engraving (27.4 x 19.8 cm). Frontispiece to volume 2 of Thomas Moore, *Letters and Journals of Lord Byron with Notices of His Life*, 2 vols (London: John Murray, 1830). Private collection.

17 William Finden after George Sanders, *Lord Byron at the age of 19*, 1833. Engraving (23 x 16 cm). Illustration to volume 1 of *Finden's Landscape & Portrait Illustrations, to the Life and Works of Lord Byron*, 4 vols (London: John Murray, 1833), plate 1. Private collection.

18 Edward Finden after George Sanders, *Lord Byron at the age of 19*, 1834. Engraving (24 x 16 cm). Frontispiece to W. Brockedon, *Finden's Illustrations to the Life & Works of Lord Byron* (London: John Murray, 1834). Private collection.

19 Attributed to George Sanders (probably artist's copy), *Byron*, *c.* 1812. Watercolour miniature on ivory (13.5 x 10.5 cm with frame). John Murray Collection.

20 Thomas Wright (1792–1849) after George Sanders (1809), *George Gordon, Lord Byron, from the portrait miniature painted by G. Sanders for the Honble. Augusta Mary Leigh, His Lordships [sic] Sister*, 1830. Stipple engraving (25 x 19 cm). New York Public Library.

21 & 22 Artist unknown, perhaps after a miniature by George Sanders (1809 or 1812), '*Lord Byron 1788-1824, given by Lord Byron to his friend Andrew Fitzgerald Reynolds, Melton Grange*',

date unknown. Miniature, watercolour, probably on ivory (7.5 x 6.5 cm), with inscription on the back made after 1824. Private collection.

23 Henry Hoppner Meyer (*c.* 1782–1847) after George Sanders (1812), *Byron*, 1812. Line and stipple engraving, proof impression (12 x 8.8 cm), John Murray Collection.

24 Richard Westall RA (1765–1836), *Illustration to* Childe Harold's Pilgrimage, *canto 4, stanzas 150-51, 'Thy sire's heart'*, 1818. Watercolour on paper (12.5 x 10 cm). John Murray Collection.

25 Emma Eleanora Kendrick (*c.* 1788-1871), *Byron after George Sanders*, *c.* 1814. Watercolour (5.3 x 4.4 cm oval). Miniature in an oval gold locket (maker unknown), inscribed on the front 'san fedele alla mia / Biondetta / non posso vivere senza te / August 14th. 1812', and on the back 'ne crede Byron'. The Bodleian Libraries, The University of Oxford, MS Eng. Misc. g.181.

26 Artist unknown, perhaps Lady Anne Blunt (1837–1917) after George Sanders (1812), *George Gordon VI Lord Byron*, date unknown. Oil on canvas (67 x 55 cm). Byron family collection.

27 Robert Graves (1798–1873) after James Holmes (1813), *Noel Byron aet: 25, from an original Miniature in the possession of Lieut. Col. Leicester Stanhope*, 1828. Stipple engraving (22.9 x 17.3 cm). Frontispiece to Leicester Stanhope, *Greece in 1823, 1824 & 1825* (London: Sherwood, Gilbert and Piper, 1828). © National Portrait Gallery, London.

28 James Holmes, *Byron 1816*, *c.* 1898. Photographic print from the negative by Sir Emery Walker (1851–1933) (14 x 8.5 cm). © National Portrait Gallery, London.

29 James Holmes (1777–1860), *Byron 1816*, artist's copy, *c.* 1824. Watercolour miniature on ivory (10.5 x 7.5 cm). Private collection.

30 Henry Hoppner Meyer after James Holmes, *Byron 1816*, 1817. Stipple engraving, hand painted in watercolour

(10.7 x 8.2 cm). © National Portrait Gallery, London.

31 Richard Westall RA, *Gordon* [sic] *Lord Byron*, 1813. Oil on canvas (91.8 x 71.1 cm). © National Portrait Gallery, London.

32 Thomas Blood (1777–1850) *Byron engraved for* The European Magazine *after a painting by R. Westall*, 1814. Stipple engraving (15.8 x 11.5 cm). © National Portrait Gallery, London.

33 George Cattermole (1800–68) after Richard Westall RA, *Byron*, date unknown (posthumous). Pencil and ink (12.5 x 14 cm). John Murray Collection.

34 Charles Mottram (1807–76) after John Doyle (1797–1868), *Breakfast at Samuel Rogers's Residence*, c. 1835. Mezzotint (67.5 x 94 cm). Private collection.

35 Richard Westall RA, *Byron*, c. 1825. Oil on canvas (76 x 63.5 cm). © National Portrait Gallery, London.

36 Richard Westall RA, *Illustration to Childe Harold's Pilgrimage, canto 1, stanza 6: 'And now Childe Harold was sore sick at heart'*, 1818. Watercolour on paper (12.5 x 10 cm). John Murray Collection.

37 Richard Westall RA, *Byron*, variant portrait, 1813. Oil on canvas (124.5 x 104 cm). © National Trust Images. Hughenden Manor, Buckinghamshire.

38 Richard Westall RA, *Illustration to 'The Dream', stanza 4, 'Couched among fallen columns'*, 1818. Watercolour on paper (12.5 x 10 cm). John Murray Collection.

39 Richard Westall RA, *Illustration to Childe Harold's Pilgrimage, canto 2, stanzas 67–8, 'Vain fear'*, 1818. Watercolour on paper (12.5 x 10 cm). John Murray Collection.

40 Charles Heath (1785–1848) after Thomas Stothard RA (1755–1834), *Illustration to 'Thyrza'*, 1814. Engraving (12.5 x 10 cm). John Murray Collection.

41 Thomas Phillips RA (1770–1845), *Portrait of a Nobleman*, 1813. Oil on canvas (91 x 71 cm). Private collection. Photograph by Natalie Shaw.

42 Thomas Phillips RA, *Portrait of a Nobleman*, 1814. Oil on canvas (89.5 x 68.6 cm). John Murray Collection.

43 Thomas Phillips RA, *Portrait of a Nobleman*, c. 1818. Oil on canvas (88 x 70.5 cm). City of Nottingham Museums, Newstead Abbey Collections.

44 John Samuel Agar (1773–1858) after Thomas Phillips RA, *Lord Byron*, 1814. Engraving (21.8 x 18 cm). Private collection.

45 Joseph West (born 1797) after Thomas Phillips RA and George Henry Harlow (1787–1819), *Lord Byron, from a sketch taken on his leaving England*, c. 1816. Stipple engraving (27 x 20 cm). Private collection.

46 Maxim Gauci ((1774–1854), *George Gordon, Lord Byron, To Chandos Leigh Esqr. ... Drawn on stone*, 1819. Lithograph (40 x 28 cm). Private collection.

47 Thomas Phillips RA, *Portrait of a Nobleman in the Dress of an Albanian*, 1814. Oil on canvas (127.5 x 102 cm). Government Art Collection, HM Ambassador's Residence, Athens.

48 Gems Ltd., head after Lorenzo Bartolini (1822), *Byron in his Albanian Costume*, 1987–8. Wax mannequin of Byron wearing his original Albanian costume (life-size). Bowood House, Wiltshire, Marquis of Lansdowne. Photograph by Dr Cathryn Spence.

49 Hablot K. Browne ('Phiz', 1815–1882), *'Mrs Jarley's Waxworks', Illustration to* The Old Curiosity Shop *by Charles Dickens* (1840–41). Engraved coloured print (17 x 10.8 cm). 19th century era/Alamy Stock Photo.

50 Thomas Phillips RA, *Byron in Albanian Dress*, artist's copy, half-length, c. 1835. Oil on canvas (76.5 x 63.9 cm). © National Portrait Gallery, London.

51 William Finden after Thomas Stothard RA, *Illustration to 'The Giaour', line 668: 'His back to earth, his face to heaven'*, 1814. Engraving (12.5 x 10 cm). John Murray Collection.

52 Anne Isabella, Lady Byron (1792–1860), *Byron*, 1815. Pencil on paper (22.8 x 18 cm). The Bodleian Libraries, The University of Oxford, Dep. Lovelace Byron 154, fol. 200r. Reproduced by permission of Paper Lion Ltd., and the Proprietor of the Lovelace Byron Papers.

53 George Henry Harlow, *Byron*, 1815. Black chalk with touches of sanguine on cream wove paper (22.6 x 17.4 cm). Private collection.

54 Henry Hoppner Meyer, *Lord Byron from a drawing by G.H. Harlowe* [sic], 1815.

Engraving (22.5 x 14.8 cm). Frontispiece to *The New Monthly Magazine*, 1 August 1815. John Murray Collection.

55 Henry Hoppner Meyer after George Henry Harlow, *George Gordon Byron, Lord Byron*, published by T. Cadell and W. Davies, in the *British Gallery of Contemporary Portraits*, 30 January 1816. Stipple engraving (38 x 32.7 cm). © National Portrait Gallery, London.

56 Gottfried Engelmann (1788–1839) after George Henry Harlow, *Lord Byron*, 1819. Lithograph (17 x 9.5 cm). Frontispiece to *English Bards and Scotch Reviewers*, third edition (Paris: Galignani, 1819). Private collection.

57 Artist unknown, commissioned by John Murray II (1778–1843) after George Harlow, gold ring set with a cornelian with an intaglio image of Byron, c. 1816–20, and impression in wax from this (oval, diameter c. 1 cm). John Murray Collection.

58 L. Werner (fl. 1850), *Drawing Room at Fifty Albemarle Street*, c. 1850. Watercolour on paper (31 x 40 cm). John Murray Collection.

59 F.W. Hunt (fl. 1871) after 'Gilchrist' (fl. 1871) with head after George Henry Harlow (1815), *Lord Byron in the University of Cambridge dress gown of a nobleman*, 1871. Engraved print (17.5 x 10 cm). Private collection.

60 Max Beerbohm (1872–1956), *Lord Byron, shaking the dust of England from his shoes*, 1904. Print of drawing (34 x 21 cm). Private collection.

61 Bertel Thorvaldsen (1770–1844), *Byron*, c. 1822. Marble bust (height 46.5 cm). John Murray Collection.

62 Josef Denis Odevaere (1775–1830), *Lord Byron on his death-bed*, c. 1826. Oil on canvas (166 x 234.5 cm). Groeningemuseum, Bruges.

63 Bertel Thorvaldsen, *Byron*, 1817. Plaster bust (height 66.9 cm). Thorvaldsens Museum, Copenhagen.

64a, 64b & 65 Bertel Thorvaldsen, *Byron*, 1830–34. Marble statue with relief panel showing 'The Genius of Poetry'. Sara Rawlinson Photography, and the Master and Fellows of Trinity College, Cambridge.

66 Max Beerbohm, *Our Abbey*, 1924. Coloured drawing (34 x 27.3 cm). Art Gallery of New South Wales, Sydney.

67 George Henry Harlow, *Byron a Venezia*, 1818. Black and white chalk with touches of sanguine on paper (28.5 x 23.5 cm). John Murray Collection.

68 Joseph Nash (1809–78) after John Scarlett Davis (1804–45), *Byron's Room in the Palazzo Mocenigo, Venice*, after 1839. Engraved print (30.8 x 40.6 cm). Private collection.

69 Richard Westall RA, *Byron & Allegra*, date unknown. Watercolour on paper (8 x 6 cm). John Murray Collection.

70 Girolamo Prepiani, *Teresa Guiccioli and Byron*, c. 1819. Probably watercolour on ivory (9.8 x 11.2 cm). Biblioteca Classense, Ravenna, Fondo Byron.

71 Girolamo Prepiani, *Byron*, c. 1817. Watercolour on ivory (3 x 2.4 cm). Biblioteca Classense, Ravenna, Fondo Byron.

72 Girolamo Prepiani, *Byron*, 1819. Watercolour on ivory (3.2 x 1.9 cm). Biblioteca Classense, Ravenna, Fondo Byron.

73 Girolamo Prepiani (1750s–after 1835), *Byron* c. 1817. Oil on ivory (6.2 x 5.1 cm). City of Nottingham Museums, Newstead Abbey Collections.

74 Girolamo Prepiani, *Byron*, c. 1817. Watercolour on ivory (circular, diameter 6.7 cm). City of Nottingham Museums, Newstead Abbey Collections.

75 Giuseppe Fagnani (1819–1873) after Girolamo Prepiani, *Byron*, c. 1860. Oil on canvas (73 x 60 cm). Private collection.

76, 77 & 78 Lorenzo Bartolini, *Byron*, 1822. *Terracruda* bust (height 50 cm without socle). Lowell Lisbon & Jonny Yarker Ltd.

79 Lorenzo Bartolini, *Byron*, c. 1822. Marble bust (height 59.7 cm) © National Portrait Gallery, London.

80 Raphael Morghen (1758–1833), *Byron*, 1822. Line engraving (26.1 x 20.4 cm). © National Portrait Gallery, London.

81 Lorenzo Bartolini (1777–1850), *Byron*, c. 1822. Plaster cast of bust (height 65 cm). Galleria dell'Accademia Firenze © 2020. Photo Scala, Florence, courtesy of the Ministero per i beni e le attività culturali e per il turismo.

82 Samuel Freeman (1773–1857) after Marianne Hunt (1788–1857), *Lord Byron as he appeared after his daily ride at Pisa and Genoa*, 1828. Engraving after cut paper silhouette (26.5 x 21 cm). Frontispiece to Leigh Hunt, *Lord Byron and Some of His Contemporaries*, 2 vols (London: Henry Colburn, 1828). Private collection.

83 William Edward West (1801–61), *Lord Byron*, 1822. Oil on canvas (78.8 x 66 cm). © National Galleries of Scotland, Edinburgh: Bridgeman Images.

84 Collected by Teresa, Contessa Guiccioli (1800–73), 'Pelle di L. Byron cadutagli in una malattia presa per aver nuotato tre ore consecutive agli ardenti raggi del sole di agosto nell'anno 1822'. Glass container with flakes of skin and handwritten note by Teresa Guiccioli. Biblioteca Classense, Ravenna, Fondo Byron.

85 Louis Edouard Fournier (1857–after 1903), *The Funeral of Shelley*, 1889. Oil on canvas (129.5 x 213.4 cm). © Walker Art Gallery, Liverpool, Bridgeman Images.

86 Count Alfred D'Orsay (1801–52), *Lord Byron fait à Gènes en 1823*, 1823. Pencil and watercolour on paper (28.2 x 20.6 cm). John Murray Collection.

87 Count Alfred D'Orsay, *Lord Byron at Genoa*, 1823. Pencil on paper (27 x 19.5 cm). John Murray Collection.

88 And[rea?] Isola (fl. 1823), *Byron at Genoa*, 1823. Pencil and red chalk on paper (circular, diameter 6.2 cm). John Murray Collection.

89 Gustave Moreau (1826–98), *Byron as described by Lady Blessington*, c. 1880. Satirical sketch: pencil on square-ruled paper (c. 12 x 8 cm). Musée Gustave Moreau, Paris.

90 E [?]. Clark after Robert Seymour, from a sketch by William Parry, 'Lord Byron on his Death Bed', 1825. Engraving (12 x 20.5 cm). Illustration to William Parry, *The Last Days of Lord Byron* (London: Knight and Lacey, 1825) page 126. Private collection.

91 E [?]. Clark (fl. 1825) after Robert Seymour (1798–1836), from a sketch by William Parry (1773–1859) 'Lyon you are no rogue Lyon', 1825. Engraving (20.5 x 12 cm). Frontispiece to William Parry, *The Last Days of Lord Byron* (London: Knight and Lacey, 1825). Private collection.

92 John Adams Acton (1830–1910) after George Henry Harlow, *The Pilgrim of Eternity*, 1893. Marble circular wall medallion with Byron's head in profile (c. 75 cm diameter). Courtesy of Hucknall Parish Church, Nottinghamshire.

93 Artist unknown, Morgan Roth & Co., Gotha, *Byron and his associates*, 1866. 24 painted porcelain pipes in a carved wooden box (octagonal, diameter 65 cm). John Murray Collection.

94 Max Beerbohm, *But for Missolonghi*, 1911. Illustration (circular, 10 cm diameter) for Max Beerbohm, *Zuleika Dobson: or, an Oxford Love Story* (London: William Heinemann, 1911). Private collection.

95 Sir Charles Lock Eastlake (1793–1865), *Lord Byron's 'Dream'*. Oil on canvas (118.1 x 170.8 cm). © Tate Britain, London.

96 Artists unknown, three cravat pins with portraits of Byron, c. 1870. Two in cameo relief and one painted on ceramic (each c. 5.5 cm long). Private collection.

97 Andrew Picken (1815–45), *Newstead Abbey, The Seat of the Late Lord Byron*, c. 1835. Puzzle print: lithograph (15.5 x 13.5 cm). Private collection.

98 Henry Burn (1807–84), *The Spirit of Byron in the Isles of Greece*, 1825. Puzzle print: lithograph (17.5 x 13 cm). Private collection.

99 Compiler and writer unknown, 'From a Lock of Lord Byron's Hair in my Possession', c. 1850. Lock of hair, wax seal and handwritten inscription on card, in a marbled cardboard oval frame, pasted into a volume of Byron's works dated 1850 (17 x 10.8 cm). Lot 1 in *The Poet, the Lover and the Patriot: Lord Byron*, auction held by Chiswick Auctions, London, 27 February 2020.

100 Artist unknown, *A new hollowcut of Byron*, c. 1816. Cut paper silhouette (12.5 x 16 cm). Private collection.

101 Artist unknown, Robinson and Leadbeater, *Byron*, c. 1870. Parian ware bust (21.5 x 14 cm). Private collection.

102 Top left: Artist unknown, *Byron*, c. 1848. Staffordshire ware seated figure (28 x 15 cm). Private collection.
Top right: Artist unknown after George Sanders, *Byron*, 1865. Minton Factory, Stoke, ceramic figure standing with hand on rock (15 x 8.5 cm). Private collection.

Bottom left: Artist unknown, *Byron c. 1850*. Staffordshire ware bust on square base (14.5 x 3 cm). Private collection.
Bottom right: Artist unknown, *Byron in Greek dress, c. 1850*. Staffordshire ware figure, full-length (40 x 14 cm). Private collection.

103 Artist unknown, *Byron, c. 1820*. Pratt ware ceramic bust (48 x 20 cm). Private collection.

104 Artist unknown, snuffbox with a profile of Byron's head, date unknown. Ivory (circular, diameter 7.5 cm). John Murray Collection.

105 John Haslem (1808–84) after Thomas Phillips RA, *Lord Byron, 1836*. Miniature portrait on Derby porcelain plaque (17 x 13 cm). Private collection.

106 Artist unknown after Thomas Phillips RA, *Byron, c. 1850*. Miniature portrait on Staffordshire ware porcelain plaque (16.5 x 11.5 cm). Private collection.

107 Artist unknown, *Byron, 1926*. Silver, hallmarked Birmingham 1926, Masonic Master's jewel for Lodge number 7426 (England) (11.5 x 5 cm). Private collection.

108 Artist unknown, *Lord Byron, c.1820*. Lustreware jug with Byron's bust and Masonic symbols (height 14 cm). Private collection.

109 Benjamin Rawlinson Faulkner, Byron, *c. 1824*. Bronze figure of Byron leaning on a column (height 21 cm, base 13.75 x 7.5 cm). Private collection.

110 Artist unknown, Grainger, Lee and Co., *Byron and the Maid of Athens, 1830–35*. Parian ware sculpture (36 x 24 cm). John Murray Collection.

111 Henry Bone RA (1755–1840) after William Edward West, *Byron, after 1823*. Oil painting on copper plaque in carved wooden frame (14 x 11.5 cm). Private collection.

112 Benjamin Rawlinson Faulkner (1787–1849), *Lord Byron, c. 1824*. Bronze commemorative medal (circular, diameter 10 cm). Private collection.

113 Filippo Pistrucci (1782–1859), *Non omnis moriar, c. 1824*. Lithograph (40.2 x 31.4 cm). John Murray Collection.

114 Patricia Ferguson (1959–2019) after George Henry Harlow, *B is for Byron*, 2009. Linocut in black and brown ink on paper (20 x 19.5 cm). Private collection.

115 Artist unknown after Thomas Phillips RA, Halcyon Days, limited edition, *Byron in Albanian costume*, 1988. Porcelain snuffbox (oval, 7 x 5 cm). Private collection.

116 Ludovico Lipparini (1802–56), *Lord Byron's Oath on the Grave of Marco Botsaris*, 1850. Civic Art Museum, Treviso, Italy.

117 Theodoros Vryzakis (1814/19–1878), *The Reception of Lord Byron at Missolonghi*, 1861. Oil on canvas (155 x 213 cm). The National Gallery, Athens, Alexandros Soutzos Museum.

118 Giorgios Vitalis (1838–1901), *Lord Byron*, 1881. White marble statue on square marble plinth (larger than life-size). Garden of the Heroes, Missolonghi, Greece.

119 Designed by Henri-Michel Antoine Chapu (1833–91), executed by Jean Alexandre Joseph Falguière (1831–1900), *Greece crowning Lord Byron*, 1895. White marble statue on circular marble base (height 300 cm). Zappeion Gardens, Athens.

120 Drawn by Thomas Fairland (1804-52), published by Adam de Friedel (*c. 1780–?*), printed by R. Martin (*fl.1827*), *Lord Byron, the Advocate and Supporter of the Greek Nation, from a series of Greek Portraits*, 1827. Coloured lithograph (28 x 24 cm). Private collection.

121 Isaac Robert Cruikshank (1789–1856), *Lobby loungers (taken from the saloon of Drury Lane Theatre)*, 1816. Engraving with watercolour (22.5 x 39 cm). Private collection.

122 Isaac Robert Cruikshank, *Fashionables of 1816 taking the air in Hyde Park!*, 1816. Engraving with watercolour (25 x 41.3 cm). © The Trustees of the British Museum, London. All rights reserved.

123 Isaac Robert Cruikshank, *The Separation, a sketch from the private life of Lord Iron who panegyrized his wife, but satirized her confidante!!*, 1816. Engraving with watercolour (24.9 x 33.3 cm). John Murray Collection.

124 George Cruikshank (1792–1878), *Fare thee well*, 1816. Engraving with watercolour (19.2 x 25.6 cm). © The Trustees of the British Museum, London. All rights reserved.

125 Charles Williams (died 1830), *Ld. Byron, A Noble Poet Scratching up his Ideas*, 1823. Engraving with watercolour (24.9 x 28.8 cm). © The Trustees of the British Museum, London. All rights reserved.

126 Charles Williams, *Anecdotes of Lord Byron – or, a touch of the marvellous, 'Weather Wise'*, c. 1825. Coloured lithograph (12 x 17 cm). © The Trustees of the British Museum, London. All rights reserved.

127 George Cruikshank, *The Lord of the Faithless*, 1820. Wood engraving (22 x 15 cm). Illustration to William Hone, *The Men in the Moon, or, The 'Devil to Pay'* (London: 1820) page 8. Granger Historical Picture Archive/Alamy Stock Photo.

128 Jules Platier (*fl. 1840–50*), *Les Amants Célèbres – Lord Byron et la Comtesse Guiccioli*, 1840–50. Engraving (29 x 20.8 cm). Chronicle/Alamy Stock photo.

129 Anonymous, *Amours de Byron*, 1837. Engraving (18 x 11.5 cm). Frontispiece to volume 1 of John Mitford, translated by Mr F ..., *La vie privée et amours secrètes de Lord Byron*, 2 vols (Paris: Terry, 1837). Private collection.

130 Dennis Price as Byron at John Murray's, in *The Bad Lord Byron*, directed by David MacDonald, 1949. Black and white photographic print (25.5 x 20.5 cm). John Murray Collection.

131 Hugh Grant as Byron in *Rowing with the Wind*, written and directed by Gonzalo Suarez, 1988. Colour film still (digital image). Private collection.

132 Jonny Lee Miller as Byron in *Byron*, BBC TV miniseries written by Nick Dear and directed by Julian Farino, 2003. Colour film still (digital image). Private collection.

133 Richard Chamberlain as Byron in *Lady Caroline Lamb*, directed by Robert Bolt, 1972. Black and white photographic print (20.5 x 25.5 cm). John Murray Collection.

134 Richard Claude Belt (1851–1920), *Lord Byron with a dog*, 1880. Bronze statue on plinth of Greek red and white marble (larger than life-size). City of Westminster.

Bibliography

Abbreviated titles

BLJ – Byron, George Gordon Noel, Lord, ed. Leslie A. Marchand, *Byron's Letters and Journals*, 13 vols (London: John Murray, 1973–94).

LBCMP – Byron, George Gordon Noel, Lord, ed. Andrew Nicholson, *Lord Byron: The Complete Miscellaneous Prose* (Oxford: Clarendon Press, 1991).

LBCPW – Byron, George Gordon Noel, Lord, ed. Jerome J. McGann, *Lord Byron: The Complete Poetical Works* (Oxford: Clarendon Press, 1980–93).

Other works cited

Anonymous, illus. I.R. Cruikshank, *Don Juan: A correct copy from the original edition* (London: G. Smeeton, 1821).

Anonymous, 'Lord Byron', in *The Nic-Nac; or, Literary Cabinet*, 12 June 1824, pages 219–21.

Angelo, Henry, *Reminiscences of Henry Angelo, with Memoirs of His Late Father and Friends*, 2 vols (London: Henry Colburn and Richard Bentley, 1830).

Art Union of London, *Thirty illustrations of Childe Harold* (London: Art Union of London, 1855).

Barber, Canon Thomas Gerard, *Byron And Where He Is Buried* (Hucknall: Henry Morley & Sons, 1939).

Barber, Canon Thomas Gerard, *Hucknall Torkard Church: Its history and Byron associations* (1925). http://www.nottshistory.org.uk/books/hucknallchurch/hucknallchurch2.htm (accessed 13 February 2020).

Beardsmore, J.H., 'Autumn Excursion: Hucknall Torkard parish church', Transactions of the Thoroton Society, 11 (1907). http://www.nottshistory.org.uk/articles/tts/tts1907/hucknallchurch2.htm (accessed 24 February 2020).

Bearnes, Hampton and Littlewood (Exeter), catalogue for an auction sale on 6–7 November 2007.

Beerbohm, Max, ed. Rupert Hart-Davis, *A Catalogue of the Caricatures of Max Beerbohm* (Basingstoke: Macmillan, 1972).

Beerbohm, Max, *The Illustrated Zuleika Dobson, or, An Oxford Love Story* (Yale: Yale University Press, 2002).

Beevers, Robert, *The Byronic Image: The Poet Portrayed* (Abingdon: Olivia Press, 2005).

Blessington, Marguerite, Countess of, ed. Ernest J. Lovell, Jr, *Conversations of Lord Byron* (Princeton: Princeton University Press, 1969).

Bond, Geoffrey, *Lord Byron's Best Friends: from bulldogs to Boatswain & beyond* (Nottingham: Nick McCann Associates Ltd, 2013).

Brand, Emily, *The Fall of the House of Byron: Scandal and Seduction in Georgian England* (London: John Murray Press, Hodder & Stoughton Ltd, 2020).

Byron, The Honourable John, *The Narrative of the Honourable John Byron* (London: S. Baker, G. Leigh and T. Davies, 1767).

Chiswick Auctions, *The Poet, the Lover and the Patriot: Lord Byron*, catalogue for an auction sale on 27 February 2020. https://auctions.chiswickauctions.co.uk/auctions/7365/srchis10694 (accessed 20 February 2020).

Clinton, George, illus. George Cruikshank, *Memoirs of the Life and Writings of Lord Byron* (London: James Robins, 1825).

Clubbe, John, *Byron, Sully, and the Power of Portraiture* (Aldershot: Ashgate, 2005).

Cochran, Peter, *Byron and Hobby-O: the Relationship between Byron and John Cam Hobhouse* (Newcastle-upon-Tyne: Cambridge Scholars Publishing, 2010).

Cochran, Peter, 'Byron: The Cinematic Image' in Kenyon Jones (2008) pages 88–98.

Cochran, Peter (ed.), *William Hone: Don Juan, Canto the Third (1820)*. https://petercochran.files.wordpress.com/2011/08/william-hone-canto-thethird.pdf (accessed 23 February 2020).

Coleridge, Samuel Taylor, *Collected Letters of Samuel Taylor Coleridge, volume 4, 1815–1819*, ed. Earl Leslie Griggs (Oxford: Clarendon Press, 1959).

Cunningham, Allan, *The Lives of the Most Eminent British Painters, Sculptors and Architects*, 6 vols (London: John Murray, 1833).

Dash, Mike, 'Erotic secrets of Lord Byron's tomb', 16 October, 2010. https://aforteantinthearchives. wordpress.com/2010/10/16/erotic-secrets-of-lord-byrons-tomb/ (accessed 23 February 2020)

Demetriou, Spiridoula, *Imagining Modern Greece: Mesologgi, Philhellenism and Art in the 19th century* (PhD thesis, University of Melbourne, 2019).

Dickens, Charles, *The Old Curiosity Shop* (London: Chapman and Hall, 1848).

Elfenbein, Andrew, *Byron and the Victorians* (Cambridge: Cambridge University Press, 1995).

Douglass, Paul, *Lady Caroline Lamb: A Biography* (New York: Palgrave Macmillan, 2004).

Elwin, Malcolm, *Lord Byron's Family: Annabella, Ada and Augusta 1816–1824* (London: John Murray, 1975).

Elwin, Malcolm, *Lord Byron's Wife* (London: McDonald, 1962).

Fagnani, Emma, *The Art Life of a Nineteenth Century Portrait Painter Joseph Fagnani 1819–1873* (Paris: privately printed, 1930).

Farington, Joseph, ed. Kenneth Garlick and Angus Macintyre, then Kathryn Cave, *The Diary of Joseph Farington*, 17 vols (New Haven: Yale University Press, 1978–98).

Finden, Edward, and William Finden, *Finden's Byron Beauties: or, the Principal Female Characters in Lord Byron's Poems* (London: Charles Tilt, 1836).

Finden, Edward, and William Finden, *Finden's Landscape & Portrait Illustrations, to the Life and Works of Lord Byron*, 4 vols (London: John Murray, 1832–3).

Garrett, Martin, *The Palgrave Literary Dictionary of Byron* (Basingstoke: Palgrave Macmillan, 2010).

Garlick, Kenneth, *A Catalogue of the paintings, drawings and pastels of Sir Thomas Lawrence* in *The Walpole Society* XXIX, 1962–4.

Guiccioli, Teresa, Contessa, trans. Michael Rees, ed. Peter Cochran, *Lord Byron's Life in Italy* (Newark: University of Delaware Press, 2005).

Hazlitt, William, ed. P.P. Howe, *The Complete Works of William Hazlitt*, 21 vols (London: J.M. Dent & Sons Ltd, 1930–34).

Hobhouse, John Cam, *A Journey through Albania and other provinces of Turkey in Europe and Asia to Constantinople during the years 1809 and 1810*, second edition, 2 vols (London: James Cawthorn, 1813).

Hobhouse, John Cam, ed. Peter Cochran, *Hobhouse's Diary for Byron's Funeral (Edited from British Library Add MS 56549)*. https://petercochran.files.wordpress.com/2009/12/32-1824-byrons-death-and-funeral1.pdf (accessed 23 February 2020).

Hobhouse, John Cam, ed. Charlotte, Lady Dorchester, *Recollections of a Long Life*, 6 vols (London: John Murray, 1909–11).

Hone, William, *The Men in the Moon, or, The 'Devil to Pay'* (London: 'Printed for the Author', 1820).

Houldsworth, A.R., 'Opening of Lord Byron's Vault, 15 June 1938: notes by A.R. Houldsworth, People's Warden, 1938–42, Hucknall, Parish Church'. Appendix in Longford (1976), pages 215–19.

Hunt, Leigh, *Lord Byron and Some of His Contemporaries; with Recollections of the Author's Life and of His Visit to Italy*, 2 vols (London: Henry Colburn, 1828).

Jamison, Kay Redfield, *Touched with Fire: Manic-Depressive Illness and the Artistic Temperament* (New York: The Free Press, 1993).

Johnson, Samuel, 'On Painting. Portraits defended', in *The Idler*, number 24, February 1759, pages 281–5.

Keats, John, ed. Robert Gittings, *Letters of John Keats: A Selection* (Oxford: Oxford University Press, 1970).

Kenyon Jones, Christine, 'Byron, Hobhouse, Thorvaldsen and the Sculptural Sublime', *Revue de l'Université de Moncton, Des actes sélectionnés du 30e Congrès International sur Byron*, numéro hors-série, 2005, pages 93–114.

Kenyon Jones, Christine, *Byron: The Image of the Poet* (Newark: University of Delaware Press, 2008).

Longford, Elizabeth, Countess of, *Byron* (London: Hutchinson, Weidenfeld and Nicolson, 1976).

Longford, Elizabeth, Countess of, *Byron's Greece* (London: Weidenfeld and Nicolson, 1975).

Lovell, Ernest J. Jr, *His Very Self and Voice, collected conversations of Lord Byron* (New York: Macmillan, 1954).

Macaulay, Thomas Babington, 'Art. XI – *Letters and Journals of Lord Byron: with Notices of his Life.* By Thomas Moore, Esq.' in *The Edinburgh Review*, June 1831 (Edinburgh: Longman etc., 1831) vol. 53, pages 544–72.

MacCarthy, Fiona, *Byron: Life and Legend* (London: John Murray, 2002).

Marchand, Leslie A., *Byron: A Biography*, 3 vols (New York: Alfred A. Knopf, 1957).

McDayter, Ghislaine, *Byron and the Birth of Celebrity Culture* (New York: SUNY Press, 2009).

Matzneff, Gabriel, *La Diététique de Lord Byron* (Paris: La Table Ronde, 1984).

Medwin, Thomas, *The Angler in Wales, or, Days and Nights of Sportsmen*, 2 vols (London: Richard Bentley, 1834).

Medwin, Thomas, ed. Ernest J. Lovell Jr, *Medwin's Conversations of Lord Byron* (Princeton: Princeton University Press, 1966).

Mitford, John, *The Private Life of Lord Byron, comprising his voluptuous amours ...* (London: H. Smith, 1836).

Mole, Tom, *Byron's Romantic Celebrity: Industrial Culture and the Hermeneutic of Intimacy* (Basingstoke: Palgrave Macmillan, 2007).

Mole, Tom, 'Romantic Memorials in the Victorian City: The Inauguration of the "Blue Plaque" Scheme, 1868', in *Branch*. https://www.branchcollective.org/?ps_articles=tom-mole-romantic-memorials-in-the-victorian-city-the-inauguration-of-the-blue-plaque-scheme-1868 (accessed 23 February 2020).

Mole, Tom, 'Ways of Seeing Byron', in Kenyon Jones (2008), pages 68–78.

Mole, Tom, *What the Victorians made of Romanticism: Material artifacts, cultural practices, and reception history* (Princeton: Princeton University Press, 2017).

Moore, Doris Langley, 'Byronic Dress', in *Costume*, vol. 5, 1971, pages 1–13.

Moore, Doris Langley, *Lord Byron: Accounts Rendered* (London: John Murray, 1974).

Moore, Doris Langley, *The Late Lord Byron* (London: John Murray, 1961).

Moore, Thomas, *Letters and Journals of Lord Byron with Notices of his Life*, 2 vols (London: John Murray 1830).

Morgan, Sidney, Lady, *Lady Morgan's Memoirs: Autobiography, Diaries and Correspondence*, 2 vols (London: W.H. Allen, 1863).

Mulvey, Laura, 'Visual Pleasure and Narrative Cinema' in *Screen*, Volume 16, issue 3, Autumn 1975, pages 6–18. https://doi.org/10.1093/screen/16.3.6 (accessed 23 February 2020).

Murray, John R. (ed.), *The Brush has Beat the Poetry!: Illustrations to Lord Byron's works* (London: Printed for presentation to the Roxburghe Club, 2016).

Noakes, Vivien, *Edward Lear: Life of a Wanderer* (Boston: Houghton, 1969).

Ordoyno, Thomas, 'Lord Byron's Funeral Procession' (Nottingham: Ordoyno, 1824).

Origo, Iris, *The Last Attachment: The Story of Byron and Teresa Guiccioli* (London: John Murray, 1949).

Nicolson, Harold, *Byron: The Last Journey April 1823–April 1824*, revised edition (London: Constable, 1940).

O'Connell, Mary, *Byron and John Murray: A Poet and his Publisher* (Liverpool: Liverpool University Press, 2014).

Parry, William, *The Last Days of Lord Byron: With His Lordship's Opinions on Various Subjects, Particularly on the State and Prospects of Greece* (London: Knight and Lacey, 1825).

Paston, George, and Peter Quenell, *'To Lord Byron': Feminine Profiles, based upon unpublished letters 1807–1824* (London: John Murray, 1939).

Paterson, Wilma, *Lord Byron's Relish: Regency Cookery Book* (Glasgow: Dog and Bone, 1990).

Peach, Annette, *Portraits of Byron* (reprinted from *The Walpole Society*, LXII, 2000).

Peach, Annette, 'Sanders, George, 1774–1846' in *Oxford Dictionary of National Biography online*. https://doi.org/10.1093/ref:odnb/24619 (accessed 23 February 2020).

Peattie, Antony, *The Private Life of Lord Byron* (London: Unbound, 2019).

Pilbeam, Pamela, *Madame Tussaud: and the History of Waxworks* (London: Hambledon, 2006).

Piper, Sir David, *The Image of the Poet: British Poets and their Portraits* (Oxford: Clarendon Press, 1982).

Prothero, Rowland E., *The Works of Lord Byron: Letters and Journals*, 6 vols (London: John Murray 1898–1904).

Andrew Rutherford (ed.), *Byron: The Critical Heritage* (London: Routledge and Kegan Paul, 1970).

Rogers, Byron, *Me: The Authorised Biography* (London: Aurum, 2009).

Scott, Walter, review of *Childe Harold*, Canto III, in *The Quarterly Review* 16 (October 1816), pages 172–208.

Shelley, Mary Wollstonecraft, ed. B.T. Bennett, *The Letters of Mary Wollstonecraft Shelley*, 3 vols (Baltimore: Johns Hopkins University Press, 1980–88).

Sinker, R., 'The Statue of Byron in the Library of Trinity College, Cambridge', in *Notes and Queries*, 26 November 1881, pages 421–3.

Smiles, Samuel, *A Publisher and His Friends: Memoir and Correspondence of John Murray; With an Account of the Origin and Progress of the House, 1768–1843*, 2 vols (London: John Murray, 1891).

Stanhope, Leicester, Colonel, *Greece in 1823, 1824 & 1825* (London: Sherwood, Gilbert and Piper, 1828).

St Clair, William, *The Reading Nation in the Romantic Period* (Cambridge: Cambridge University Press, 2004).

Stocking, Marion Kingston (ed.), *The Clairmont Correspondence: Letters of Claire Clairmont, Charles Clairmont, and Fanny Imlay Godwin*, 2 vols (Baltimore: Johns Hopkins University Press, 1995).

Story, Alfred T., *James Holmes and John Varley* (London: Richard Bentley and Son, 1894).

Thackeray, William Makepeace, ed. Richard Pearson, *The William Makepeace Thackeray Library: Volume 2 – Early Travel Writings* (Abingdon: Routledge, 1996).

Trelawny, Edward John, *Records of Shelley, Byron and the Author*, 2 vols, 1878 (reissued New York: Benjamin Blom, 1968).

Tuite, Clara, *Lord Byron and Scandalous Celebrity* (Cambridge; Cambridge University Press, 2015).

West, William Edward, 'Lord Byron's Last Portrait …', in *New Monthly Magazine*, 16 (1826), pages 243–8.

Wilkins, George, *Lord Nelson: Tracing the Hero's Features* (Ballarat: Bridgemall Collections, 2016).

Williams, D.E., *The Life and Correspondence of Sir Thomas Lawrence*, 2 vols (London: Henry Colburn and Richard Bentley, 1831).

Williams, Edward E., ed. Richard Garnett, *Journal of Edward Ellerker Williams* (London: E. Mathews, 1902).

Wilson, Frances (ed.), *Byromania: Portraits of the Artist in Nineteenth- and Twentieth-Century Culture* (Basingstoke: Macmillan, 1999).

Acknowledgements

The authors and publisher would like to thank the following individuals, institutions, collections, photographic libraries, museums and galleries for their assistance, knowledge and photographs. The authors are interested in new discoveries of Byron portraits and will be pleased to hear about them.

Agence Roger-Viollet

Alamy Ltd

Nasser Al-Tell

Dr Floriana Amicucci, Ufficio Manoscritti e Rari, Istituzione Biblioteca Classense, Ravenna.

Art Gallery of New South Wales, Sydney

Christine Ayre

Helen Barron

Professor Roderick Beaton

Istituzione Biblioteca Classense, Ravenna, Fondo Byron

The Bodleian Libraries, The University of Oxford

Bowood House, Wiltshire, Marquis of Lansdowne

Bridgeman Images

© The Trustees of the British Museum, London

Simon Brown, Curator, Newstead Abbey Collections

Brian Butler

Lord Byron and the Byron family

Julia Casella

Ben Chisnall

Chiswick Auctions, London

City of Nottingham Museums, Newstead Abbey Collections

City of Westminster

Dr Trudi Darby

Monica Farthing

Dr Donatino Domini, Palazzo Guiccioli, Ravenna

Galleria dell'Accademia, Firenze © 2020

Garden of the Heroes, Missolonghi

Government Art Collection, HM Ambassador's Residence, Athens

Granger Historical Picture Archive

Dr Darryll Grantley

Groeningemuseum, Bruges

Dr Claudia Giuliani, Palazzo Guiccioli, Ravenna

Harry Ransom Humanities Research Center, The University of Texas at Austin

Gary Hope Photography

Hucknall Parish Church, Nottinghamshire

Richard Jackson, Hucknall Parish Church

Lowell Lisbon & Jonny Yarker Ltd

The Earl of Lytton

Nick Hugh McCann, Artist

David McClay

Professor Jerome J. McGann

Ministero per i beni e le attività culturali e per il turismo, Firenze

John Murray Archive, National Library of Scotland

John R. Murray

Ocky Murray

Virginia Murray

Musée National Gustave Moreau, Paris

Musei Civico de Treviso

© National Galleries of Scotland, Edinburgh

The National Gallery, Athens, Alexandros Soutzos Museum

© National Portrait Gallery, London

© National Trust Images. Hughenden Manor, Buckinghamshire

New York Public Library

Paper Lion Ltd and the Proprietor of the Lovelace Byron Papers

Francesca Parinello

Professor Carla Pomarè

Sara Rawlinson Photography

© Royal Collection Trust. Her Majesty Queen Elizabeth II, 2019

Danièle Sarrat

Scala Archives

Natalie Shaw Photography

Dr Cathryn Spence, Curator, Bowood House, Wiltshire

© Tate Britain, London

Thorvaldsens Museum, Copenhagen

The Master and Fellows of Trinity College, Cambridge

© Walker Art Gallery, Liverpool

Index

155

Published in 2020 by Unicorn,
an imprint of Unicorn Publishing Group LLP
5 Newburgh Street, London, W1F 7RG

www.unicornpublishing.org

A catalogue record for this book is available from the British Library

Designed by Ocky Murray
Printed in Slovenia on behalf of Latitude Press Ltd

ISBN 978-1-912690-71-8

Endpapers: woodblock cipher, by Reynolds Stone.